ROBIN HAMLYN

ROBERT VERNON'S GIFT

British Art for the Nation 1847

TATE GALLERY

Exhibition sponsored by Sun Life Assurance Society plc

SUN LIFE

cover
Sir David Wilkie **Newsmongers** 1821
detail (no.71)

frontispiece
William Henry Pickersgill **Robert Vernon** 1846
(no.54)

ISBN 1 85437 116 9

Published by order of the Trustees 1993
for the exhibition at the Tate Gallery 16 March – 31 October 1993

Designed by Caroline Johnston
Photography of works in the Vernon Gift by Tate Gallery Photographic Department
Published by Tate Gallery Publications, Millbank, London SW1P 4RG
© Tate Gallery 1993 All rights reserved
Typeset in Ehrhardt by Apex Computersetting, London
Printed in Great Britain at the University Press, Cambridge

ROBERT VERN

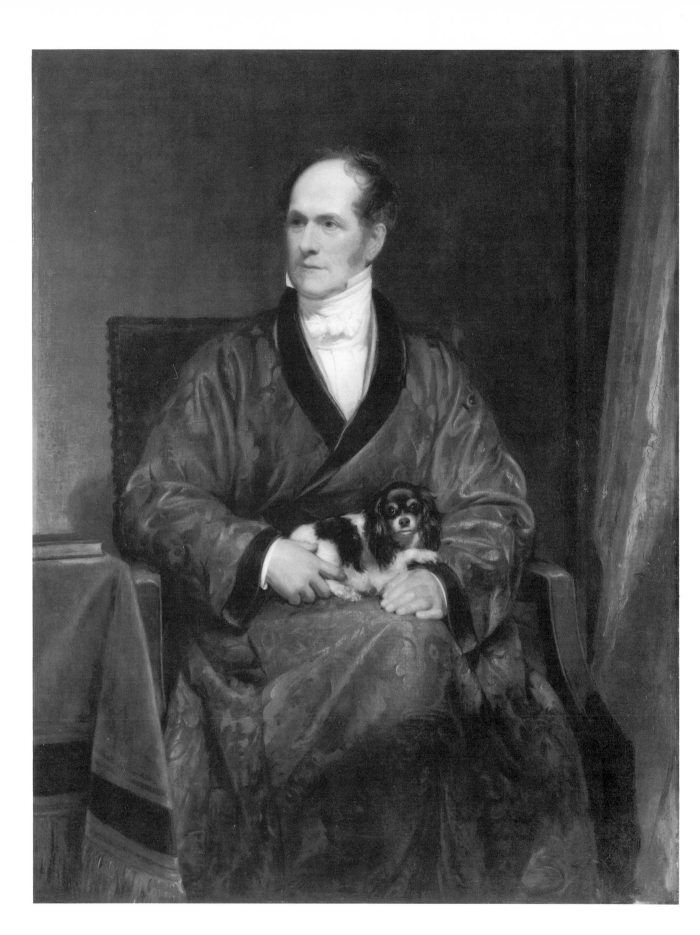

Contents

Sponsor's Foreword

It gives Sun Life Assurance Society plc enormous pleasure to sponsor *Robert Vernon's Gift*. Like the Tate Gallery, Sun Life's origins stretch back to the nineteenth century. In 1810, just as Vernon was firmly establishing his business, we opened our first office directly opposite the Bank of England. Since then we have maintained a strong presence in the City, and an even larger one in the broader financial services arena.

Although the worlds of investment, life assurance and pensions might seem far removed from *Robert Vernon's Gift*, in fact, wise investment most certainly underpinned Vernon's success as a patron of art. This outstanding display, which shows some of the fruits of his commercial acumen, has given us a welcome opportunity to sponsor art that reflects Sun Life's longevity, quality and strength.

These wonderful paintings give a vivid insight into what constituted popular artistic taste in the first half of the nineteenth century. Please enjoy them. I hope that you derive as much pleasure from these masterpieces as we have from supporting the display.

Peter Grant
Chairman
Sun Life Assurance Society plc

Foreword

In 1847 Robert Vernon presented 157 paintings and eight sculptures by British artists to the Trustees of the National Gallery. His aim, in which he was widely supported by artists and critics, was to lay the foundations of a Gallery of British Art which would be an integral part of the National Gallery. By taking this first practical step Vernon provided one of the cornerstones of what became the National Gallery of British Art (since its inception fondly known as the Tate after its benefactor Sir Henry Tate) which opened here at Millbank in 1897.

As we approach our centenary in 1997 this exhibition not only provides a timely opportunity for us to celebrate and enjoy a vital part of our origins – and incidentally the crucial role which private patronage has always had in our history – but also to reflect further on the recently initiated debate about the future of the Tate as a Gallery of British Art.

Robin Hamlyn, Assistant Keeper in the British Collection, has selected and catalogued this display but, as he would be the first to acknowledge, a part of this publication inevitably draws on the research of past and present colleagues in his department. Of these, two in particular, Martin Butlin, former Keeper, and Leslie Parris, Deputy Keeper, were enthusiastic supporters of the idea of a Robert Vernon exhibition from the time it was first proposed some years ago.

This exhibition has involved a lot of preparatory work by the Paintings, Framing and Sculpture conservation studios. Anna Southall has co-ordinated the conservation programme and has herself undertaken much of the necessary work, along with her colleague Chris Holden. John Anderson has designed new picture frames to replace those that had been removed and lost in earlier years, and with his colleagues Caroline Wright, Stephen Huxley and Jack Warans, he has carried through the most intensive programme of frame restoration the Tate has ever undertaken. This was made possible by generous grants from Mrs Jean Sainsbury and the Worshipful Company of Goldsmiths.

Finally, we are extremely grateful to Sun Life Assurance Society plc for the interest they have shown in this project, and for their enthusiastic and generous support.

Nicholas Serota
Director

Robert Vernon 1774-1849: Patron

ROBIN HAMLYN

The Image of a Patron

fig.1 George Jones (1786–1869) and Henry Collen (1798–c.1872) **Robert Vernon** 1848 Oil on panel 76.2 × 62.9 (30 × 24¾) *National Portrait Gallery*

The earliest and only full account of Robert Vernon's life can be found in volume twenty of the *Dictionary of National Biography* which was published in 1909. It is brief and to the point, but, even so, Vernon's inclusion in the *DNB* fixes him securely in the pantheon of British worthies. Not among the truly great but – so all the evidence would suggest – among those noble, self-made and patriotic men whose lives and works have contributed to the moral and material progress of our nation. Vernon was, we read:

> born in 1774, was of humble origin, and became, through his own exertions, a job-master, posting contractor, and dealer in horses in London in a very large way. He amassed a large fortune as contractor for the supply of horses to the British armies during the wars with Napoleon. He turned his attention to pictures … [He] is said to have bought [these] without the intervention of dealers, and with little guidance beyond that of his own judgement. On 22 Dec. 1847 he presented a selection of 157 pictures from his collection to the nation.

Here, then, is a man whose success owed almost everything (it would seem) to those virtues of 'application and diligence', 'patience and perseverance' and the seeking of 'elevation of character' so much admired by the Victorians;[1] a man, moreover, whose personal achievement was, in some specific way, bound up with an important event in the nation's destiny – the eventual victory over France in 1815.

Today we can see that this spare but rather stock image of a nineteenth-century philanthropist who has made good through his own exertions is over-simplistic. It serves a purpose, but it should not be taken at face-value. One reason, surely, for this over-simplification must stem from Vernon's own reluctance ever to discuss his origins, for at no time during his lifetime or in his obituaries are they alluded to (though his business as a job master, or horse dealer, was). Maybe Vernon would not divulge them lest it adversely affected his image; maybe there was even a certain distaste or contempt for a man who, as a supplier of horses to the nobility and gentry, was clearly a servant of the Establishment but had nevertheless through his patronage of the arts became a master: 'A Jobber he certainly was, by nature as well as by trade' snorted one of his artists.[2]

He was certainly characterised, once, as one 'whose apparent interest in art was really used simply as a means of lifting him out of obscurity into some sort of *locus standi* in the world'.[3] Such a view gains some support from what we know about the background to his gift: that before he offered his pictures to the National Gallery in 1847, another collector, John Sheepshanks (1784–1863) had proposed giving his, rather similar, collection of British pictures to the nation:

> Mr Sheepshanks consulted Mr Vernon on the expediency of making a joint gift of their separate collections … Unfortunately, Mr Vernon preferred to stand alone, and declined to co-operate.[4]

Another whiff of self-aggrandisement on Vernon's part in his dealings with the state is discernible in an account of how Queen Victoria and her government set about recognising his generosity. The *Builder* for 9 September 1848 reported:

We mentioned a few weeks ago, with some shame, that a *knighthood* had been offered to Mr Vernon, and of course declined … no friend of Mr Vernon entertained for one moment the idea of his receiving it, – as the lowest honour the Queen can bestow, and one which is given on very trifling occasions for no service at all, it was felt, and justly, that the offer of it did not shew a proper appreciation of the gift … Everyone concluded that a baronetcy would have been offered, and this Mr Vernon would doubtless have accepted.[5]

Cruelly, perhaps, neither a baronetcy nor a knighthood came Vernon's way. We shall never know if he died a disappointed man: the only public thanks he ever received from a grateful nation were those mouthed by peers and MPs at Westminster, paying tribute to his 'rare munificence', 'magnificent donation', 'given in a most disinterested public spirit'.[6] An attempt to muster support among artists for a commemorative testimonial failed (see no.7). Vernon was left with the dubious pleasure of knowing that his gift was entombed in the most unsatisfactory rooms in the National Gallery in Trafalgar Square (fig.2). But an appropriated coat-of-arms, which still adorns his memorial in Ardington parish church, and which links him with the old Vernon families of Shipbrook, Cheshire and Haddon Hall, Derbyshire, survives as a lasting reminder to later generations of his rise from obscurity (fig.3).[7] Unmarried and childless, in naming an heir he directed in his will that he took the name and arms of Vernon.[8] The parishioners of Ardington, who benefited from an instruction in Vernon's will that the profits from government stocks should be used for their welfare, no doubt attended his burial one late May day in 1849.[9] Even the portrait of Vernon by Jones and Collen (fig.1 on p.9), which shows him with the Turner which went to the National Gallery as a token of his gift of British art at the end of 1847 (no.65) and Gibson's sculpture of 'Hylas Suprised by the Naiades' (no.29), seems an awkward and forlorn attempt at preserving the man's name.

fig.3 The Vernon Monument, Holy Trinity Church, Ardington, Berkshire

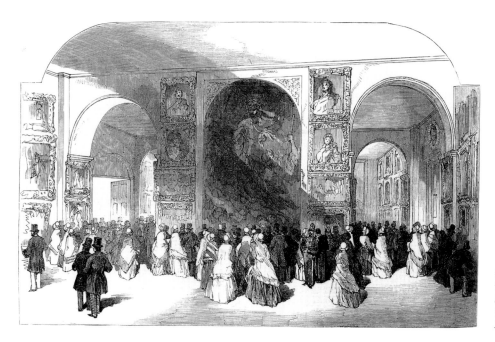

fig.2 Anon, **The Vernon Gallery in the National Gallery, Trafalgar Square** Wood engraving 14.6 × 23.2 (5¹³⁄₁₆ × 9⅛) from *The Illustrated London News*, vol.13, no.342, 4 Nov. 1848, p.284

While there can be little doubt about the obscurity of Robert Vernon's beginnings, they were not quite what the word 'humble' would suggest. At the time of his father's death in December 1801 we find him in trade, certainly, but also the inheritor of a well-established and going concern (albeit burdened with some debts) in the most fashionable part of London. When William Vernon, hackneyman of Mount Street, Berkeley Square, Mayfair, signed his carefully thought-out will on 19 October 1801, he left £100 to be paid to his widow Mary immediately after his death and he further directed that thereafter she should be paid an annuity of £150. He also specified that 'all stock of wines and liquors, all household goods, furniture, printed books, prints, pictures, linen and china' were, after her decease, to be divided between his two sons, Robert and Edward. Another son (possibly by a previous marriage) was bequeathed £200. One of the two stable-yards which he leased, Black-horse Yard in New Bond Street, together with all its appurtenances, was left to Robert, and the other, behind the house in Mount Street, was left in trust to two friends 'to offer for sale' to Robert.[10]

The tone and substance of the will suggests a confident and well-off tradesman, one, indeed, who in the words of a close friend, was 'unequalled in his line of business',[11] and, for another, was 'so Just a man'.[12] It is an impression strengthened by the little we can glean from his will about his circle of friends: his executors were other tradesmen – another hackneyman, and a coal merchant – and a farmer and, of the three mourning rings which he left, two were for men described as 'gentlemen'. As far as we can tell, William had been established in Mount Street since early 1793[13] – where he remained until his death – although in the intervening period he paid rates on other properties (one of them a stable-yard) in the immediate vicinity.[14] Together with the two stable-yards already mentioned and a property (probably leased as a rural 'retreat') out among the fields and nurseries of Brook Green, near Hammersmith,[15] William Vernon was a man with quite widespread interests. When his estate was finally valued, it was worth the considerable sum of just over £3,350, which included the value of 130 horses and two hacking coaches.[16] Had there been a struggle to establish the Vernon family fortunes, it had fallen to William, and not Robert, to succeed.

If the air of sound commercial success, financial security and a certain social ease which pervades his father's will helps give the lie to the idea of Robert as a self-made man, then the brief reference in it to 'printed books, prints, pictures' must, inevitably, further shift our perceptions of him as a collector: that he might possibly have grown up in a household which contained inherited art, or where the acquisition of pictures was regarded as a perfectly reasonable way of spending business profits; that he could have inherited a taste for art (and literature, for that matter) as a youth and actually lived with pictures for some time before he started his own collection. The nature of his father's collection, could we but define it, combined with some sense of that time when Robert Vernon, perhaps, broke away from the constraints it imposed on his own taste, could give us an insight not only into his real motives for buying British art but also convey some idea of what patronage in nineteenth-century Britain was all about.

A clue to this seems to lie in two documents which can be found among Robert Vernon's papers in Balliol College Library. One is an undated inventory of just over one hundred paintings and prints, together with a number of books, which is written on blue paper watermarked 1810.[17] This list appears to be associated with an inventory of the contents of the house of Mrs Vernon as sold at Hallgate West, Doncaster, in 1812.[18] Quite conceivably, this Mrs Vernon might be William Vernon's widow; but, anyway, the preservation of the list of pictures among Vernon's papers and its approximate dating to about 1812[19] demonstrates, at the very least, that it had some place in his early history.

Furthermore, there is a precise connection with Robert Vernon, for quite a few of the pictures on this list reappear in the sale of the residue of his estate held at Christie's in 1877.[20] Among them, quite remarkably, was an oil painting, attributed from 1838 to Gabriel Metsu (1629–67), now known to be by Jan Vermeer (1632–75), and which has been in the Metropolitan Museum, New York since 1889, and which can only have been the picture described merely as 'Woman at a Window' in the early list (fig.4).[21]

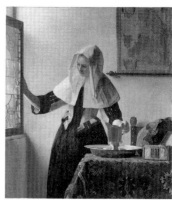

fig.4 Johannes Vermeer (1632–75)
Young Woman with a Water Jug
*c.*1660 Oil on canvas 45.8 × 40.6 (18 × 16)
Metropolitan Museum of Art, New York

Apart from this exquisite little masterpiece – at present the only work which can be even tentatively linked with the origins of Robert Vernon's collecting – the quality of the '1812' list remains unknown. It is made up almost entirely of seventeenth-century portraits (mostly of English sitters) and Dutch and Flemish landscapes and marines, all attributed, with a degree of optimism one suspects, to well-known Old Masters: five portraits each 'by' Sir Anthony van Dyck (1599–1641), and Sir Peter Lely (1618–80); four each by Cornelius Johnson (1593–1661), Sir Godfrey Kneller (?1649–1723) and Daniel Mytens (*c.*1590–*c.*1648); three by Hans Holbein (1497/8–1543) and one each by Jan van Eyck (active 1422, *d.*1441) and Diego Velàzquez (1599–1660), together with a scattering of landscape subjects – notably half-a-dozen sea-pieces by the Dutchmen Simon de Vlieger (1600/1–1653), Ludolf Bakhuizen (1631–1708) and Jacob van Ruisdael (1628/9–1682), a landscape by F. de Moucheron (1633–86), a church interior by Peeter Neeffs the Elder (*c.*1578–1661) or Younger (1620–after 1673), and a still life by Abraham Mignon (1640–79). It is a group of works not altogether untypical of the sorts of collections which could be found among a few of the better-off trades people at this time. It might have been flawed, but it clearly aspired to the tastes and habits of display of the upper classes; and might (especially if we take account of the Vermeer) demonstrate a discerning taste.

At some point around 1812, Vernon must have inherited these pictures and then lived with them for some time while he consolidated his affairs. By the end of 1802 he had taken over the Mount Street business in which, as far as the future was concerned, a family friend pointed out, he had only to pursue 'a good plan … & a line Drawn that you have no more to Doo but follow up to that'.[22] He ran this in tandem with the stables in Bond Street. Combined, they made up a sizeable enterprise: of the debts, referred to earlier, which amounted to about £2,500 on 1 September 1802,[23] £1,000 or so remained uncollected by the end of the month.[24] The debtors came from the upper crust of society: the Prince and Princess of Wales, the Earl of Bristol, Lord Mexborough, Earl Cowper, Lord Rodney, the Duke of Bedford, numerous Esquires – and so on.[25]

For what, precisely, were these people in debt to the Vernons? Well, William and then Robert were among the invisible managers of eighteenth and nineteenth-century London's traffic system. As hackneymen and stable keepers they owned and let out carriages and horses on daily, monthly or yearly 'jobs' (hence the general term 'job master' which is applied to such people) both in and out of town. They would stable horses, have them shod at their forges and supply forage for them, wherever they were.[26] Being a job master was a noisy, smelly business carried out in the straggling, cobbled mews, once found beyond those robust, rusticated and pedimented arches which still punctuate some of London's handsomest terraces, but which are now mostly demolished or gentrified. In such places, the rich Miss Crawley of William Thackeray's *Vanity Fair* would have found the liveryman from whom she 'jobbed her carriage' and the doting young David Copperfield of Dickens's novel would have hired the 'gallant grey' which bore him, bouquet tucked in his hat, down to Norwood for Dora Spenlow's birthday. In short, Vernon's services were indispensable to the smooth running of the capital's social and commercial life.

What little is known about Robert Vernon during the period 1802–18 comes from the Rate Books for the Parish of St George's, Hanover Square, and trade directories. He continued running his business at Mount Street until 1815.[27] He first appears in a trade

directory in 1805, still at the livery stables, 31 New Bond Street, left him by his father;[28] in 1818 when he voted in the general election, he was registered as a 'stable keeper' of 40 New Bond Street.[29] However, one thing does seem to be clear: there is no evidence to connect Vernon (or his father) with the supply of horses to the British army during the Napoleonic Wars which ended with the triumph of Waterloo in 1815 – nothing in his surviving papers; nothing, so far as can be established, in the War Office documents in the Public Record Office. Instead, it was one, rather mundane, deal which transformed Vernon's business affairs as well as his social standing and which, in turn, sparked off an active interest in modern British art. That Vernon himself considered this one deal as a turning point in his fortunes might, perhaps, be deduced from the fact that out of all the transactions which he must have made, this is the only one whose details are preserved among his papers.

Vernon probably approached the executors of Christopher Hall, job master, some time in May 1820 with a view to taking over his stables and horses. The timing was well chosen. The March general election was out of the way; the accession of George IV (once, as Prince of Wales, one of William Vernon's customers) to the throne the previous January held out the promise of a lavish coronation, together with all the social whirl that went with it, the splendour of which would have rubbed off on the horse and carriage trade; the price of forage was falling,[30] while simultaneously the yield on Vernon's investment in 3 per cent. Consols was declining.[31] There was, then, every reason for him to explore new enterprises.

It is not entirely clear just how much Hall's business cost Vernon but, after some haggling on both sides, it appears to have been in the region of £30,000 – a vast sum at the time – raised partly through mortgages and paid partly in installments. For this, he acquired more than three hundred horses (299 of them on yearly jobs) and a distinguished clientele amongst whom were the Lord Chancellor, Lord Eldon, the Bishop of London and General Phipps – one of whose pictures Vernon later owned (see no.71). Along with the tenancy of Hall's stables in Pembroke Mews North[32] – just next to Tattersall's horse auctions – and far more important, Vernon also acquired Hall's house at 2 Halkin Street, Grosvenor Place, behind which lay the core of the business: twenty-two stables (with 106 stalls), a counting house, riding school and granary. There can be little doubt that Vernon was entering, as Hall's executor pointed out to him, 'a superior business in its full play: the profits of which insure a rapid & liberal fortune to any man who has sufficient capital & abilities like yourself to carry it on'.[33]

Number 2 Halkin Street was (and still is) a handsome, four-storey Regency brick house with a simple, dignified front doorway and plain cast-iron balconies at its three, high, first floor windows; on one side, a wide arched opening leads to a yard. Next door but one is the mews arch. Part of an elegant terrace, it was, in 1820, just a few minutes walk from the open ground which Vernon's future next-door neighbour, the entrepreneurial builder Thomas Cubitt, was to lay out five years later as London's noblest square – Belgrave Square. Robert Vernon's new residence was almost certainly much larger and more graceful than any house he had previously occupied – either in Mount Street (which had always been largely populated by businesses and trades),[34] or Bond Street. Having, in one sense, broken with his past and poised, as he now was, to take advantage of the influx of rich people into his neighbourhood, Vernon used the Hall business as a springboard for commercial and social expansion.

By leases dated 30 August 1820, 25 January 1821 and 2 March 1821,[35] Vernon took on a coach house, stables, workshops and a blacksmith's shop in nearby Grosvenor Mews; and then, on 9 September 1822, he re-established a foothold in the immediate vicinity of Berkeley and Grosvenor Squares, by leasing, from Earl Grosvenor, a house and its associated stables, at 119 Mount Street – a few doors away from his father's old house.[36] From now on, however, we are no longer concerned with how Vernon made his money –

he died a very rich man – but how he enjoyed and displayed his wealth. When the 1822 edition of the handy, pocket-sized, social register *Boyle's Court Guide* was published, the name of Robert Vernon, at his new address, appeared for the first time among those tightly packed lines of small print which listed all those who counted for something in London. After his name was the much coveted 'Esq.': it was a succinct enough announcement that Robert Vernon, Gentleman, had 'arrived'. Along with this came the comfortable rural villa, much favoured by the city's prosperous businessmen, and which in Vernon's case was found five miles out of town on the picturesque and woody slopes of Crouch End.[37]

The time when Vernon started actively collecting modern British art can be dated fairly precisely to the years immediately following his move to Halkin Street. If, by this date, as we suppose, he owned the collection that once belonged to his father, then he already had a few minor modern British pictures on his walls: three 'Sea-Pieces' by William Anderson (1757–1837) and a 'Landscape and Figures' by Julius Caesar Ibbetson (1759–1817) along with a couple of prints by William Woollett (1735–85) and, perhaps, Richard Earlom (1743–1822). Also, it is not at all too far fetched to assume that by the 1820s Vernon, with a flourishing business in Mount Street up until 1815, could have become familiar with the pioneering collection of British paintings formed by Sir John Leicester (later Lord de Tabley) and exhibited in a specially built gallery next to his house in Hill Street from 1806: Hill Street was a few minutes walk away from Mount Street. Vernon's later acquisition of five of de Tabley's pictures when they were sold in 1827 (including nos.10, 69; see also fig.5) smacks of pragmatism as well as of sentimental attachment. Just a short stroll down Mount Street towards Hyde Park Vernon would have come to the great house of Earl Grosvenor whose Old Master and British paintings

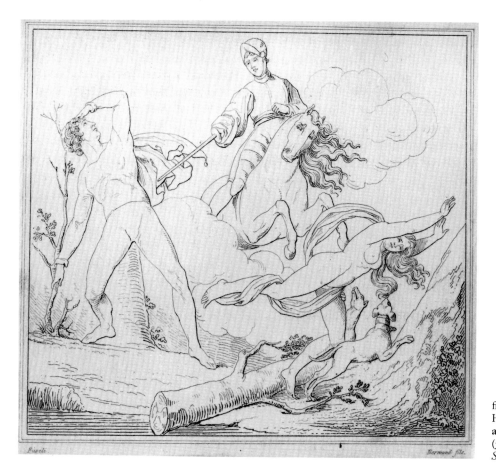

fig.5 C. Normand (1765–1840) *after* Henry Fuseli (1741–1825) **Theodora and Honoria** 1818 Engraving 9 × 11.2 (3⁹⁄₁₆ × 4) from E. Hamilton, *The English School*, 3 vols., 1832, vol.3

were, from 1808, accessible to a select public; from 1819, they were displayed in a magnificent purpose built gallery.[38]

But it would, in any case, have been surprising if Vernon in his position, once on the margins of society but then suddenly part of it, had not been aware of a growing taste for British art and heard the appeals for support made by artists and their exhibiting bodies to their well-heeled public: the Royal Academy of Arts, under the patronage of the King, the *British* Institution and the Society of *British* Artists (established in 1824) were perpetual reminders of the fact that an association with modern art not only brought patrician respectability but also, in these years following the victory at Waterloo, carried with it potent, utterly respectable, nationalistic connotations.

Even so, the signs are that Vernon first needed some encouragement before he started collecting seriously, if at first, tentatively. He seems, from the outset, to have been a patron who needed support, if not advice, from his close acquaintances. Vernon Heath, his nephew and man-of-business in later years, recorded that it was two friends, the comic actor John Fawcett (1768–1837) and the playwright Thomas Morton (?1764–1838), who induced him to buy modern pictures.[39] In addition, we know that on at least two occasions when Vernon went to artists' studios he was accompanied by friends,[40] while the Royal Academician George Jones went so far as to claim that Vernon's collection was formed under his 'guidance, suggestion and judgement'.[41] At the very least, this suggests that Vernon had doubt about his own aesthetic judgement. Perhaps, also, he was only too well aware of how collectors and connoisseurs, once their taste was exposed to public view in the exhibition or auction room, could be pilloried as eccentric, ignorant or gullible – not only in caricatures by the likes of Thomas Rowlandson and George Cruikshank but also in print: a newspaper report about Sir John Leicester when he was ennobled in 1826, stated that 'the only thing we can say of *this Gentleman* is, that he possesses a fine house in the country, and a Picture Gallery, which has been collected with more *liberality* than distinction'.[42] It was a comment which could not have failed to make any potential collector of British art a little wary of buying new art rather than pictures by the established Old Masters.

Quite possibly, Vernon started buying British art as early as 1823[43] or 1824,[44] but his first known purchases were made at the British Institution in 1826 when he acquired two small works by minor artists – Edmund Bristow's 'Cattle' (181) and Alexander Fraser's 'The Lucky Fisherman' (85).[45] From what we know of the work of these artists, who are now more-or-less totally forgotten, their pictures were 'true to nature' in the sense that they were well-observed and highly finished. Fraser's 'low-life' subject of a fisherman coming home and showing his catch to his wife possessed 'a clearness and brilliancy of scene united with character and nature in the figures'[46] derived from Dutch seventeenth-century models via the art of David Wilkie. These two pictures define Vernon's taste at this stage as conventional and unadventurous – very much following the fashion for literalness and the anecdotal in art. Tellingly, he clearly avoided some of the more important and interesting names in British art who were represented in the same exhibition and in this Vernon comes over as a man who was reluctant to spend too much money on his art.[47] A similar pattern can be seen in Vernon's purchases at the exhibition of the Society of British Artists which opened in April 1826: another work by Bristow, 'The Trouble of Property' (61) – probably a 'monkeyana' subject; a small sub-Landseer rendering of a dog in a larder of dead game entitled 'The Thief' by Henry Pidding (58),[48] a fruit piece by George Lance and two landscapes by John Wilson and T.C. Hofland.

This kind of art, essentially decorative in character and not particularly distinguished in terms of handling and colour, was scarcely the stuff of a great collection in the making. Indeed, Vernon weeded such works out of his holdings before he approached the National Gallery about giving his pictures to the nation in 1847. It was not until 1827 that Vernon finally found his feet as a patron. At the beginning of the year he acquired a large

history painting by H.P. Briggs (no.9). Because history painting, with its grand and heroic themes (the antithesis to Bristow's and Pidding's subject matter), was central to the Royal Academy's promotion of native genius, Vernon's choice would have immediately identified him to the world at large, and artists in particular, as a serious collector. He also bought from the same exhibition his first picture by an Academician, Henry Howard's 'Florentine Girl' (N00349). And then, in July 1827, he bought five pictures at the controversial sale of Lord de Tabley's British paintings, including his first work by a deceased master, Henry Fuseli, who had died in 1825 (fig.5). Of the five purchases, two of which survive in the Vernon Gift (nos.10, 69), the Fuseli was undoubtedly Vernon's most curious acquisition so far: in its extravagant, spectral qualities it was quite different to anything he had bought. It is likely that he was encouraged to acquire it by one or several of the many artists who, as we know, were anxious to preserve the de Tabley collection in some way for the country.[49] This may be the point at which George Jones entered Vernon's life, but whatever the facts, it does seem clear that Vernon's acquisition of this picture, and also the Briggs, indicates that the community of artists had succeeded in harnessing his riches and his goodwill for the benefit of British Art.

'Mr Vernon's great house in Pall Mall'[50]

The nature and scope of Vernon's patronage from 1827 onwards will emerge from the catalogue entries which follow. However, it seems appropriate at this point – with the dissolution of de Tabley's great gallery of British art complete – to move forward five years to 1832 when Vernon took the most important step in his career as a collector and created his own, unofficial, 'National Gallery of British Art'.

The year 1832 was described by the radical history painter Benjamin Robert Haydon as 'the most wonderful year in the history of England'.[51] He was referring not to the prospects for art – though he might well have done had he been aware of Vernon's activities at this moment – but to the passing of the Reform Bill. This, with its provision for the extension of the vote and redistribution of parliamentary seats, marked a turning point in the nation's history. The whole process of reforming the old, corrupt, electoral system had preoccupied the country for more than a year. The mob violence that accompanied the political debate was so widespread and threatening that it prompted John Constable to anticipate that such fundamental constitutional change would 'give the government into the hands of the rabble and dregs of the people, and the devil's agents on earth – the agitators'.[52]

How Vernon felt about these matters is unknown but since he had voted in 1818 for John Cartwright,[53] an old advocate of universal suffrage known as the 'Father of Reform',[54] and might well have been an admirer of a more pragmatic reformer George Canning (no.4), it would be reasonable to assume that he did not see the new Bill as a great threat to him or his country. Certainly he continued collecting at the same rate of about ten pictures per year during the period 1831–2; also by late 1831 he had acquired a new country residence at Titchfield in Hampshire which he gave up a few years later in favour of Marble Hill Cottage, on the Thames at Twickenham (fig.6).[55] Then, on 22 May 1832, just before the Reform Bill was passed, he successfully bid for the residue of a 999 lease on a large house at 50 Pall Mall (fig.7).[56]

The property, previously the premises of a firm of bankers which went bankrupt in March 1832, had been built in the late 1760s and was ideally suited to Vernon's requirements. It was in one of London's most fashionable streets and only two doors east of the British Institution whose annual winter exhibitions Vernon had been patronising since

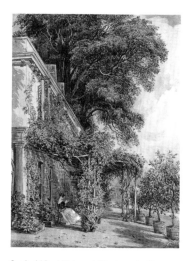

fig.6 Alfred Edward Chalon (1781–1860) **The Garden Front of Mr Robert Vernon's House at Twickenham** *?c.*1839 Watercolour on paper 51.1 × 37.7 (20⅛ × 14⅞) *Board of the Trustees, Victoria and Albert Museum, London*

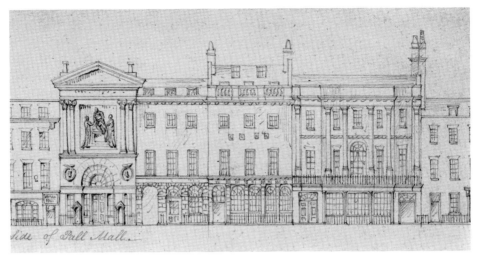

THE BRITISH INSTITUTION ROBERT VERNON'S HOUSE

1826, if not before; Christie's, the main picture auctioneers, were nearby; the National Gallery, only eight years old, with its meagre (for many) holdings of British paintings, was a short walk away. With a government vote of funds just announced in April, plans for its eventual move in 1837 to its present position in Trafalgar Square, just at the end of Pall Mall, were at least in the air.

The newspaper advertisement which must have first drawn Vernon's attention to the house, helps convey some idea of what it looked like inside:

> These very capital and commanding Premises are adapted for any public establishment, or for a professional or private residence. They are most substantially constructed, and in complete repair … The ground floor is admirably arranged for business, and in the basement are fire proof strong rooms, in addition to servant's offices, and a detached kitchen, with a pump of fine spring water. The upper floors embrace every accommodation for a family, the front drawing room is spacious and lofty, and an ante-room connects it with an excellent eating room. The entrance hall is distinct, and an elegant stone stair case rises to the bed chambers, which are numerous, with water closets on each landing …[57]

As is evident from the 1814 view of the north side of Pall Mall which is illustrated here, 50 Pall Mall was not the grandest house in the street. It probably looked much the same in 1832 and although it was usually termed a 'mansion' during Vernon's occupancy, the use of the word is compromised in our eyes today by the appearance of a ground floor which obviously reflects a commercial use.

Vernon did not move into number 50 until about mid-1833 or early 1834[58] but from the moment he had the property in mind his collecting embraced a larger view of British art. Up until this time his involvement in the wider debate among artists and patrons about the status of the national school of painting and its right to be recognised alongside the achievements of foreign schools had been marginal: he bid at the de Tabley sale and in February 1828 he became an annual subscriber to the British Institution whose Governors, besides exhibiting British paintings and sculptures, had periodically attempted to resolve the issue of how to form a permanent display of them.[59] Taking over the Pall Mall House changed this. Bolstered as much by the prestige which his new address gave him as by the space which it provided, not only did Vernon buy his first major British 'Old Master' in May 1832 (Gainsborough's 'Sunset: Carthorses Drinking at a Stream', no.27) but he also set about buying pictures by those living artists, hitherto unrepresented, whose presence was crucial to a proper survey of contemporary art: he bought his first

Turner at the Academy in 1832 (N00369) and also a large Etty (no.26). Other canvases by Turner (nos.64–5), David Wilkie (nos.73–4), John Constable (no.17) and William Mulready (nos.50–2) came in the following years, as did a fine piece of neo-classical sculpture by John Gibson (no.29). From this period must surely date the beginnings of Vernon's plan to offer his collection to the nation.

By 1839, such was its prestige that the newly-launched art magazine, the *Art-Union* inaugurated its series of 'Visits to Private Galleries' with a visit to Pall Mall. The description they gave of Vernon's house conveys some sense of the patron's achievement and, also, a noticeable determination on his part to appear unostentatious:

> Every room in his mansion is filled with [pictures] – from the parlour to the attic; they are evidently brought together far less for display than to render HIS HOME intellectually delightful; to receive enjoyment from every chamber to which he has constant and hourly access. His good taste is displayed also in the other arrangements of his apartments; there is no gaudy drapery or gilded furniture to attract the eye and distract the attention; the chairs, tables, and sideboards, are perfectly plain; the pillars simple and quiet; and the looking-glasses framed in weak and narrow strips of moulding. Even the brass-rods that hang the pictures are painted over.[60]

Four years later, in the summer of 1843, following consultation with a number of Royal Academicians,[61] Vernon opened his house to the public for the first time. Admission was by ticket only (obtainable from Academicians) on two afternoons a week during the Season. Preceded as it was by a dinner to which all the leading artists of the day were invited[62] it was an occasion pregnant with a sense of national importance – as the *Art-Union* pointed out:

> Here a right notion may be formed of the capabilities of British Art; and to this glorious gallery every foreigner should be especially directed … All honour to so veritable a patron – so true a patriot!

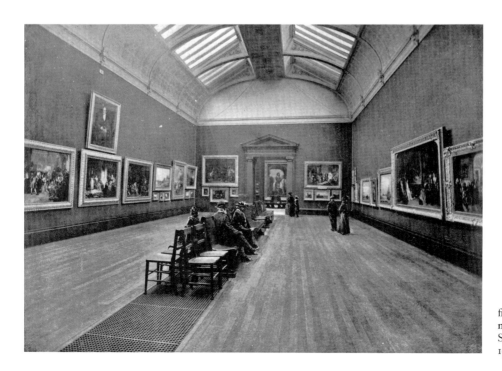

fig.8 **The Vernon Room (Gallery no.1) in the Tate Gallery** *c.*1905 from Sir Charles Holroyd, *The Tate Gallery*, 1905, p.13

Notes

The place of publication is London, unless otherwise stated.

1. As set out by Samuel Smiles in *Self Help; with Illustrations of Conduct and Perseverance*, new ed., 1880, p.v.
2. J.C. Horsley, *Recollections of a Royal Academician*, ed. Mrs E. Phelps, 1903, p.60.
3. Horsley 1903, p.60 (see no.34).
4. *Journal of the Royal Society of Arts*, vol.6, 5 May 1858, p.237; meeting of 3 March 1858 addressed by Henry Cole.
5. *Builder*, vol.6, 9 Sept. 1848, p.434.
6. *Hansard*, , vol.98, 3rd ser., 23 May 1848, 1254, 1261.
7. I am grateful to Timothy H.S. Duke, Rouge Dragon Pursuivant, for identifying Vernon's arms.
8. His heir was Leicester Viney Smith (1798–1860), second son of his old friend Major-General Sir Sigismund Smith of the Royal Artillery (1764–1834). He took the name Vernon by Royal Licence, May 1850.
9. Last Will and Testament of Robert Vernon; Public Records Office (PRO), Prob. 11/2095, LH 238–47.
10. Will of William Vernon, PRO, Prob. 11/1367; 830.
11. Bartholomew Arnott to Robert Vernon, 10 Dec. 1801; Jenkyns 2a ack. I am grateful to the Master and Fellows of Balliol College, Oxford, for giving me access to the papers of John Jenkyns, one of Vernon's executors, on deposit in the college library from the Jenkyns family; hereafter referred to as Jenkyns.
12. C. Picton to Robert Vernon, Kingston, 23 Dec. 1802; Jenkyns 2a.
13. Parish of St George's, Hanover Square, *Poor, Highway and Scavenger Rates* (Grosvenor Ward) c.491, Westminster Public Library (WPL), Victoria Library, Buckingham Palace Road where the local history librarians have been my invaluable guides through this and other related material.
14. Adams Mews, between March 1794 until at least the end of March 1797, and South Street, March 1796 until at least 30 March 1797 (WPL, c.492–5).
15. C. Picton to R. Vernon at Mount Street, 16 Feb. 1802; Jenkyns 2a.
16. 'Valuation of the Stock of the Executors of the late Mr Wᵐ Vernon'; Jenkyns 2a.
17. Jenkyns II.3.
18. Jenkyns II.3; Brian Barber, Archivist, Doncaster Metropolitan Borough Council, kindly supplied details of a Mrs Vernon's residency in Doncaster in 1797 and of a Miss Vernon's between 1800–11.
19. Which can be substantiated by the known publication dates of some of the books in the list.
20. *Catalogue of the Valuable Collection of Ancient and Modern Pictures, and Historical Portraits, of that Eminent Amateur the late Robert Vernon Esq., Removed from Hatley Park, Cambridgeshire*, Christie's, 21 April 1877.
21. I am grateful to Burton Fredericksen of the Getty Art History Information Program for supplying details of the change of attribution and also the location of the Vermeer.
22. B. Arnott to R. Vernon, 10 Dec. 1801; Jenkyns 2a.
23. 'Account of Outstanding Debts due the Estate of the Late Mr Wᵐ Vernon dec'd 1 Sept. 1802; Jenkyns 2a.
24. C. Picton to R. Vernon, 26 Sept. 1802; Jenkyns 2a.
25. 'Account of Outstanding Debts – 1 Sept. 1802' (names of debtors and sums owing from the 'Small Ledger' and 'Great Ledger'); Jenkyns 2a.
26. This description is based on the details of the business of Christopher Hall which Vernon purchased in 1820; Jenkyns II.4.
27. See note 13 above: c.501–14.
28. *Holden's Triennial Directory*, 4th ed., for 1805–7, vol.2 (1805), p.[30].
29. *The Poll Book for Electing Two Representatives in Parliament … for Westminster*, 1818.
30. Exemplified in the fall in the price of oats from 31 shillings a quarter in 1818 to 18 shillings in Dec. 1821; see A.D. Gayer, W. Rostow, and A.J. Schwartz, *The Growth and Fluctuation of the British Economy 1790–1850*, 2 vols., Oxford 1953, I, p.143.
31. Vernon sold, through his bank, £5,000 of 3 per cent. Consols on 12 July 1820, partly to finance his purchase of Hall's business. They yielded just over £3,400: Jenkyns II.4.
32. Grosvenor Estate, *Register of Leases* on deposit at WPL, 1049/4/50 f.75; I am grateful to William Ellis, Archivist, Grosvenor Estate, for his help.
33. Thomas Cuff to R. Vernon, 30 May 1820; Jenkyns II.4.
34. See *Survey of London, vol.40: The Grosvenor Estate in Mayfair*, Pt. 2, 1980, pp.316–19.
35. Grosvenor Estate, *Register of Leases*, WPL, 1049/4/50, ff.69, 71.
36. Grosvenor Estate Lease no.672, on deposit WPL, Marylebone Road.
37. An address for Vernon at Crouch End appears on a Guardian Fire and Life Assurance Co. share certificate dated 15 Oct. 1822 (Jenkyns II.3); for Crouch End at this period see T.F.T. Baker, ed., *A History of Middlesex (Victoria Country History)*, vol.6, 1980, pp.108–11, 143–9.
38. For the de Tabley collection at Hill Street see Douglas Hall, 'The Tabley House Papers', *Walpole Society*, vol.38, 1960–2, pp.58–122; for the gallery at Grosvenor House see *Survey of London* (n.34, above), pp.241–3.
39. Vernon Heath, *Recollections*, 1892, p.2. Portraits of Fawcett and Morton by Thomas Lawrence and M.A. Shee were included in Vernon's Gift to the National Gallery: see Checklist.
40. In the case of T.S. Cooper, with Fawcett and Morton (see no.19) and in that of John Constable, with the artists J.J. and A.E. Chalon (see no.17).
41. George Jones, RA, *Sir Francis Chantrey, RA,*

Recollections of his Life, Practice, and Opinions, 1849, p.209; some support for this claim is found in Jones's letter of 15 Jan. 1845 to Vernon (Jenkyns 11) in which he recommends the purchase of a picture by Linnell (no.47).

[42] Reported in the *Examiner*, 2 July 1826, p.418.

[43] A picture by the battle painter Abraham Cooper, 'The Battle of Naseby' exh. in 1823 (250), was in a sale of works owned by Vernon, Christie's, 6 May 1842 (203); a 'Scene from the "Winter's Tale"' by Henry Thomson, possibly a work exhibited at the Royal Academy in 1823 (197), was in the sale of the residue of Vernon's estate, Christie's, 21 April 1877 (122).

[44] He owned Edwin Landseer's 'Puppy and Frog', exh. BI 1824 (202) which was sold out of his collection, Christie's, 5 July 1849 (35).

[45] From a list of purchasers published in the *Literary Gazette*, 1 April 1826, p.203.

[46] *Literary Gazette*, 4 Feb. 1826, p.76.

[47] Compared with, for example, the Duke of Bedford who bought six pictures, one by the brilliant and much sought after Edwin Landseer; Lord Northwick, two pictures, one by the well-established Academician William Mulready; John Gibbons, one by Francis Danby; John Sheepshanks, one by Landseer. The largely unknown R.P. Bonington found two purchasers in Sir George Warrender and the Countess de Grey.

[48] Description from the catalogue of a sale of works owned by Vernon, Christie's, 6 May 1842 (34).

[49] For a brief survey of the de Tabley sale in the context of collecting British art (including Vernon's contribution) see Robin Hamlyn and Judy Collins, *'Within these Shores': A Selection of Works from the Chantrey Bequest*, exh. cat., Tate Gallery in association with Sheffield City Art Gallery, Graves Art Gallery, Sheffield 1989.

[50] John Constable to George Constable, 3 Aug. 1835, quoted in C.R. Leslie, *Memoirs of the Life of John Constable, Esq.*, RA, 1845, p.267.

[51] *The Autobiography and Memoirs of Benjamin Robert Haydon* ed. Tom Taylor, new ed., 2 vols., 1926, vol.2, p.551.

[52] Constable to C.R. Leslie, undated letter 1832; *John Constable's Correspondence*, vol.3, Ipswich 1965, p.49.

[53] See n.29 above.

[54] *Boyle's Court Guide [Jan.] 1832*.

[55] An oil painting by J.J. Chalon, 'Marble Hill Cottage, the Summer Residence of Robert Vernon Esq.' was exhibited at the Royal Academy in 1839 (194; London art market 1965; present whereabouts unknown). In 1839 Vernon also took over a large country house at Ardington, Berkshire.

[56] He paid £5,200 for the lease; 'Assignment of Premises, 50 Pall Mall ... to Robert Vernon Esq' 8 Aug. 1832'. Records of the Prudential Assurance Co., Document no.10.7. I am grateful to John Harvey of Prudential Assurance and Alison Scott of Lovell, White, Durrant, for making this and other related material available. John Greenacombe of the Survey of London kindly assisted with background information about 50 Pall Mall.

[57] *Times*, 23 April 1832, [p.4].

[58] WPL, Victoria Library, Rate Books for the Parish of St James's, Piccadilly, 1834; 5204, D155.

[59] Victoria and Albert Museum, English MSS, Minutes of the British Institution, R.C. vol.15, p.87v.; for the British Institution see Peter Fullerton, 'Patronage and Pedagogy: The British Institution in the Early Nineteenth Century', *Art History*, vol.5, no.1, March 1982, pp.59–72.

[60] 'Visits to Private Galleries: The Mansion of Robert Vernon Esq., in Pall Mall', *Art-Union*, vol.1, March 1839, p.19.

[61] Among them Edwin Landseer: Landseer to Vernon, 23 March 1843; Jenkyns 11.1.

[62] Held on 3 May 1843; acceptances and refusals are in Jenkyns 11.3.

No Short Mechanic Road to Fame

The Implications of Certain Artists' Materials for the Durability of British Painting: 1770–1840

LESLIE CARLYLE AND ANNA SOUTHALL

Robert Vernon's gift to the nation contains some of the best of British painting from the mid-eighteenth to the mid-nineteenth centuries. The works of many artists of the period, such as William Mulready, are still in very fine condition; unfortunately, those of a few major figures of the time, such as William Hilton, are not. The great drying cracks and fissures that spoil the surface of many of Hilton's works demonstrate the difficulties that he experienced with his painting materials.

For artists, this was a period of emulation and innovation: emulation of the Old Master paintings that were so rare and costly to collect, and innovation in artists' paints. Many, sometimes surprising substances were added to them, often by the artists themselves. Asphaltum, prized for its colour, and megilp, valued for the transparency and consistency that it gave to paint, were just two of the more notorious of these materials.

Looking at the paintings included in this catalogue, H.P. Briggs's dramatic portrayal of 'The First Interview between the Spaniards and the Peruvians' (no.9) is a good example of a work where the sky is scarred with cracks through the upper layers of paint, revealing the darker colours beneath; the garments of the figures at either side of the work have crept and shrunk into glistening globular islands of soft and soluble paint. The cracks on David Wilkie's 'The First Ear-Ring' (no.73) demonstrate a brittle fracture through the rich, translucent paint to the white ground, or preparatory layers, beneath. A much finer network of cracks on J.C. Horsley's 'The Pride of the Village' (no.34) has so lightened the dark areas by revealing the white ground that it is now difficult to separate the father's coat from the wainscoting behind it.

In Horsley's picture it is only the browns that have cracked. Certainly dark colours and browns were more prone to cracking, so that works using a light palette, such as E.W. Cooke's 'Dutch Boats in a Calm' (no.18) or A.W. Callcott's 'Dutch Landscape with Cattle' (no.12), appear less changed by time. So too do some works where browns have been used, such as T.S. Cooper's 'Milking Time – Study of a Farmyard' (no.19). There is perhaps a certain irony here in that very often the art of the British school which has survived best was not that painted in the Grand Style, advocated by Sir Joshua Reynolds, first President of the Royal Academy, but that which took its inspiration from the 'low and confined subjects'[1] of the seventeenth century Dutch school, from which Cooke, Cooper, Callcott and Mulready derived their inspiration. Much of Reynolds's own work recreated the rich colours and thickly applied paint of the Venetian school, and it is these works that have not stood the test of time. The obvious comparison with which to highlight this point is, say, between Reynolds's 'Self-Portrait' (no.56) and Mulready's 'The Last In' (no.50).

Most relevant to the condition of a painting are the materials used in its creation and the way they are used, including the lessons learnt by some artists from their previous misuse. Many writers have blamed either the brown pigment called asphaltum or bitumen, or the overuse of a painting medium called megilp for the disfiguring disruptions in the paint film which have come to characterise eighteenth and nineteenth-century paintings.

Asphaltum or bitumen, prized for the beauty of its hue and its mellow tone, was used extensively and it is probably the most notorious of all painting materials. Its reputation was well established by 1835, as George Field, colourmaker, chemist and friend to many artists noted: 'Its fine brown colour, and perfect transparency are lures to its free use with many artists, notwithstanding the certain destruction which awaits the work on which it is much employed.'[2] Yet this material had a long history of use on the painter's palette prior to the mid-eighteenth century without apparently causing problems. Certainly it was previously used sparingly, often as a glaze, or transparent finishing layer, rather than 'much employed' as Field emphasises. Recipes for the preparation of asphaltum involved the use of many materials to aid its drying, such as resin, shellac, balsams, gold size, megilp and lead driers, and wax was often added to give it body. Excessive or inappropriate combinations of such additions could play a part in uneven drying, especially in a thick paint film, where a wrinkled skin might form which, upon contracting further, could tear open before hardening fully.

Manner of use is one factor: a more compelling explanation for the apparent change in the drying properties of asphaltum is the evidence that the pigment sold by the colourmen came from more than one source. Eighteenth

century references indicate that there were two varieties: the native, or natural, and the artificial. Both were still described in nineteenth-century manuals. The native variety occurred as a brownish-black solidified liquid near natural oil deposits; one important source was the Dead Sea. This hard material required roasting and grinding prior to being added to the oil to give colour to the paint. Artificial asphaltum which, by contrast, was soluble in oil, was a product of the manufacture of lamp black or pitch. It could include other balsamic substances which, because of their poor drying and solvent-like properties, could well cause problems.

In the early nineteenth century a third variety of asphaltum was being introduced. In a hearing by a Committee of the House of Commons on 5–6 May 1809, the chemist-researcher Fredrick Accum testified that he had found that coal yielded a tar consisting of a 'certain quantity of volatile oil and a residuary matter resembling asphaltum'. He noted that the latter 'answered all the purposes of the asphaltum procured in the market'.[3] By 1833, English sources were reporting on difficulties with an inferior asphaltum made from coal-tar 'which never hardens properly'.[4] Because there were so many qualities and descriptions of asphaltum, it was very difficult for artists to distinguish the good from the bad. There are indications that asphaltum from the coal-tar source was used the most. In 1841 George Field noted that 'This pigment is now prepared in excessive abundance, as a product of the distillation of coal at gas manufactories'.[5] The widespread use of this poor substitute appears to have continued throughout the century, for Sir Arthur Church, the paint chemist, wrote as late as 1890 that the 'imitative' coal-tar asphaltum was 'now largely sold in lieu of the original and genuine product'.[6] Very probably this was the material responsible for Hilton's ravaged paint surfaces, which were described by the artist Richard Redgrave and his brother Samuel as 'shrunk and weazened, corrugated or gaping in wide glistening fissures'.[7] They commented some thirty years after it was painted that 'Edith and the Monks Searching for the Body of Harold' (N00333) which was once regarded as one of the jewels of Vernon's collection, was now a 'seamed wreck of his genius'. The staff at the National Gallery had to turn the picture from time to time so 'that the eyes and limbs may float back again from whence they had slipped'.[8] The Redgraves, who did not distinguish between the types of asphaltum, also singled out Wilkie's 'The First Ear-Ring' (no.73) and 'The Peep-o'-Day Boys' Cabin, in the West of Ireland' (no.74) as 'other fast decaying evidences of this dangerous practice'.[9]

In 1892 the paint chemist George Hurst said that while asphaltum from natural sources was brittle and prone to cracking, it was the artificial variety which was the poor dryer.[10] The differences between the brittle fracture of paint or glazes containing natural asphaltum, and the rents or tears in the paint, called drying cracks, associated with artificial asphaltum may be simply demonstrated

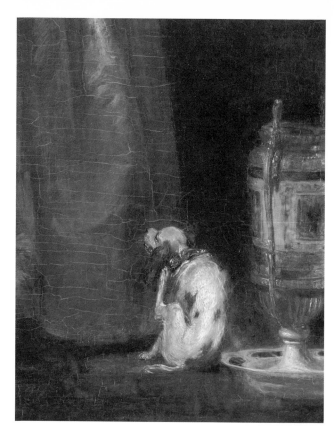

fig.9 Detail from David Wilkie **The First Ear-Ring** 1834–5 (no.73)

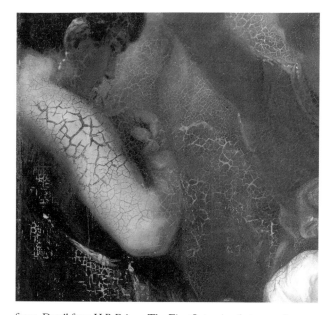

fig.10 Detail from H.P. Briggs **The First Interview between the Spaniards and the Peruvians** exh.1827 (no.9). The drying cracks in the flesh colour reveal the dark paint beneath

(figs.9, 10). The more extreme drying defects, perhaps caused by the tarry bitumen derived from the distillation of coal, can result in wrinkled and torn paint that looks like an alligator skin (fig.11), or shiny islands of one colour floating meaninglessly on paint of quite another colour (fig.12). In reality the categorisation of cracks cannot be quite so simple as one must take into account the other materials that were used in the preparation of asphaltum, each one of which could contribute to drying problems. As one author of an artists' manual wrote,

> Notwithstanding that painters are frequently aware of the bad results of the use of Asphaltum in pictures, they are tempted, by the beauty of its hue, to try further experiments with it in their own way, and they persuade themselves, that their own special methods of application, will overcome its objectionable tendencies.[11]

Apart from the search for satisfactory ways of using this beautiful pigment, artists had a further incentive to experiment with their paint. From contemporary accounts it is evident that paint purchased ready-prepared from the colourmen, unlike that ground by artists themselves and used freshly prepared, was stiff and difficult to brush out without the addition of a medium, like megilp. Such mediums also gave the paint translucency. One artist, Julius Caesar Ibbetson, who restored paintings complained: 'the common colour [from] the shops appeared like gritty mud upon the mellow transparent shades of the exquisite pictures of the last age.'[12] In the eighteenth century, some artists sought different mediums to bind their pigments. William Blake, for example, rejected the 'cloggy vehicle' of oil for a form of glue tempera; George Stubbs experimented with 'permanence' using porcelain glazes fired onto copper or biscuitware supports and, rediscovering the ancient encaustic or 'Grecian' manner of painting he and others developed a variety of techniques using wax as the medium.

Copying paintings by Old Masters was common practice among artists, and not just while they were studying in the Academy schools: Edwin Landseer copied a Rubens when he was about twenty, for example, and William Etty copied paintings by Titian when he was nearly forty. Callcott was about fifty when he copied Willem van de Velde's 'The Shore at Scheveningen', c.1820–30 (no.11). These acts of homage were not simply a question of learning about subject and style: in the later eighteenth century many artists – Benjamin West is a good example – were fascinated by old techniques and searched avidly for 'systems' and 'secrets', thought to have been known to the great sixteenth-century Venetian master Titian, for example, and since lost: megilp was held by many to be the key to his gorgeous colours. Some were never seduced; James Barry described 'Magilphs and Mysteries' in disparaging terms in his letters from Italy in the 1760s.[13] If the excellent condition of his paintings today, as exemplified by 'King Lear Weeping over the Dead Body of Cordelia' (T00556) is an indication

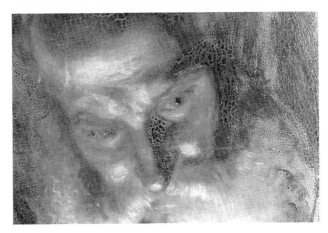

fig.11 Detail from William Hilton the Younger **Editha and the Monks Searching for the Body of Harold** exh.1834 (N00333)

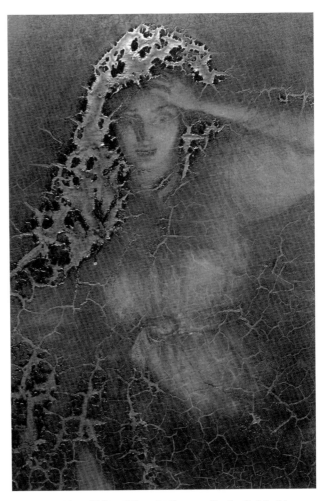

fig.12 Detail from William Hilton the Younger **Study of a Monk's Head for 'Editha and the Monks'** c.1834 (N00335)

of good practice, then we must conclude that he had reason to scorn these secrets. In 1809 M.A. Shee, who was later to become President of the Royal Academy, described this pursuit of secrets as a delusive and dangerous folly: 'The artist who has been once visited by this mania, is restored with difficulty to the rational path of practice. As in most other insanities the cure is never complete!'[14]

By the early years of the nineteenth century old paintings were becoming increasingly accessible as private collections opened their doors and, in 1824, the National Gallery itself opened. A better study of the paintings themselves and the advances made in chemistry allowed for a more informed interest in artists' materials of the past. Callcott, for example, was making copious notes on the subject and Sir Charles Eastlake published his research in 1847. Many artists began experimenting more seriously with paint and painting methods, such as William Collins who kept detailed diaries and Mulready, who earned himself a reputation as a consummate technician and excellent teacher. But there were others, such as Hilton, who did not heed the warnings and continued in their unfortunate choice of materials. None of Hilton's five paintings in the Vernon Gift can be made fit for display, even by the skilled restorers of today.

The earliest published reference to 'megilp' appears in a satirical novel of 1768: 'The magilp was a nostrum known only to the ancients; but our modern artists, unsatisfy'd at their not being in the secret, have labour'd with infinite drudgery to find out this valuable mystery'. The novelist continues, describing a 'gentleman ... more curious in his researches than the rest,' who 'committed a rape upon the body of Venus painted by the celebrated Titian, and brought away a piece of her buttock, to find out the secret by the divine flavour of her ladyship's backside.'[15]

The gentleman in question was undoubtedly Reynolds, whose searches for the secrets of the Old Masters, which involved scraping down their paintings, layer by layer, are described by several contemporaries. In his own notebooks of 1767 we find the earliest reference by an artist to megilp being used as a painting medium, that is a liquid, or in this case a gel, added by the artist to the paint to improve its manipulability.[16] Joseph Farington, who described thinning his paint with 'macgilp',[17] also reported that his teacher in the mid-1760s, Richard Wilson, a contemporary of Reynolds, used 'a magylph or majellup of linseed oil and mastic varnish' as his 'usual vehicle'.[18]

Although the origins of megilp remain obscure, gelled mediums are described in several seventeenth-century sources, such as the remarkable but anonymous technical notes dating from 1673–99 that are copied into the Memorandum Book of Ozias Humphrey.[19] These give recipes for what is called Basha Bombelly's oil, as made for him by a colourman in Venice. The ingredients for this medium are like those for megilp, although the preparation method differs significantly as the materials are all cooked together. Certainly this material may have been similar to megilp,

but it was not megilp as it was made in the later eighteenth century.

This was a mixture of drying oil made with a lead drier and mastic varnish.[20] The oil and varnish were prepared separately and then mixed, most commonly in equal parts, by shaking them together briefly. On standing they formed a clear gel, which imparted a rich transparency and a special buttery quality to oil paints. As a result, the paints were said to 'keep their place in working, with a flimsy firmness that is perfectly delightful'.[21] Megilp was also used on its own. William Etty, for example, recommended its application before and during painting: 'with a large brush rub [megilp] over the canvas or picture you have to paint on. This is the best medium ... a vehicle that will keep flesh tints pure.'[22]

Megilp was the most frequently described medium in the artists handbooks of the nineteenth century, but many other paint modifiers were mentioned, such as balsams, waxes, starch, gums, egg and even soap. In comparison with some recipes, megilp begins to appear a rather conservative choice. Nevertheless, like asphaltum, it had a reputation for causing premature decay in the finished painting. By the turn of the century artists, among them John Opie, professor of painting at the Royal Academy, were condemning vigorously this and other short cuts as 'nostrums for producing fine pictures without the help of science, genius, taste or industry'.[23] Nevertheless, megilp remained firmly rooted in the painters' palette. As one author explained, '[it] is so pleasant to work with, that it allured many painters to the most indiscreet use of it'.[24]

By the late eighteenth and throughout the nineteenth century megilp had a reputation for contributing to the overall darkening and cracking of paintings in which it was used, yet similar materials were known to earlier painters. Analysis of paint from a number of works in the Vernon Gift points to megilp, as well as asphaltum, being a promoter of disfiguring drying problems.[25] Precisely what brought about this change at this particular time is not yet clear but we can draw some conclusions based on a close comparison between the few early recipes for gelled mediums, and those for making megilp.

Whereas the seventeenth-century gelled mediums were formed by boiling or simmering oils and resins together, the ability to form a gelled medium like megilp relied on the presence of two ingredients, lead treated oil and mastic varnish, which formed a gel when mixed at room temperature. If pure linseed or walnut oil were used, a gel would not form. Similarly mastic, rather than copal, a harder resin, was required for the mixture to gel.[26] At least some of the appeal of megilp must have been the ease of preparing it, since artists could simply mix the two ingredients which were available to them ready-prepared. In fact, we know from the earliest surviving colourman's catalogue, published by Winsor & Newton in about 1835, that they could purchase megilp itself.

In 1835 George Field thought that mastic resin might

cause problems, suggesting that the resin contributed 'defects which arise from the feeble body of mastic, its softness, and a degree of disposition to darken and cloud by age'.[27] This distrust of the mastic may have been well founded. He suggested substituting copal, but recognised the difficulty such a mixture would present in gelling. We know that some artists did use copal: as his work included here demonstrates, Mulready successfully adopted a copal medium sometime after 1816. By the 1840s the colourman Roberson had devised a gelled medium containing copal as well as mastic resin. Robersons's Medium enjoyed an excellent reputation amongst artists and it was prized by among others, Lord Leighton, whose work, for example, 'And the Sea Gave Up the Dead which Were in It' of 1892 (NO1511) does not generally exhibit problems associated with the paint medium.

Further support for the theory that mastic resin was at fault comes from the Redgraves. Remarking on the poor condition of Wilkie's work in 1866, they postulated that in the case of the 'The Blind Fiddler' (N00099) he had used 'magylph'. B.R. Haydon had said that Wilkie's medium for this picture was oil,[28] but the Redgraves wrote:

> Yet notwithstanding this assertion, we are inclined to think that magylph was really used. 'The Blind Fiddler' stood perfectly until it was varnished about ten years ago, and then in the course of one short month it cracked in widening hair cracks down to the white ground; and [on] "The Village Festival" [N00122] ... much of the thinly painted background ... is entirely broken up with cracks of the same kind ... It will be seen that in our opinion pictures painted in mastic magylph do not crack when left unvarnished, but are liable to fail when this is done.[29]

Was this also the cause of the cracks on 'The First Ear-Ring'? In fact the Redgraves then acknowledge the complexity of the problem when they say that Wilkie usually varnished his paintings soon after completion. But accounts such as this do suggest that the paint was somehow predisposed to cracking when solvent (from the varnish) was applied. Earlier West had described a painting completed c.1790 that cracked so badly on being varnished with a 'strong' mastic varnish over five years later, that he virtually repainted it.[30]

In analysing the problems caused by megilp it will be important to consider not only the role of mastic varnish, but also that of the lead used in the treatment of the oil. Although we know from the earliest accounts of artists'

materials that drying oils had long been prepared by simmering, boiling or simply standing over lead compounds, there were two changes in the eighteenth century which could be significant. In the mid-eighteenth century, artists adopted the use of 'sugar of lead' or lead acetate, as a drier, and in 1792 a new method of purifying oil was patented using sulphuric acid. The change to a different lead compound may have influenced the chemical effect of the lead as could the use of acidified oil. The fact that megilp was prepared, not by boiling all of the ingredients but by mixing them at room temperature may also be significant.

As this discussion reveals, the exact causes of the relatively sudden changes in artists' materials of the time are not known with any certainty, even today; but it is clear that artists were warned throughout the nineteenth century of the dangers involved in using both asphaltum and megilp. Despite the warnings, the delicious working properties of their paint and the hope that their own work might escape the destructive effects encouraged many to continue using them.

Too often the sad results of this seduction remain with us today. The cleaning of paintings of this period is difficult because the paint remains soluble in the solvents used to remove the varnishes and some works therefore remain uncleaned – dark and obscure. Many of the modern 'masterpieces' bought by Robert Vernon now little resemble the Old Masters they were inspired by: the glowing colours and rich effects so admired by connoisseurs and patrons are now hidden or destroyed, and this makes the interpretation and appreciation of these paintings difficult, and sometimes impossible. These are the works that cannot be displayed, for what we see today is, certainly in technical terms, the result of a kind of natural selection. Would that more painters had heeded the warnings issued by painters, chemists and others, when they said that there were no short cuts to knowledge, or to painting. M.A. Shee put it more elegantly when he wrote that painters should be

> With just respect impress'd for genuine Art,
> Which time alone to talent can impart,
> Rich prize of Taste! achieved by toil and thought,
> No palette miracle by process wrought!
> From study's open channel never stray,
> To chase the favourite phantom of the day;
> Nor vainly hope, relieved from labour's claim,
> To find a short mechanic road to fame.
> From Horace learn, ye tribes! who make pretence
> To write or paint, the secret is-good sense![31]

Notes

The source of information on materials, and recipes throughout this essay is: Leslie Carlyle, *A Critical Analysis of Artists' Handbooks, Manuals and Treatises on Oil Painting Published in Britain Between 1800–1900: With Reference to Selected Eighteenth Century Sources*, unpublished PhD dissertation, Courtauld Institute of Art, University of London 1991.

The authors would like to thank Helene Dubois for information on Reynolds; Evelyn Newby for access to the index she is preparing for Farington's diary; and Richard Hearn for suggesting some of the nineteenth-century artists' journals and other writings which have been such a rich and enjoyable source of information.

The place of publication is London, unless otherwise stated.

[1] Sir Joshua Reynolds, *Discourses on Art*, ed. Robert R. Wark, New Haven and London 1975, p.51.

[2] George Field, *Chromatography; or, a Treatise on Colours and Pigments and their Powers in Painting, &c*, 1835, p.161.

[3] From Accum's testimony, quoted in Charles Albert Browne, 'The Life and Chemical Services of Fredrick Accum', *Journal of Chemical Education*, vol.2, no.10, New York 1925, p.1009.

[4] J. Neil Wilson, 'The Art of Making Copal and Spirit Varnishes, &c.', *Transactions of the Society for the Encouragement of Arts, Manufactures, and Commerce...*, vol.XLIX, 1833, p.57.

[5] George Field, *Chromatography; or, a Treatise on Colours and Pigments and their Powers in Painting, &c*, 2nd ed., 1841, p.282.

[6] Sir Arthur Church, *The Chemistry of Paints and Painting*, 1890, p.209.

[7] Richard and Samuel Redgrave, *A Century of Painters of the English School...*, 2 vols., 1866, II, p.171.

[8] Ibid. II, p.596.

[9] Ibid. II, p.595.

[10] George H. Hurst, *Painters' Colours, Oils and Varnishes*, 1892, p.404.

[11] William Muckley, *A Handbook for Painters and Art Students...*, 2nd ed., 1882, pp.72–3.

[12] Julius Caesar Ibbetson, *An Accidence or Gamut, of Painting in Oil...*, 1803, p.8.

[13] John Gage, 'Magilphs and Mysteries', *Apollo*, July 1964, p.38.

[14] M.A. Shee, *Elements of Art...*, 1809, p.288, footnote.

[15] W. Donaldson [?], *The Life and Adventures of Sir Bartholomew Sapskull Baronet – By Somebody*, 2 vols., 1768, I, pp.116–7.

[16] M. Kirby Talley Jr, '"All Good Pictures Crack": Sir Joshua Reynolds' Practice and Studio', *Reynolds*, Royal Academy of Arts, 1986, p.62.

[17] *The Diary of Joseph Farington 1793–1821*, 16 vols., ed. Kenneth Garlick and Angus Maclintyre, New Haven and London 1978–84, I, p.176.

[18] T. Wright, *Some Account of the Life of Richard Wilson, Esq., R.A.*, 1824, p.20.

[19] Memorandum Book of Ozias Humphrey, 1777–95, British Museum MS Additional 22, 950, ff.47v.–48r. (From M. Kirby Talley Jr in *Portrait Painting In England: Studies in the Technical Literature before 1700*, Paul Mellon Centre for Studies in British Art, 1981, pp.326–7.)

[20] Linseed and walnut were the oils most commonly used to bind the pigments in paint-making at this time. Both harden, or dry, by oxidation unlike many other oils, such as olive oil. Certain metal compounds, known as driers, were used in the preparation of artists' oils, or sometimes by the artists themselves, to speed the drying process. Mastic varnish is made by dissolving the resin in a volatile solvent.

[21] John Scott Taylor, *Modes of Painting Described and Classified...*, 1890, p.33.

[22] Alexander Gilchrist, *The Life of William Etty*, 1854 (from R.W. Alston, *Painters Idiom*, London and New York 1954, p.68.)

[23] J. Opie, *Lectures on Painting delivered [in 1807] at the Royal Academy of Arts...*, 1809, p.145.

[24] William Muckley, *A Handbook for Painters and Art Students...*, 2nd ed., 1882, p.47.

[25] Tate Gallery Conservation Department Records: Joyce Townsend, Anna Southall.

[26] Confirmation of nineteenth-century statements concerning the ability of megilp to gel only when lead-treated oil and mastic resin were used was made by Katherine Ara, who worked with various megilp recipes. Katherine Ara, *An investigation of Late 18th C. and Early 19th C. Thixotropic media: Megilps and Gumptions, Based on the Investigations Carried Out by Leslie Carlyle from Documentary Sources*, Hamilton Kerr Institute, University of Cambridge 1990.

[27] Field 1835, p.202.

[28] Benjamin Robert Haydon's diary is an invaluable source of technical information. Although it has been used, it has not been much cited in this essay as Haydon is not represented in the Vernon Gift. *The Diary of Benjamin Robert Haydon 1780–1846*, ed. Willard Bissell Pope, 5 vols., Cambridge, Mass. 1960.

[29] Richard and Samuel Redgrave, 1866, II, pp.261–2. It should be noted that the ground of 'The Blind Fiddler' is in fact mid-brown, not white.

[30] 'Christ Presenting a Little Child' in the Thomas Coram Foundation for Children: General Committee Minutes, 18 Nov., 1801.

[31] M.A. Shee, 1809, pp.292–4.

18 Edward William Cooke **Dutch Boats in a Calm** 1843

25 William Etty **Candaules, King of Lydia, Shews his Wife by Stealth to Gyges, One of his Ministers, as She Goes to Bed** exh.1830

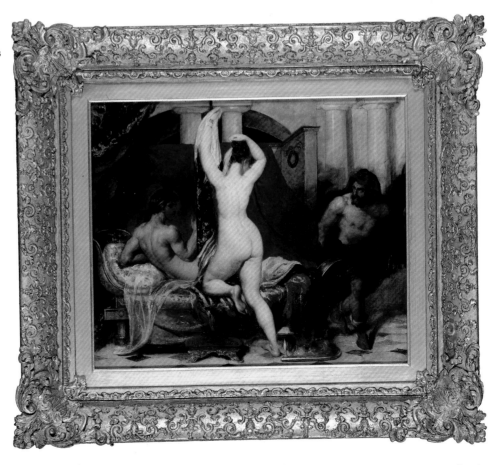

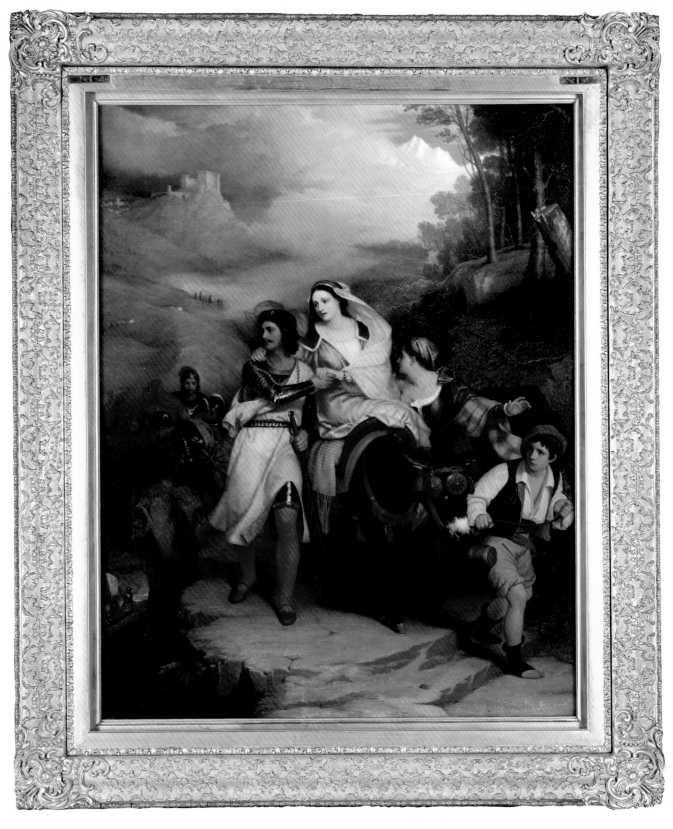

23 Sir Charles Lock Eastlake **The
Escape of Francesco Novello di
Carrara, with his Wife, from the
Duke of Milan** 1849

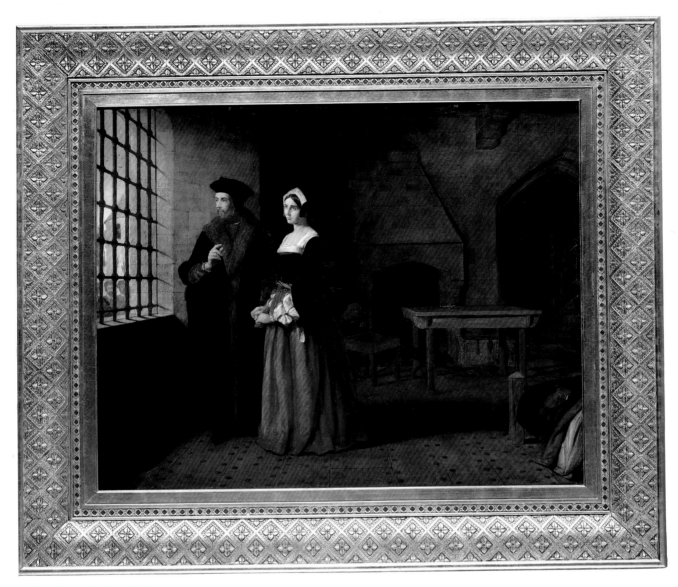

32 John Rogers Herbert **Sir Thomas
More and his Daughter** 1844

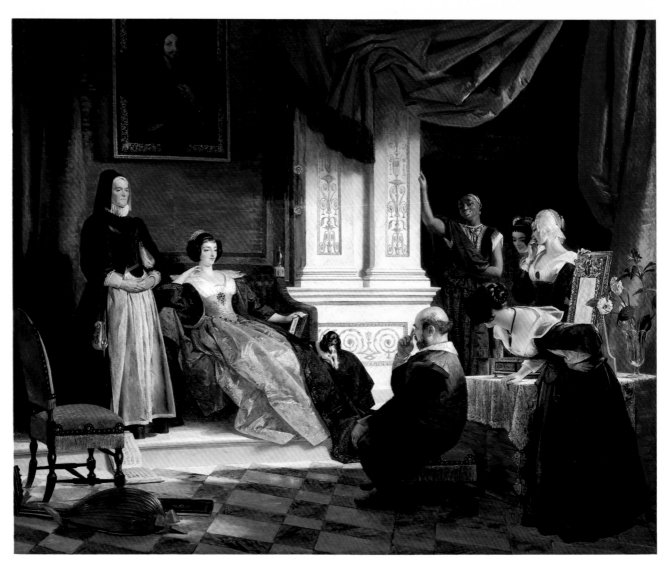

46 Charles Robert Leslie **Sancho Panza in the Apartment of the Duchess** 1843–4

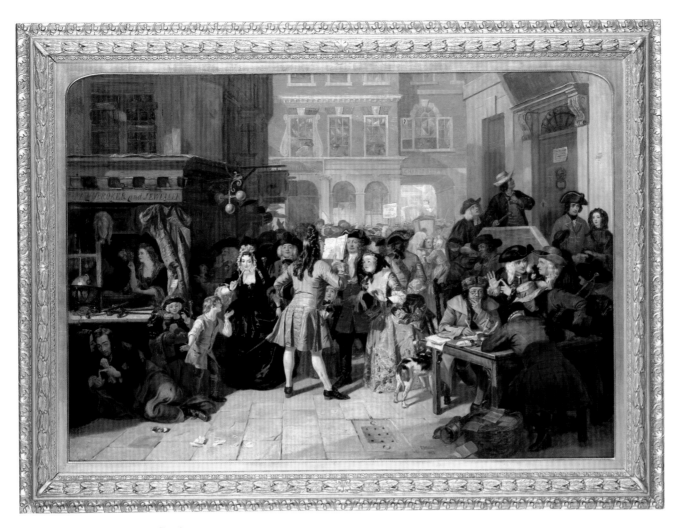

68 Edward Matthew Ward **The South
Sea Bubble: A Scene in 'Change
Alley in 1720** 1847

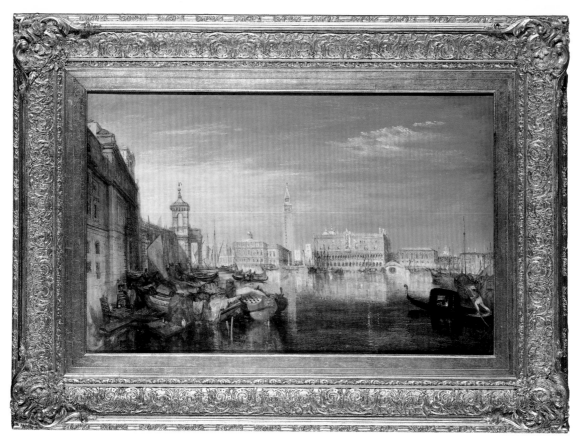

64 J.M.W. Turner **Bridge of Sighs,
Ducal Palace and Custom-House,
Venice: Canaletti Painting**
exh.1833

75 Richard Wilson **Lake Avernus
and the Island of Capri** *c.*1760

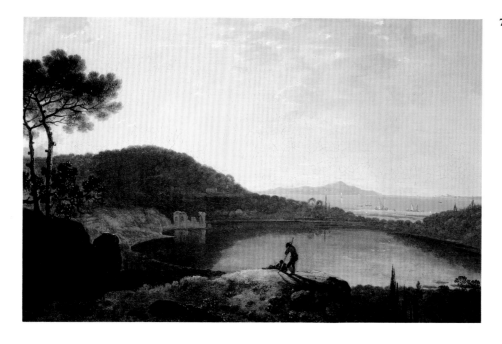

Catalogue

Works are catalogued in chronological order under artists, who are listed alphabetically.

Measurements are in centimetres, followed by inches in brackets; height before width before depth.

Exhibition history (where appropriate) is confined to the first occasion on which the work was shown at the Royal Academy, British Institution, or Society of British Artists, with catalogue number.

Works illustrated in colour are marked *

Abbreviations

BI British Institution
engr. engraved
exh. exhibited
inscr. inscribed
RA Royal Academy
SBA Society of British Artists

'Copy' refers to a work that can be identified in *A Catalogue of the Engravers' Drawings Made by the Best Talent of the Day, of the Pictures in the Vernon Gallery, the Property of Mr Underwood, of Birmingham* (sale catalogue) Fosters, London, 8–9 April 1857.

'Jenkyns' refers to Robert Vernon's Papers kept by his executor John Jenkyns. These are on deposit from the Jenkyns family in Balliol College Library, Oxford. The Master and Fellows of Balliol have kindly given access to this material.

SIR WILLIAM ALLAN 1782–1850

1 **Tartar Robbers Dividing Spoil**
1817
Oil on mahogany panel 64.2 × 52.4
(25⁵⁄₁₆ × 20⁵⁄₈)
Inscr: 'William Allan fecit │ 1817'
bottom right
Exh: RA 1817 (329)
Engr: J.T. Smyth, *Art Journal*, 1850,
opp. p.377
N 00373

Allan was born in Edinburgh, and trained in the Trustees' Academy under John Graham at the same time as David Wilkie. By 1803 he was living in London and had become a student in the Royal Academy Schools. In 1805, having failed to establish a reputation, he set off for Russia where he remained until 1814 when he returned to Edinburgh. During these years he travelled to the southern edge, and beyond, of the Russian Empire: what used to be known as Tartary, the Crimea and then, also on the Black Sea, Circassia and Turkey. One of Allan's achievements was to amass a large collection of ethnic costumes, weapons and other artifacts and bring them back home with him. He used these as props in many of his paintings and included them among an exhibition of his works which he held in Edinburgh in 1817.

The authenticity of costumes and accessories in the pictures which resulted from this voyage undoubtedly gave Allan's work a superficial novelty value which was widely admired even if it did not attract any purchasers. 'Tartar Robbers Dividing Spoil' did not sell either at the Academy in 1817 or at the British Institution in 1818; it seems to have still been in the artist's hands in 1821 when it was exhibited in Edinburgh. The picture was Allan's last treatment of a 'Russian' theme.

Some of the accessories in 'Tartar Robbers' might possibly be identifiable with objects which were sold in 1850 at the dispersal of Allan's studio contents: these included 'A Tartar Cap', 'a leathern bottle', 'a curious Antique Gun, used by the Cossacks of the Black Sea, mounted with Silver and inlaid with Mother-of-Pearl', and a 'Splendid antique Circassian Rifle, beautifully inlaid and mounted in gold and silver'.

When the picture was exhibited for a second time in London in 1818, the art critic of the radical periodical the *Examiner* saw a parallel between its subject and the activities of the long-serving Tory government:

no place – and money-hunting member of subservient ministerial majorities, those licenced robbers, could be more eager to divide the spoils of the people, than are the Tartar robbers here dividing the spoil taken by a not less justifiable law of established usage of Asiatic power.

Robert Vernon probably acquired 'Tartar Robbers' in April 1835, when it was sold at Christie's for 46 guineas.

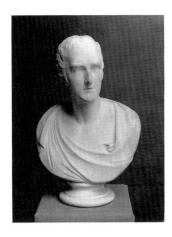

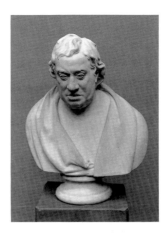

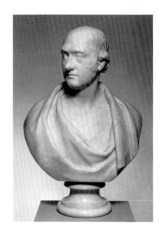

JOHN BACON THE YOUNGER
1777–1859

2 **The Marquis Wellesley** ?exh.1808
 Marble 62.2 × 42.3 × 29.5
 (24½ × 16⅝ × 11⅝)
 Inscr: 'J.Bacon. | Sculptor.' on back
 Exh: ?RA 1808 (985)
 Transferred from the Tate Gallery to
 the National Portrait Gallery 1957
 National Portrait Gallery, London

Richard Colley, Marquis of Wellesley
(1760–1847) was the eldest brother of the
Duke of Wellington. He became Gov-
ernor General of India in 1797 and in
April 1809 he became Ambassador to
Spain at the time when his brother was in
command of the British army in Portugal.
He became Secretary of State for Foreign
Affairs, resigning in January 1812, and was
Lord Lieutenant of Ireland 1821–8. He
retired from politics in 1834.

Bacon was the second son of the sculp-
tor John Bacon, RA (1740–99); he was a
prolific carver of church monuments but,
unlike his father, he was not very highly
regarded by his colleagues.

EDWARD HODGES BAILY
1788–1867

3 **Samuel Johnson** (after Joseph
 Nollekens) 1828
 Marble 68.5 × 58 × 29
 (27 × 22¹³⁄₁₆ × 11⅜)
 Inscr: 'E.H.BAILY, R.A. | AFTER
 NOLLEKENS, | 1828.' on back
 Transferred from the Tate Gallery to
 the National Portrait Gallery 1957
 National Portrait Gallery, London

Copied from a cast (owned by Baily) taken
from a bust sculpted by Nollekens (1737–
1823) in 1777, now in Poets' Corner,
Westminster (replica Pembroke College,
Oxford). According to Nollekens's biogra-
pher, J.T. Smith, Francis Chantrey
thought it 'by far, the finest head' ever
produced by the sculptor.

Dr Johnson (1709–84) was one of the
most eminent literary personages of the
eighteenth century and a close friend of
the first President of the Royal Academy,
Sir Joshua Reynolds. His *Dictionary of the
English Language* was published in 1755.
Among its definitions is found that for a
'patron': 'one who countenances, supports
or protects. Commonly a wretch who
supports with insolence, and is paid with
flattery'.

In 1845 Vernon acquired a picture by
E.M. Ward (see nos. 67–8), 'Doctor John-
son in Lord Chesterfield's Ante-Room'
(N00430) which shows the lexicographer
waiting in vain for Chesterfield's help in
advancing the *Dictionary*.

EDWARD HODGES BAILY
1788–1867

4 **Sir Isaac Newton** (after Louis
 François Roubiliac) 1828
 Marble 68.5 × 51 × 29
 (27 × 20⁹⁄₁₆ × 11⅜)
 Inscr: 'E.H.BAILY R.A. | AFTER
 ROUBILIAC | 1828' on back
 Transferred from the Tate Gallery to
 the National Portrait Gallery 1957
 National Portrait Gallery, London

Sir Isaac Newton (1642–1727), philos-
opher, discovered the nature of light and
colour, which was summed up in his *Op-
tics*, published in 1704. He set out his laws
of motion and gravity to the Royal Society
in 1703 and was knighted in 1705.

Roubiliac (1702–62) was French-born
and was the most brilliant sculptor active
in England during the eighteenth century.
Baily's bust was copied either from Roubi-
liac's bust of Newton of 1751 in Trinity
College, Cambridge or from the terracotta
model or from a cast. Roubiliac's bust was
based on a portrait of Newton by Thorn-
hill, and on a death mask.

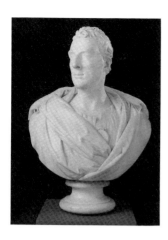

Roman general, Baily shows him in a less specific classical form of drapery. Arthur Wellesley (1769–1852) assumed the title of Marquis in 1812 and became the 1st Duke of Wellington in 1814. He was the victor at the Battle of Waterloo in 1815.

EDWARD HODGES BAILY

5 The First Duke of Wellington
(after Joseph Nollekens) *c*.1828–30
Marble 79.3 × 59 × 32.5
(31¼ × 23¼ × 12¹³⁄₁₆)
Inscr: 'COPIED BY | E.H.BAILY
R.A. | FROM NOLLEKENS | HEAD |
OF WELLINGTON' on the back
N02236

This and three portrait busts of Dr Samuel Johnson, Sir Isaac Newton and George Canning (nos.3, 4, 6) seem to have been commissioned by Vernon in about 1828. A fifth bust by Baily (after Roubiliac) of the poet John Milton, sold out of Vernon's collection in 1877, was probably part of the same commission.

In 1827, Vernon had identified himself as a serious collector when he successfully bid for five works at the important sale of Lord de Tabley's British paintings. The commission to Baily for a group of busts of living and deceased British worthies suggests that Vernon certainly aspired to emulate longer established old master collectors and patrons of the arts: a painting by P.C. Wonder, 'Patrons and Lovers of Arts', *c*.1824 (private collection) depicts Sir Robert Peel, the 3rd Earl of Egremont, and the Revd W. Holwell-Carr, among others, in an imaginary gallery of old master pictures. Placed around the walls of this gallery are busts of Shakespeare, Milton, Sir Walter Scott and the Duke of Wellington. Vernon's commission to Baily is the earliest sign of how his collecting had begun to take on a nationalistic purpose – underpinned by references to British achievements in letters, politics, science and war.

The bust by Joseph Nollekens (1737–1823) from which Baily took his copy was exhibited at the Royal Academy in 1813 (835) as 'Marquis of Wellington' and is now in Apsley House. Whereas Nollekens shows Wellington wearing the clothes of a

EDWARD HODGES BAILY

6 George Canning (after Joseph Nollekens) 1829
Marble 72.4 × 50.8 × 27.9
(28½ × 20 × 11)
Inscr: 'E.H.BAILY – R.A. | AFTER
NOLLEKENS | 1829' on back
N02247

Canning (1770–1827), statesman and orator, was in government during much of the period of the Napoleonic Wars. He was Foreign Secretary between 1807–9 when he sent the army, subsequently commanded by Sir Arthur Wellesley (later the Duke of Wellington), to Portugal then Spain. He was Foreign Secretary again from 1822 until 1827 when, for the last few months of his life, he was Prime Minister of a reforming Tory government.

WILLIAM BEHNES 1795–1864

7 Robert Vernon 1849
Marble 77.5 × 58 × 28
(30½ × 22¹³⁄₁₆ × 11)
Inscr: 'BEHNES | sculpᵗ | 1849' on back
N02237

At the beginning of 1849 the picture dealers Paul and Dominic Colnaghi suggested, in a letter to the *Art Journal*, that Vernon's gift to the nation should be commemorated in some way. They proposed raising a sum of money through a public appeal with the interest on this being used to fund 'The Vernon Medal'. This was to be awarded annually 'to meritorious students in the Academic class' by the President of the Royal Academy. Vernon supported the scheme but despite contributions from Queen Victoria and Prince Albert and Sir Robert Peel, the subscription was a failure, raising only £191, and the project was abandoned. In a curious verdict on Vernon's patronage, the scheme was partly defeated because of the indifference of the great majority of Royal Academicians.

About two months before his death, in May 1849, Vernon sat to William Behnes, who modelled a portrait in profile for the proposed medal, as well as a bust from which this marble was taken. The medallion portrait was illustrated in the *Illustrated London News* of 13 October 1849 and exhibited at the Academy in 1850 (1393). When the 'Vernon Medal' proposal was formally dropped at a meeting of a few interested subscribers in June 1849 it was agreed that Behnes should be commissioned to sculpt two busts of Vernon, this one and a replica for Ardington parish church where Vernon was, by then, buried (fig.3 on p.10).

This bust, in 'a state of advancement' by September 1849, was finally presented to the Trustees of the National Gallery in 1850. It was placed in the entrance hall of

Marlborough House shortly after Vernon's gift had been transferred there from the National Gallery and re-opened to the public on 5 August 1850. The bust was placed on a square scagliola pedestal upon which were inscribed the names of the subscribers. The *Art Journal* at the time described Behnes's bust as 'a most striking and spirited likeness' of Vernon. The toga-like garment Behnes gave his subject endowed Vernon with a classical nobility appropriate to his standing even if, in the end, so few people were actually prepared to pay to immortalise him.

RICHARD PARKES BONINGTON
1802–1828

8 View of the Piazzetta near the Square of St Mark, Venice 1827
Oil on canvas 44.2 × 36.7 (17½ × 14½)
Exh: BI 1828 (198)
Copy: J.F. Salmon
Engr: J.W. Allen, *Art Journal*, 1851, opp. p.192
N00374

Bonington was born in England but lived and worked in France. He visited Venice between mid-April and May 1826. He made numerous watercolours, oil sketches and drawings during his stay, among them a large study in graphite on grey-green paper (National Gallery of Canada, Ottawa) which formed the basis of this oil painting.

Bonington had first exhibited in London in 1826; at the time that this picture appeared at the British Institution in early 1828 his work was still relatively unknown in this country. In purchasing the 'View of the Piazzetta near the Square of St Mark, Venice' from this exhibition, Vernon would undoubtedly have been aware of the fact that two eminent collectors, the 2nd Earl Grosvenor and the 3rd Marquess of Lansdowne, already possessed paintings by Bonington. Such recognition of the artist's talents by established connoisseurs must have made this picture a more desirable acquisition for Vernon.

In its liney treatment of the architecture, and cursory handling of aerial perspective, the 'Piazzetta' is one of the less successful of Bonington's Venetian views. Its execution was criticised by one reviewer of the exhibition as 'miserably cold and meagre'. A small engraving of the picture by Edward Finden was published in *The Book of Gems* for 1837.

HENRY PERRONET BRIGGS
1793–1844

9 The First Interview between the Spaniards and the Peruvians
exh.1827
Oil on canvas 147.5 × 197.6 (58 × 77¾)
Exh: BI 1827 (47)
Copy: B. Wilkinson
Engr: W. Greatbach, *Art Journal*, 1851, opp. p.56
N00375

Exhibited with the following quotation printed in the exhibition catalogue:

'As the Inca drew near, Father Vincent Valverde, Chaplain to the expedition, explained in a long discourse the doctrines of the Catholic Faith, exhorting the Inca to acknowledge the supreme Jurisdiction of the Pope, and to submit to the King of Castile as his lawful Sovereign, promising him protection if he complied; but if he refused, denouncing war and vengeance in his master's name'. The conference ended in a general massacre of the Peruvians and the imprisonment of the Inca.

The quotation is a translation from the Spanish of G. de la Vega's *Royal Commentaries of the Incas* which gives a detailed account of the Spanish conquest of Peru by Pizarro. The postscript is based on William Robertson's *History of America*, first published in 1777.

Briggs shows the scene in the great square of Caxamarca on 16 November 1632 when Pizarro's chaplain, Valverde, confronts King Atalhuellpa. Impatient with the king's lengthy and impassioned response to Valverde, during which he questions the truth of Christianity, Pizarro and his soldiers fell on the Inca. In the struggle, Pizarro, who is standing on the right, was slightly injured, but those Incas who did not flee when they saw their king captured, were slaughtered.

In accordance with the accepted rules for history painting Briggs carefully chose that moment in the action which anticipates its climax. Valverde has one hand resting on a cannon while in the other he holds the prayer book or bible which Atalhuellpa is about to seize and throw to the ground. Pizarro is drawing his pistol. The vulnerability of the innocent Incas in the face of this might is brought home to the viewer through the presence of the mother and child beside the king.

Briggs, who along with William Etty, was the only history painter during the first part of the nineteenth century who enjoyed consistent success, first exhibited this subject at the Royal Academy in 1826. It was praised by the critics and bought by the collector William Wells, who allowed it to be engraved for an annual, the *Amulet*, in 1830. Vernon purchased this version when it was shown at the British Institution at the beginning of 1827. Briggs had a penchant for painting martial subjects and in 'The First Interview between the Spaniards and the Peruvians' he seems to owe a debt to Rembrandt's great military group portrait 'The Night Watch' of 1642.

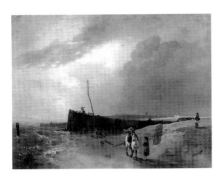

SIR AUGUSTUS WALL CALLCOTT
1779–1844

10 Littlehampton Pier 1811–12
Oil on canvas 140.3 × 106.1
(55¼ × 41¾)
Exh: RA 1812 (14)
Copy: J.F. Salmon
Engr: J. Cousen, *Art Journal*, 1851,
opp. p.251
N00345

This picture was originally commissioned
by Sir John Fleming Leicester (later 1st
Lord de Tabley) for his gallery of British
paintings. It was possibly intended as a
replacement for a work by Callcott with
which Leicester was dissatisfied. Leicester
was unusual among collectors in the early
years of the nineteenth century in that he
purchased only modern British paintings.
When he died in 1827 his collection was
sold and Vernon, as a result, acquired five
pictures for his own collection. Only three
of these purchases, this Callcott (bought
for 155 guineas), James Ward's 'View in
Tabley Park' (no.69) and Henry Thom-
son's 'The Dead Robin' (now destroyed)
were part of Vernon's gift to the nation.

Leicester's discerning taste and patriot-
ism were promoted in two catalogues of
his collection. A small etching of 'Little-
hampton Pier' appeared as an illustration
in the catalogue that was published in
1827. In a fuller catalogue of 1829 the
words used by the critic William Carey
when describing this painting convey a
good idea of what a connoisseur looked for
in landscape painting at this date:

the pier-head terminates abruptly, near
the left side of the prospect, forming a
clear though dark mass, united with the
receding shadows of the shore and
waves … A high crane … assists the
form by carrying up the eye consider-
ably above the angle of the pier head …
Beyond … a sandy height presents a
bold light against a bleak sky … The
bright lights on the wings of the sea-
fowl … assist in toning the aerial tints
on the horizon … All [the] parts have an

accord, or local relation; and it is this
unity of character in the whole that consti-
tutes the interesting impression of this
otherwise desolate and uninviting
prospect.

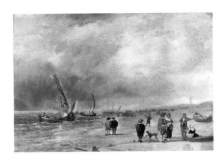

SIR AUGUSTUS WALL CALLCOTT

11 The Shore at Scheveningen (after
Willem van de Velde) *c.*1820–30
Oil on oak panel 16.4 × 24 (6½ × 9½)
Copy: J.C. Bentley
Engr: J.C. Bentley, *Art Journal*, 1852,
opp. p.188
N00348

A 'copy', about quarter-size, of 'The
Shore at Scheveningen' (1659; oil on
canvas 75 × 104 cm; 29½ × 41 in) by
Willem van de Velde the Younger (1633–
1707), is now in a private collection in
Duisberg, Germany. The manuscript list
of Vernon's collection prepared for the use
of the National Gallery Trustees in 1847
refers to Callcott's picture as a 'copy of Sir
R. Peel's picture', as does the *Art-Union*
for November 1847; but it is unclear if the
Duisberg picture, which was in Britain in
the late nineteenth century, was once
owned by Robert Peel. A related work by
van de Velde, owned by Peel from about
1835, was acquired by the National Gal-
lery in 1871 (873).

However, because Callcott's picture is
not a true copy, it would seem most likely
to have been painted immediately follow-
ing one of the annual old master exhibi-
tions held by the British Institution in its
galleries in Pall Mall (fig.7 on p.17). Stu-
dents and professional artists were allowed
to study selected pictures in a 'school' that
opened after these exhibitions had fin-
ished. To encourage the emulation of
great masters rather than mere repro-
ductive work, the Governors of the Insti-
tution stipulated in 1812 that 'no copy be
made of any Picture' but that students
should learn through 'Imitations, Studies
& Sketches and by the endeavour at pro-
ducing companions to the pictures lent'.

Apart from making his painting smaller
than the original, Callcott also altered the
relationship between the figures on the
shore and the boats at sea; a coach and
horses prominent in the foreground of the
Duisberg picture are shifted to the middle
distance, and foreground details are added
where there are none in the original.

A number of seashore scenes by van de
Velde were exhibited at the British Insti-
tution between 1821 and 1841, including a
'View on Coast of Holland' lent by Peel in
1823 and which might be the Duisberg
picture.

SIR AUGUSTUS WALL CALLCOTT

12 Dutch Landscape with Cattle
*c.*1830–40
Oil on panel 16.2 × 33.5 (6⅜ × 13³⁄₁₆)
Copy: R. Brandard
Engr: R. Brandard, *Art Journal*, 1851,
opp. p.76
N00342

In the description of Vernon's collection in
the *Art-Union* for November 1847, this
picture was described as a 'pair' to Call-
cott's copy of van de Velde's 'The Shore at
Scheveningen' (no.11). Whilst not quite
accurate, the painting was, nonetheless,
inspired by the work of another Dutch
artist, Aelbert Cuyp (1620–91). Among the
many seventeenth-century Dutch masters
whose work was collected in Britain dur-
ing the early 1800s, Cuyp was regarded
with particular affection; the warm, golden
tonality and soft effects of aerial perspec-
tive which suffuse his landscapes and
marines were features of his art which
many British painters strove to emulate.
The accessibility of some fine Cuyps when
the Dulwich Gallery opened in 1814 and
the appearance of others at the British
Institution Old Master exhibitions, helped
encourage this taste: Turner, who de-
scribed Cuyp as one who 'knew where to
blend minutiae in all the golden colour of
ambient vapour', and Callcott, were the
two most successful re-interpreters of
Cuyp.

A great many of Cuyp's landscapes
depict groups of standing and recumbent

cattle against a low horizon, frequently with the land rising to the left or the right of the viewer. In 'Dutch Landscape with Cattle' Callcott does not imitate the almost southern glow of Cuyp's light but he does adopt the same sort of composition, while the presence of the church tower in the right-hand distance is a clear echo of the way Cuyp introduced the ruins of Merwede Castle or the tower of the Great Church at Dordrecht into his cattle pieces.

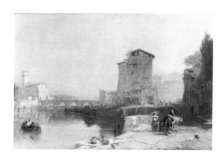

SIR AUGUSTUS WALL CALLCOTT

13 **Entrance to Pisa from Leghorn** exh.1833
Oil on canvas 109.2 × 164.5
(43 × 64¾)
Exh: RA 1833 (185)
Copy: J.C. Bentley
Engr: J.C. Bentley, *Art Journal*, 1850, opp. p.288
N00346

This work is a product of the time that Callcott and his wife spent in Pisa during April 1828. The *Gentleman's Magazine* for June 1833, in commenting on all six of Callcott's 1833 Academy exhibits, described them as 'of a very pleasing and picturesque character' with 'Entrance to Pisa from Leghorn' being numbered among the artist's 'very gorgeous pictures, in which there is a fine glow of colouring'.

SIR FRANCIS CHANTREY
1781–1841

14 **Sir Walter Scott** 1841
Marble 76.2 × 53.3 × 31.8
(30 × 21 × 12½)
Inscr: 'SIR FRANCIS CHANTREY | SCULPTOR | 1841'
Transferred from the Tate Gallery to the National Portrait Gallery 1957
National Portrait Gallery, London

Sir Walter Scott (1771–1832), author of the Waverley novels, was the greatest and most widely read novelist of his day. In particular, his Scottish novels of 1814–19 exerted a powerful influence on the imaginations of other writers as well as composers and artists, and made him one of the most important figures of European Romanticism. Many British artists were inspired by Scott's writings, among them Edwin Landseer, C.R. Leslie, J.M.W. Turner, and David Wilkie, all of whom were represented in Vernon's collection by the time he came to commission this bust.

The bust is one of five replicas, based on a plaster model (now in the Ashmolean Museum, Oxford), which Chantrey took from the life during the spring of 1820. The first replica, executed 1820–1, is in Scott's house at Abbotsford. Chantrey thought it was the finest bust portrait he had ever produced. It was exhibited at the Royal Academy in 1821 and the Paris Salon in 1824 and, through plaster casts, authorised and unauthorised, and pirated copies, it rapidly became the definitive portrait of Scott, known throughout the world. Vernon's replica was the last to be made. The sculptor's account book in the National Portrait Gallery records that it was ordered in 1838 and it was possibly still in Chantrey's studio at the time of his death in November 1841. Vernon paid 100 guineas for the work on 12 September 1842.

Prior to his commission to Chantrey,

Vernon had already acquired a few busts of other eminent Britons by E.H. Baily (nos.3–6). Such sculptures were desirable ornaments in the house of any cultivated man. However, given the wider nationalistic aims which were informing Vernon's collecting by the time he ordered Chantrey's 'Sir Walter Scott' one can perhaps sense in this commission some desire on his part to create a gallery of British worthies to complement his 'Gallery of British Art'. In fact, such an idea was not realised until 1856 when the National Portrait Gallery was founded.

Chantrey was unrivalled as a portrait sculptor in his time. In his work is seen a finely poised balance between the classical and the modern – well exemplified in this bust of Scott by the manner in which the drapery around his shoulders is clearly defined as a tartan plaid and yet possesses all the nobility of the Roman toga. Chantrey died a very rich man. Under the terms of his will, which Vernon seems to have known about before the sculptor's death, his fortune was to be used for the purchase of art, executed in Great Britain, for the nation. What is now known as the Chantrey Bequest came into force in 1877 and continues to this day.

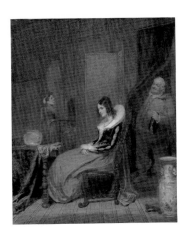

GEORGE CLINT 1770–1854

15 Falstaff's Assignation with Mrs Ford ?1830–1
Oil on canvas 76.6 × 64.3 (30 × 25¼)
Exh: BI 1831 (95)
Copy: William Goodall
Engr: W. Bourne, *Art Journal*, 1853, opp. p.125
N00377

This picture illustrates a scene at the beginning of Act III, scene 2 of Shakespeare's comedy *The Merry Wives of Windsor*. The fat knight, Sir John Falstaff, who has fallen on hard times, sets out to woo Mistress Ford and Mistress Page, both of whom hold the purse strings in their respective households. Falstaff writes identical love letters to both women, though his intentions are immediately betrayed to their husbands by the knight's cast-off followers, Nym and Pistol. The knowing wives conspire to lead Falstaff on and then show him up as an ass.

His first assignation is with Mistress Ford, and Clint shows that moment when Falstaff enters her room uttering the passionate words

'Have I caught my heavenly jewel?'
Why, now let me die, for I have lived
long enough: this is the period of my
ambition: O this blessed hour!

The co-conspirator Mistress Page exits to the left. She later reappears to warn of the impending arrival of Master Ford, which is the cue for Falstaff to be hidden in a basket of dirty laundry and then unceremoniously tipped into the River Thames nearby.

Clint was a well-known painter of actors and theatrical scenes and the character of Falstaff in this work has been identified by Raymond Mander and Joe Mitchenson as a portrait of the actor William Dowton (1764–1851). An oil sketch showing Dowton wearing the same costume as that depicted here is in the Mander and Mitchenson Collection.

Dowton was one of the finest comic actors of his age and the fact that Clint exhibited this work at the beginning of 1831 suggests that it is, in part at least, a record of his Falstaff in the revival of *The Merry Wives* which opened at the Theatre Royal, Drury Lane, on 7 October 1830. On this occasion, the critic of the *Athenaeum* described Dowton as 'if not altogether the Falstaff of our imagination … at least the best now on the stage'. The critic in the *Library of Fine Arts* pointed out that the picture was 'not … copied from the actual modern representatives on the stage' though the certain identification of Dowton contradicts this assertion.

Similarly, it is difficult to relate any of the props Clint uses to contemporaneous theatre practice, though the two-dimensional quality of the gothic background suggests the effect of a stage flat. In other respects, Clint uses the sort of narrative devices which were to be found in genre paintings of this period: the fish in the bowl on the table hints at Falstaff's being hooked by the scheming wives as well as his watery punishment, while the oriental vase has a riverside scene painted on it.

According to the critic in the *Examiner* of 20 February 1831, the picture was bought for 100 guineas from the British Institution exhibition by the collector William Wells. However, the painter R.W. Buss, who was Clint's pupil, reported in the artist's obituary that the work was painted for Vernon and indeed, the *Literary Gazette* for 16 April 1831 listed it as having being acquired by him.

WILLIAM COLLINS 1788–1847

16 Prawn Fishing 1828
Oil on mahogany panel 43.8 × 58.4 (17¼ × 23)
Inscr: 'W Collins | 1828' bottom left
Exh: RA 1829 (371)
Copy: C. Cousens
Engr: J.T. Willmore, *Art Journal*, 1849, opp. p.148
N00352

In 1815 Collins visited Norfolk and the coastal scenes which he saw there provided him with just the kind of novel subject matter which was necessary for an artist to make a mark in the London exhibitions. Thereafter he frequently exhibited seashore themes, based on sketches made during further visits to Norfolk, Kent and Sussex and then, in 1827, the Isle of Wight. 'Prawn Fishing' appears to be inspired by this latter trip although it was painted entirely in his London studio. Despite this, Collins's handling of the landscape in this picture retains a surprising freshness. This can be attributed to a resolution the artist had made two years earlier. He had tended to be a slow worker until, in 1826, a fellow artist, Sir William Beechey, expressed surprise at the amount of time he spent on each picture and cited the example of Willem van de Velde the Younger as a painter who had worked successfully at great speed. Collins disagreed with Beechey's opinion but nonetheless felt that van de Velde, and a number of his contemporaries, 'preserved the spirit of their work, by painting much faster than most people seem aware of'. Collins resolved to paint with 'less timidity and anxiety; as nothing can replace the want of that vigour and freshness, which things done quickly (with a constant reference to Nature) necessarily possess'.

'Prawn Fishing' was commissioned by Sir Francis Freeling, Secretary to the General Post Office, for 153 guineas. Vernon bought it at Freeling's sale in 1836 for 122 guineas.

JOHN CONSTABLE 1776–1837

17 The Valley Farm 1835
Oil on canvas 147.3 × 125.1
(58 × 49½)
Inscr: 'John Constable R.A. [?fecit]
1835' bottom right
Exh: RA 1835 (145)
Copy: J.C. Bentley
Engr: J.C. Bentley, *Art Journal*, 1849,
opp. p.159
N00327

After the purchase of the lease of a large house in Pall Mall in May 1832, Vernon's collecting became more confident. The prospect of more space – he did not move to 50 Pall Mall until about mid-1833 – certainly meant that he could contemplate buying larger pictures. But it is almost as though, having acquired this new address in one of London's most fashionable streets (and near the National Gallery), Vernon felt he at last had sufficient social standing to approach the most eminent, and in some ways perhaps, inaccessible, members of the artistic profession: those whose works he had so far chosen not to buy, despite the critical attention they had attracted throughout the period he had been collecting. In 1832 he bought from Turner for the first time (N00369), from whom he bought again in 1833 (no.64) and 1834 (N00371). In November and December 1834 he was in touch with Wilkie, without success (see no.74) and then Constable.

Vernon first called at Constable's house in January 1835, possibly having heard about the large canvas ('The Valley Farm') which had been preoccupying the artist since the latter part of the previous year; but, more likely, Vernon went anticipating that, with sending-in day for the British Institution exhibition imminent, Constable would have had a finished work available for inspection. Constable was away on that occasion and it was not until

Vernon returned in March that he was able to view a picture. Constable reported to his close friend, the artist C.R. Leslie, that 'M^r Vernon … called with the Chalons [the artists A.E. and J.J. Chalon] – he saw ['The Valley Farm'] free from the mustiness of old pictures – he saw the daylight purely – and bought it – it is his'. Vernon left Constable to fix a price, finally agreed at £300, which was paid in September 1835. It was the largest price Constable ever received for a picture.

When it was exhibited at the Academy in May 1835, 'The Valley Farm' was fiercely attacked by the critics who focused on Constable's use of flake-white which, in their eyes, gave the subject a false glitter. The critic of the *Observer* for 10 May 1835 thought that Constable, with his exaggerated effects of light and shade, had abused his talents, adding that the artist's defence 'as we hear' was 'that it was only necessary to keep his picture a certain number of years, and it will sober down'. This defence might have emerged through Vernon himself, possibly alarmed and embarrassed at being the owner of a suddenly notorious picture: it was recorded by the *Art-Union* for 1 November 1847 that Constable had told him 'that time would alter' the spottiness caused by the white paint.

After the Academy exhibition the picture went, not to Pall Mall, but back to Constable's studio where he worked on 'mellowing and finishing it' until December, with the aim of re-exhibiting it at the British Institution in February 1836. Vernon, no doubt fearful of another attack, did not want this to happen. Constable's view eventually prevailed, but not before he had reassured Vernon (or so it would appear from a draft letter) that his motive in keeping it so long was to 'make it as good as I possibly can for both our sakes. I should arrive at the height of my ambition, could I make my art … a feature in "English Landscape", and this picture is in all respects my best and will give me the fairest chance of doing so'. Vernon had the picture in his home for a few weeks before sending it to the British Institution – a few doors away (see fig.7 on p.17).

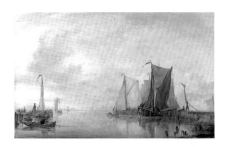

EDWARD WILLIAM COOKE
1811–1880

18 Dutch Boats in a Calm* 1843
Oil on mahogany panel 42.5 × 49
(16¾ × 27⅟₁₆)
Inscr: 'E.W. Cooke 1843' bottom right
Exh: BI 1844 (205)
Copy: J.F. Salmon
Engr: T. Jeavons, *Art Journal* 1849,
opp. p.208
N00447

Cooke's reputation as a marine painter was established from the time his work appeared at the British Institution in 1835, and Vernon first purchased a picture from him in 1836 (N00448). After his first visit to Holland in 1837, Cooke's shipping scenes more obviously reflected the influence of seventeenth-century Dutch painters, whose work he also collected: in his studio sale there was a 'Sea Piece' by J. van de Capelle (*c*.1623/5–1679) and a group of drawings by van de Velde the Younger.

After the sale of his 1836 picture, Cooke seems to have worked on two other pictures for Vernon in 1840 and 1842, though neither ever entered his collection. 'Dutch Boats in a Calm' was begun after a three month trip to Holland which Cooke made with his wife between July and September 1843. He painted the picture at Redleaf, Kent, the home of William Wells who was a prominent collector of British art; it was commenced on 13 November and finished on 1 December 1843 when, as can be seen clearly, he inscribed his signature in the wet paint. The *Art-Union* for March 1844 described the 'Dutch Boats' as 'one of the choicest works of its class that has been produced in England'. Vernon bought the picture in the exhibition for 50 guineas.

(Information for this entry has been kindly supplied by John Munday.)

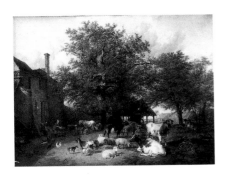

THOMAS SIDNEY COOPER
1803–1902

19 Milking Time – Study of a Farm-Yard near Canterbury 1833–4

Oil on canvas 96.8 × 132.7
(38⅛ × 52½)
Inscr: 'T.S.Cooper│1834' bottom right
Exh: RA 1834 (239)
Copy: J. Sleape
Engr: J. Godfrey, *Art Journal*, 1853,
opp. p.353
N00435

Cooper made his debut in the London art world when he exhibited at the British Institution in February 1833. Within a few weeks, with his pictures of cattle in landscapes being shown at the Artists and Amateurs' Conversazione at the Freemason's Tavern and then at the spring exhibition of the Society of British Artists, Cooper's career was successfully launched. His first Academy picture of the same year was bought by Lord Northbrook – a leading patron of living artists.

Vernon first met Cooper in late 1833 at the Society of British Artists winter exhibition when, according to the artist, he 'very much' wanted to buy one of his pictures but would not because it was already in the hands of a dealer. Soon afterwards, Vernon visited Cooper's studio to look at a painting which he had provisionally agreed to purchase. He was accompanied by his friends – Thomas Morton the playwright and John Fawcett the actor – and it was the latter who found this picture among a group of unfinished canvases. Cooper had started the work, using sketches made during the summer of 1833, with a view to sending it to the Royal Academy exhibition of 1834. Vernon there and then offered to acquire the picture for £100 when it was completed. Cooper later wrote that when Vernon saw the picture again in the studio in spring 1834, just before sending-in day, he said 'he liked it very very much'; and added, 'send it by all means to the Royal Academy; I am sure they will accept it for the exhibition'. Cooper also stated that

although 'Milking Time' was indeed accepted, it was overlooked by the Hanging Committee when they were arranging the rooms. George Jones, a member of the Hanging Committee (and a friend of Vernon's), saved the day by removing one of his exhibits to find space for Cooper's picture.

Cooper was born in Canterbury and the landscape of the valley of the River Stour nearby was a constant source of inspiration to him throughout his long career, rather as Dedham Vale was for John Constable. 'Milking Time' shows a view of Tonford Manor, Thanington, which is now a suburb of Canterbury; some of the fortifications which at one time surrounded the house can be seen in the distance between the house and the large oak tree. Tonford was originally built by Sir Thomas Browne, controller to King Henry VI, and Henry VIII had stayed there in 1512 (information kindly supplied by Brian Stewart and David Fuller).

Cooper's depiction of a building rich in historical associations but now in a state of decay and turned over to common domestic use was very much in the tradition of English Picturesque art. However, Cooper's particular emphasis on cattle and sheep in his landscapes introduced a new note into English art which, as he rightly judged, could only help his career. This was a direct result of the influence which the Belgian painter Eugène Verboekhoven (1798–1881) had on Cooper at the beginning of his three year stay in Brussels in 1827. Verboekhoven, who specialised in cattle pictures which were consciously and successfully modelled on the seventeenth-century Dutch masters of the genre like Paulus Potter (1625–54) and Aelbert Cuyp (1620–91), persuaded Cooper to paint in oils; under him Cooper adopted both his style and subject matter, as well as his practice of always using studies from nature as the basis for finished work. This, combined with a trip which Cooper made to Holland on the eve of his return to England in 1830 when he saw 'the works of the great animal painters', confirmed for him 'the feeling that this branch of Art was not much practised in England'.

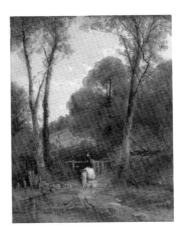

THOMAS CRESWICK 1811–1869

20 The Stile 1839

Oil on mahogany panel 61 × 50.1
(24 × 19¾)
Inscr: 'Tho. Creswick 1839' bottom right and 'N°I THE STILE│THO. CRESWICK' on back of panel
Exh: BI 1839 (106)
Copy: J.C. Bentley
Engr: J.C. Bentley, *Art Journal*, 1849,
opp. p.272
N00429

Creswick was born in Sheffield and studied with the Birmingham landscape painter J.V. Barber before moving to London in 1828. He exhibited first at the British Institution and then at the Royal Academy that same year, but his early reputation was made through his contributions to the smaller and less important exhibiting body, the Society of British Artists. His consistent truth to nature was particularly admired as were the cool greens he used in his palette which he combined with silvery effects of aerial perspective. He soon became known as a landscape artist who, in a favourite expression of the time (though not one, incidentally, that was often applied to his much older contemporary, John Constable), 'always takes us out of doors'. In 1835, one of his paintings was favourably compared with a work by the eighteenth-century painter, Canaletto.

This picture was one of three which Creswick showed at the British Institution in 1839. The critic in the *Athenaeum* for 9 February noted especially how in all three 'the masses of foliage are managed with great richness and variety' – achieved, he noted, through the 'feathering' effect of Creswick's brush. A surviving receipt dated 8 May 1839 and signed by William Barnard, Keeper of the British Institution, shows that Vernon bought this picture for 40 guineas. (Jenkyns II.4).

Prior to the publication of the engraving of 'The Stile' in the *Art Journal*, a proof of the print was shown to the artist for his approval. On the steel plate, he added a spire to the church tower to make it more prominent.

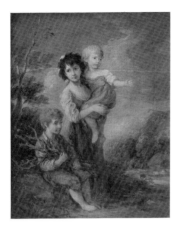

21 Cottage Children
Oil on canvas 46 × 36.2 (18⅛ × 14½)
Copy: R. Woodman Sr
Engr: G.B. Shaw, *Art Journal*, 1850, opp. p.102
N00311

This picture was bought by Vernon as a work by Thomas Gainsborough. In an account of Vernon's collection in the *Art-Union* for November 1847, it is described and also referred to as a 'study for the large picture – but highly finished'. This must be a reference to Gainsborough's noble 'Wooded Landscape with Peasant Family at a Cottage Door', famous during the nineteenth century, which was sold out of Lord de Tabley's collection in 1827 (Henry E. Huntington Library and Art Gallery, San Marino, California). From the *Art-Union* comment we might perhaps adduce the principal reason for Vernon wanting to own the picture. The figures in Vernon's 'Gainsborough' do loosely relate to three of the figures in the 'Wooded Landscape'; however, the work is more likely attributable to Gainsborough Dupont on stylistic grounds.

Dupont was Gainsborough's nephew and worked in his uncle's studio, as his only assistant, from 1772 onwards. He pursued an independent career after Gainsborough's death in 1788 but his subject matter and technique are derived almost wholly from Gainsborough.

22 Christ Lamenting over Jerusalem ? 1846
Oil on canvas 104.8 × 156.2 (41¼ × 61½)
Copy: C.H. Woodman
Engr: J. Outrim, *Art Journal*, 1854, opp. p.107
N00397

A repetition, painted for Vernon, of a painting exhibited by Eastlake at the Royal Academy in 1841 (75). On that occasion the work was shown without a title but was accompanied by a number of quotations from the New Testament, including verses 37 and 38 from chapter 23 of the Gospel according to St Matthew, in which Christ, with his disciples on the Mount of Olives, foretells the destruction of Jerusalem:

O Jerusalem, Jerusalem, *thou* that killest the prophets, and stonest them which are sent unto thee, how often would I have gathered thy children together, even as a hen gathereth her chickens under *her* wings, and ye would not! Behold, your house is left unto you desolate.

The 1841 picture was unanimously hailed as a masterpiece by the critics: the *Art-Union* for May 1841 described it 'as near perfection as was ever a production of genius'; the *Athenaeum* for 8 May thought it 'the finest work in the exhibition', while the *Literary Gazette* for 15 May felt that it was one of the 'performances in the Exhibition which exalt the British School'. Such lavish praise, from all quarters, for the work of a living artist, was unusual at this time and it must have helped persuade Vernon that the subject would be a highly desirable addition to his collection; undoubtedly, also, the presence of such a powerful Christian image in a collection which, by now, was almost certainly destined for the nation, would have appealed to Vernon.

The picture must originally have been partly inspired by Eastlake's awareness of the religious controversies which were,

from the late 1830s, dividing the Church of England. These centred on the Oxford Movement, led by John Newman, and its belief in the Roman Catholic heritage of the Protestant Church. Eastlake's realisation of the scene on the Mount of Olives, and his use of allegory in the accessories which he introduced, seems to echo the religious controversialists' attempts to reconcile the idea of the scriptures as a record of historical fact as well as of doctrine. Likewise, the theme of the destruction of a great city would probably have been linked by the artist not only with the prospect of schism in the established church, which Newman's beliefs threatened to bring about, but also with the debate about the diminution in the moral authority of the state (at the heart of which lay London) which provoked numerous religious, social and political tracts.

The symbols in Eastlake's picture are easily read. For example: the axe in the tree behind Christ foreshadows the destruction of the city, as does the broken bough in the foreground; the shepherd carrying a sheep symbolises Christ as the good shepherd; the scythe and the sheaf of wheat represent the gathering in of Christ's harvest and the milling of the flour for bread, which is representative of Christ's body at the Eucharist. The grains of wheat and the poppies possibly refer to the parable of the wheat and the tares. The hen sheltering her chicks is a direct allusion to St Matthew's text. According to the *Art-Union* for November 1847, the sheep and the birds in the picture were painted by T.S. Cooper (see no.19). The picture was finished in 1846. Vernon paid the artist 500 guineas for the work.

SIR CHARLES LOCK EASTLAKE

23 The Escape of Francesco Novello di Carrara, with his Wife, from the Duke of Milan* 1849
Oil on canvas 127 × 101.6 (50 × 40)
Exh: RA 1850 (169)
Copy: R. Woodman Sr
Engr: S. Smith, *Art Journal*, 1853, opp. p.128
N00399

An illustration of a passage from the *Histoire des Républiques Italiennes du Moyen Age* by the French historian Leonard Simond de Sismondi (1773–1842). When the picture was exhibited it was accompanied by a quotation in the original French from volume 7 (p.100) of this work. Sismondi's *Histoire* later appeared in 1832 in a much reduced English edition under the title *A History of the Italian Republics, Being a View of the Origin, Progress and Fall of Italian Freedom* in which the episode Eastlake depicts is described (p.193) in the following words:

> Several attempts had been made to assassinate Francis II in the province of Asti, whither he had been exiled. In spite of many dangers he at last escaped, and fled into Tuscany, taking his wife, then indisposed, with him.

Francesco Novello di Carrara, the last Lord of Padua, is shown with his wife, Taddea d'Este, on a mountain pass near Ventimiglia. They are escaping from Giovanni Galeazzo Visconti, Duke of Milan, who had first exiled and then attempted to kill Carrara. He and his wife and servants are struggling along a precipitous path whilst the Duke's followers are in pursuit in the valley below. The escape took place in March 1389.

'The Escape of Francesco Novello di Carrara' was a repetition of a picture which Eastlake painted for James Morrison (1789–1857), a patron of art who had made a fortune in the drapery business, become a Liberal MP and, in 1838, bought Basildon Park in Berkshire. Morrison's picture was exhibited at the Royal Academy in 1834 (64) and was subsequently engraved.

Eastlake, who had lived in Italy almost continuously between 1816 and 1830, was a learned and sympathetic scholar of the Italian Middle Ages. One senses in this painting, as in the 'Christ Lamenting over Jerusalem' (no.22), the historian in him being drawn to particular historical subject matter because of its contemporary relevance: in this case the commencement of the young Mazzini's struggle to liberate Italy from foreign rule and lead it to unification. During the 1820s and 1830s thousands of Italians were forced into exile because of their liberal sympathies; many of them, among them Gabriel Rossetti, father of the Pre-Raphaelite painter Dante Gabriel Rossetti, came to London.

This picture was among the last of Vernon's commissions and it was not finished until 1849. When it was exhibited in 1850 the critic of the *Builder* for May described it as 'an almost faultless specimen of drawing and careful, laborious finish, but is wanting in energy and force of effect'. By this date the Risorgimento had created a wider interest in Italian history. In painting this manifested itself most notably in Holman Hunt's Pre-Raphaelite picture 'Rienzi' of 1849 and, exhibited at the same time as Eastlake's work, James Clark Hook's treatment of the escape of the Carrara family.

AUGUSTUS LEOPOLD EGG
1816–1863

24 Scene from 'The Devil upon Two Sticks' 1844
Oil on canvas 87 × 111.3 (34¼ × 44½)
Inscr: 'Augᵗ Egg. 1844' on napkin bottom right
Exh: RA 1844 (462)

Copy: W. Goodall
Engr: S. Sangster, *Art Journal*, 1851, opp. p.116
N00444

A scene from chapter 8 of the romance *Le Diable boiteux* (The Devil upon Two Sticks) by the French comic writer Alain René Le Sage, first published in 1707. It was translated into English and was popular in this country during the eighteenth and nineteenth centuries. Egg probably used the edition published in London in 1837 by Charles Daly.

The devil of the book's title is a spirit who is released from a glass phial by the scholar Don Cleofas Leandro; he is about thirty inches tall with goat's legs, walks with crutches and has a long, pointed face rather like Mr Punch. Le Sage's book consists of a series of loosely connected stories: Cleofas is taken around Madrid by the devil (also known as Asmodeus) who, with his diabolical powers, can 'lift off the Roofs of the Houses and notwithstanding the Darkness of Night, clearly expose whatever is now under them'. *Le Diable boiteux* is a satire on the follies and vices of mankind and although it is set in Madrid (and was based on a Spanish prototype) it was in fact originally aimed at Parisian society of the time.

At the centre of Egg's picture is Patricio, a 'loose husband' who is discovered by the devil and the don fast asleep and snoring while his long-suffering wife delivers a curtain lecture. During the day that has just finished, Patricio had been consumed by lust for 'a lady very well made and neatly dressed [who] shewed a fine well turned leg, with a pink-coloured silk stocking and silver garter'. She is called Luisita and her companion is called Jacintha. They are both women of the town but Patricio, quite blind to this and in high hopes of eventually seducing Luisita, offers to be of service to her. All three go to a tavern where, in a private room, Patricio buys breakfast. This runs to several courses as the girls make the most of a free meal: partridges, two cold chickens, pigeons, ham, bread and lots of wine. Jacintha sneaks the pigeons and the partridges into her pocket whenever Patricio leaves the room to order more food. Eventually, the amorous Patricio attempts, unsuccessfully, to make Luisita give him 'those returns he expected from her gratitude'. He hopes that he might in the end be rewarded but before they leave the tavern 'there was a necessity for paying the vintner, who mounted the bill to fifty reals; [Patricio] put his hands into his pocket, where finding but thirty reals, he was

forced to pawn his beads [i.e. rosary] garnished with silver medals for the rest'. Egg depicts this moment; the rosary can be seen around Patricio's neck. The story continues with Patricio, still hoping to win Luisita, who follows her home only to find that she and her companion both gave him the slip in the darkness. 'Ashamed of being fooled by a couple of jilting baggages' he finally goes home to bed.

At the Liverpool Academy in 1842 Egg had exhibited a smaller picture which showed a slightly earlier moment in Patricio's breakfast. This was sold to a local collector and, clearly encouraged by this success, Egg decided to treat the same episode from Le Sage on a larger scale, even though the critic of the *Art-Union* had described the 1842 exhibit as 'not a pleasant subject'. This 1842 picture was sold at Sotheby's in April 1991.

Just how far Egg was interested in the moral which Le Sage was driving home, or in the sexual innuendo permeating his account of a mealtime encounter between a married man and his two loose companions, is unknown. At the very least, Egg would have seen in *Le Diable boiteux* humour and a Spanish setting which gave him the opportunity of creating a colourful and eye-catching picture. We know from the contents of the artist's studio, sold up after his death, as well as from his close connection with Charles Dickens's private theatricals, that Egg had an abiding interest in costume and drama; the critics were unanimous in 1844 in seeing this picture as a clever and delightful picture in just these terms, even if some felt that Egg's talents should have been used on a more substantial work.

Interestingly, S.C. Hall, editor of the *Art Journal*, who might have written the review of Egg's 1842 picture, took up the question of the artist's choice of subject matter when he wrote the commentary which accompanied the engraving of Vernon's picture which appeared in *The Vernon Gallery*: 'characters drawn by Le Sage are not such as would be placed for public exhibition among a people who pride themselves on possessing an amount of refinement'. Hall, a stuffy individual, accordingly rewrote the plot to the extent of describing the two girls as merely 'heartless and mischievous and indifferent to the consequences of [Patricio's] foolish good-nature'.

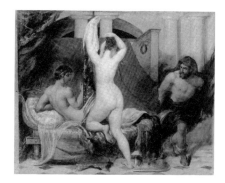

WILLIAM ETTY 1787–1849

25 Candaules, King of Lydia, Shews his Wife by Stealth to Gyges, One of his Ministers, as she Goes to Bed* exh.1830
Oil on canvas 49.7 × 60.7
(19⅞6 × 23⅞)
Inscr: 'No 4 Wᵐ Etty R.A.' on back of stretcher
Exh: RA 1830 (331)
N00358

This picture illustrates an episode in the life of Candaules which was recorded by the Greek historian Herodotus as having taken place in about 718 BC. Candaules arranged that Gyges should see his wife, Nyssia, naked. The queen was so angry at her husband's weakness and imprudence that she gave Gyges the choice of either being put to death or of murdering Candaules. Gyges murdered the king, married the queen, ascended the throne and reigned for thirty-eight years.

Etty was the most eminent figure painter as well as one of the most distinguished colourists of his time. During his life, his reputation rested on the historical and mythological subjects which he exhibited regularly at the Royal Academy from 1820 onwards. These works were largely formed around his tireless study of the nude, particularly the female figure. Etty was a regular attender in the Life School of the Royal Academy and, after it was formed in 1824, the private Academy for the Study of Living Models. Apart from the Royal Academy this was for many years the only place in London where artists could study from the naked figure by daylight and gaslight. Etty was a highly inventive poser of the human figure and it seems very likely that most of the innumerable oil studies from the nude derive from his attendance at the Living Model Academy; here the figures were set by distinguished visitors, such as Etty, who would sometimes place them in attitudes borrowed from classical statues or old master paintings.

In 'Candaules', the pose of Nyssia is very obviously taken from life. The degree of finish in the queen's figure compared to the sketchiness of other parts of the canvas, suggests that Etty painted this figure directly in front of the motif and completed the rest of the composition in his studio. There he would have set up the perspective lines (drawn in pencil and visible on the floor beneath the figure of Gyges), and added the two other figures and the architectural accessories. The female model would have had her left knee and right elbow resting on plinths and she would have supported her left hand on an upright post attached to the plinth below. This upright could sometimes be concealed with a drape – a detail which Etty turned to advantage in his finished picture.

Such a view of the naked female is not especially unusual in art, but it is unusual in British art. Finished studies from the life by Joshua Cristall, drawn in the 1820s, show a very similar pose (Victoria Art Gallery, Bath), but Etty's treatment exists quite independently of these and seems rather to owe a debt to old master precedents, particularly to the work of the Flemish painter Jacob Jordaens (1593–1678).

Etty's picture was certainly the first rendering of the Candaules story by an established British artist and its appearance at the Academy in 1830 was the first time the subject had been put before the public. This particular episode appears quite frequently in seventeenth-century Italian, Dutch and Flemish art, with a painting by Jordaens of 1646 being perhaps the best known depiction of it (National Museum, Stockholm since 1872). In keeping with the spirit of late eighteenth and early nineteenth-century English history painting, Etty was eclectic in his borrowings. So, the figure of Gyges on his bed is derived from the figure of Herakles (Hercules) or Dionysos on the east pediment of the Parthenon which Etty would have known from his early study of the Elgin Marbles in the British Museum. Whilst there is no evidence that the artist had ever seen Jordaens's 'Candaules', we do know that he was familiar with and admired this painter's work. Indeed, in 1828 he acquired a 'Bacchanalian Revel', containing thirty-three figures, which was attributed to Jordaens. It was a picture which, with its 'splendid and masterly style of colouring' Etty had 'long cast an eye on' and which, if nothing else, probably influenced the rich palette he used in 'Candaules'. If, as seems likely, this was a replica of the painting by Jordaens now in

the Musée des Beaux-arts, Brussels, then it was Jordaens's manner of setting his female figures, with their backs to the viewer and their arms upraised, which showed Etty the way to place his model for Nyssia.

Even by Etty's standards, 'Candaules' is a highly-charged depiction of sexual aggression and the critic of the *Literary Gazette* reproved the artist 'for his occasional tendency to a debasing sensuality in his small productions'. In a comparison with 'foreign artists' – a reference, perhaps, to the sensual and violent treatment of women in Delacroix's 'The Death of Sardanapalus' which had been exhibited at the Paris Salon three years earlier – the writer asked 'is one of our own purer school ... to mistake the proper direction of art and thus to offend against decency and good taste?'. It was clearly for this reason that twenty years later S.C. Hall, the editor of the *Art Journal* who secured the right to publish engravings of the Vernon pictures in his magazine from 1849, did not have a print made from 'Candaules'. It was a decision undoubtedly prompted by the fact that, previously, engravings after nude or semi-nude sculptures had been torn out of the magazine and returned to him in the post 'with an indignant protest'.

WILLIAM ETTY

26 Youth on the Prow, and Pleasure at the Helm 1830–2
Oil on canvas 158.7 × 117.5
(62½ × 46½)
Inscr: 'No 1 Wᵐ Etty, R.A.' on back of stretcher
Exh: RA 1832 (196)
Copy: J. Fussell
Engr: C.W. Sharpe, *Art Journal*, 1850, opp. p.128
N00356

First exhibited with the following lines from Thomas Gray's Pindaric ode, *The Bard*, published in 1757:

> Fair laughs the morn, and soft the
> zephyr blows,
> While proudly riding o'er the azure
> realm,
> In gallant trim, the gilded vessel goes,
> Youth on the prow, and Pleasure at the
> helm,
> Unmindful of the sweeping whirlwind's
> sway,
> That, hushed in grim response, expects
> his evening prey.

Etty considered painting this subject as early as 1818–20 when he listed it among 'subjects of Poetry' in a notebook. He exhibited it as a 'sketch' at the British Institution in 1827 (now Public Library, Boston, Lincolnshire), possibly being prompted to work up his initial idea by the appearance of a picture dealing with the same theme, William Hilton's 'Nature Blowing Bubbles for her Children' at the Royal Academy in 1821 (128; now Tate Gallery N01791). A small compositional study for the Vernon picture, on an envelope postmarked '30 Jan. 1830' is in the Victoria and Albert Museum. The work was possibly commissioned by Vernon though Etty's account book only records a part payment of £250 for it from Vernon on 7 August 1832.

This picture was untitled when it was shown at the Academy and the quotation from Gray was intended to stimulate a deeper reading of the image. Etty explained his view of the subject matter in a letter to the engraver C.W. Wass:

> it is a general allegory of Human Life, morally, where what we see here portrayed, is often real. How ... youth ... snatch at the bubbles of pleasure, of amusement and of promised happiness; delighted with the chace and pursuit, till the roar of the whirlwind of distress, and misery, and death, awakens them from their pleasant dreams and sweeps them to the general doom ... The imaginary 'Being of the Whirlwind' is shadowed forth in the dark cloud above.

For Etty, the pleasures of human life were 'empty, vain ... if not founded on the laws and promises of Him who is the Rock of Ages'.

Because of his predilection for the female nude and his luscious rendering of it on canvas, Etty's seriousness was frequently overlooked. The critic of the *Morning Chronicle* for 8 June 1832 described this picture as an 'indulgence of ... a lascivious mind'. Although the picture

was bought by Vernon and first exhibited in 1832, it was shown a second time at the British Institution at the beginning of 1833.

THOMAS GAINSBOROUGH
1727–1788

27 Sunset: Carthorses Drinking at a Stream *c.*1760
Oil on canvas 144.9 × 155.1
(57⅛ × 61⅛)
Copy: J.C. Bentley
Engr: J.C. Bentley, *Art Journal*, 1849, opp. p.72
N00310

Vernon bought this picture for 220 guineas at a Christie's auction in 1832. It was the first Gainsborough that he owned and at the time it was the largest landscape in his collection. Furthermore, its acquisition seems to mark a turning point in the way Vernon viewed his growing gallery of British art: it was his first major British 'old master' and, as such, it signals the start of a concerted attempt to represent the modern school in depth rather than just by the achievements of living artists. 'Sunset: Carthorses Drinking at a Stream' also appears to have further stimulated Vernon's interest in the pre-eminent contemporary landscapists: he bought his first Turner (N00369) at more or less the same time, another in 1833 (no.64) and his only Constable in 1835 (no.17).

Vernon obviously liked Gainsborough's work. In 1837 he bought three of his landscape drawings at Sir Francis Freeling's sale and then in 1838 he purchased 'Boy Driving Cows' (no.28). At an unknown date he acquired another painting believed to be by Gainsborough but now attributed to Gainsborough Dupont (no.21). For the nineteenth-century viewer,

Gainsborough's ideal landscapes, such as 'Sunset' and 'Boy Driving Cows', possessed a elegaic quality which spoke of the pleasures of retreat from urban life. C.R. Leslie, Professor of Painting at the Royal Academy in the 1840s, told his students that 'if ever landscape was poetic on canvas, it is such landscape as [Gainsborough's]'. Vernon, like other rich men, was able to retire to the country periodically: he bought this Gainsborough to enjoy in his London mansion but at about the same time he acquired a new rural retreat at Holly Hill, Titchfield, in Hampshire.

THOMAS GAINSBOROUGH

28 Boy Driving Cows near a Pool
*c.*1786
Oil on canvas 62.7 × 76 (24⅝ × 29⅞)
Copy: J.C. Bentley
Engr: W. Miller, *Art Journal*, 1853,
opp. p.184
N00309

Purchased by Vernon at Christie's in March 1838 for 230 guineas at the same time that he bought another British 'old master', Richard Wilson's 'Strada Nomentana' (N00301). The acquisition consolidated Vernon's holdings of Gainsborough's work, which he further added to in 1839 when he bought the large 'Musidora' (N00308).

During the nineteenth century 'Boy Driving Cows near a Pool' acquired a reputation as a particularly fine example of Gainsborough's art. When it was sold at Christie's in 1801 it was described by the auctioneers as 'fascinating as the most brilliant production of Rubens' and the high price Vernon paid for it in 1838 underlines just how highly regarded it was. The *Art-Union* for 1 November 1847, describing the picture as seen in Vernon's Pall Mall house (where it hung adjacent to Maclise's 'The Play Scene in Hamlet',

no.49, and Richard Redgrave's literary subject, 'The Return of Olivia', not included in the Vernon Gift), singled it out as 'singularly fresh and brilliant ... certainly the most charming of the minor productions of this artist we have ever seen'.

When the engraving of the picture was published in volume 3 of *The Vernon Gallery*, S.C. Hall, who wrote the text which accompanied the print, pointed out that the picture represented a view, 'we believe, in the immediate vicinity of De Tabley House ... near Knutsford, Cheshire' and pinpointed it as showing 'a portion of the park wall, and ... a ... gateway which ... is now used as a boat house'. There is no reason for associating Gainsborough's picturesque composition with Tabley House; but had such an anecdote been current at the time of Vernon's purchase it might have appealed to him because the work would have provided a link between his collection and that of an earlier great collector of British art – Sir John Leicester – and also complemented the picture of Tabley Park by James Ward which he already owned (no.69).

JOHN GIBSON 1790–1866

29 Hylas Surprised by the Naiades
1827–?36
Marble 160 × 119.4 × 71.8
(63 × 47 × 28¼)
Inscr: 'ΥΩΑΣ ΚΑΛΟΣ' on top of vase
and 'I GIBSON FECIT | ROMA' on
tree trunk
Exh: RA 1837 (1178)
Engr: W. Roffe, *Art Journal*, 1854,
opp. p.22
N01746

According to Greek mythology, Hylas was the beautiful son of King Thiodamus.

Herakles having killed the king took Hylas as his servant and lover. They joined the Argonauts, led by Jason, in their search for the Golden Fleece. When their ship was forced to make for land, Hylas went ashore to fetch water at a fountain. The nymphs of the fountain (or naiads) were so taken by his beauty that they pulled him in so he might always live with them. The story is recounted by the Greek poet Theocritus. The inscription in Greek which Gibson chiselled into the marble translates as 'Beautiful Hylas'.

Gibson spent his entire working career in Rome from the time he arrived there in 1817 until his death. He was a pupil of the great Italian neo-classical sculptor Antonio Canova. Gibson soon became widely admired as the English sculptor whose work best exemplified the Grecian ideal, in Lord Lytton's words, of 'simplicity, calm and concentration'. The flowing line and fine finish which characterises his work is particularly well shown in 'Hylas surprised by the Naiades'.

In his autobiography, Gibson recorded that the commission for this piece of sculpture arose out of a visit which William Haldimand, a businessman and Member of Parliament, made to his studio in Rome in May 1826. At the time, the sculptor was modelling the subject of Hylas and the nymphs. Haldimand left England to live in Switzerland and he wrote to Gibson asking to be released from the commitment to purchase the finished work. He compensated Gibson for what he had done up until that time and the sculptor subsequently found a purchaser in Robert Vernon. Quite when Vernon expressed an interest in acquiring the 'Hylas' is not known, but he would undoubtedly have heard about its existence from the many British artists who visited Gibson during their travels in Italy. J.M.W. Turner, for example, was in Rome in November 1828 and wrote to Francis Chantrey that Gibson's '"The Rape of Hylas" [was] very forward, though I doubt if it will be in time ... for the Exhibition [of 1829], though it is for England'. Turner went on to describe the piece as 'two standing figures of nymphs leaning, enamoured, over the youthful Hylas, with his pitcher'. A few years later, in September 1832, Gibson informed a friend in England that having had 'Hylas' in hand for five years, it was now almost completed (information kindly supplied by Edward Morris). Since the work was not actually exhibited until 1837 Gibson quite possibly continued working on it up until about summer 1836 at which time Vernon might have agreed to buy it.

When 'Hylas' was exhibited at the Academy, it attracted little critical attention partly because sculpture was not especially highly regarded in Britain and partly because the room in which sculpture was displayed, being dark and cramped, made it impossible to study the exhibits properly. The commentary which accompanied the engraving published in the *Art Journal* for 1854, noted that the subject of 'Hylas' had to be treated with especial care lest it should exceed the bounds of propriety'. It was felt that the artist had successfully avoided 'an offence', principally, one assumes, through the judicious use of drapery.

sure of a painter's real ability – suggests that he might have been influenced by Henry Richter's early experiments in painting under bright sunlight. This defect, with its echoes of primitivism, prompted adverse comments from the critics, though in fact the *Examiner* for 18 March 1827 felt that 'A Man Reading' was 'without the repetition of Mr Good's usual edgy light along the outline'.

Vernon bought the picture off the walls of the British Institution. He also acquired paintings by Briggs (no.9), Henry Howard (1769–1847; N00349) and David Roberts (1796–1864) from the same exhibition, but the Good, as far as one can establish, appears to have been the first 'modern life' subject Vernon bought. Its subject matter can be compared with Wilkie's 'News-mongers' (no.71).

and sensitive under-drawing for the principal figures and suggests that Goodall must have drawn directly onto the canvas from studio models.

The painting was well received at the time of its exhibition, not only for its handling but also for its sentiment. However, the *Art-Union* for June 1842 rightly felt that the girl was a 'repetition'. Because there was a restricted supply of models in London at this time such repetitions were a common failing among artists. Vernon bought the picture for 100 guineas. Five years later he acquired another, larger, canvas by Goodall – 'A Village Holiday' of 1847 (N00450) – for 500 guineas.

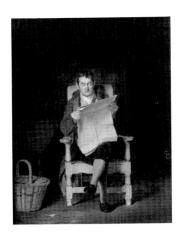

THOMAS SWORD GOOD
1789–1872

30 A Man Reading exh.1827
Oil on mahogany panel 24.1 × 19
(9½ × 7½)
Exh: BI 1827 (238)
Copy: B. Wilkinson
Engr: C.W. Sharpe, *Art Journal*, 1852,
opp. p.94
N00378

Good was born in Berwick-upon-Tweed and was apprenticed as a housepainter to his father. He lived in Berwick for almost his entire career, first exhibiting in Edinburgh in 1815 and then in London, at the Royal Academy, in 1820.

He specialised in small, highly finished, 'cabinet' pictures, often depicting one or two figures, which were essentially portraits laced with anecdotal detail. The pictures he exhibited in London are notable for the way in which the figures are posed under strong daylight effects. This unconventional omission of half-lights and half-shades – the successful capturing of which was at this time regarded as a mea-

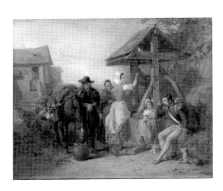

FREDERICK GOODALL 1822–1904

31 The Tired Soldier Resting at a Roadside Well 1842
Oil on canvas 71 × 91.4 (27¹⁵⁄₁₆ × 36⅛)
Inscr: 'F. Goodall. |1842' bottom left
Exh: RA 1842 (72)
Copy: W. Goodall
Engr: F. Croll, *Art Journal*, 1852,
opp. p.296
N00451

Goodall first went to France in 1838 having been recommended to visit Normandy by the engineer I.K. Brunel. He returned there in 1839 and 1840 and soon after established his reputation as an artist solely on the basis of the French subjects he exhibited. In 1841 he went to Brittany, staying on the Mont St Michel as well as in the town of Fougères. The sketches, particularly costume studies, he made then must have inspired 'The Tired Soldier Resting at a Roadside Well': the girl at the well is wearing characteristic Breton dress. An examination of the picture under infra-red light has revealed careful

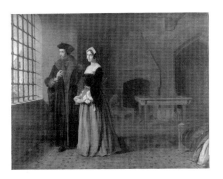

JOHN ROGERS HERBERT
1810–1890

32 Sir Thomas More and his Daughter* 1844
Oil on canvas 86.2 × 112 (34 × 44⅛)
Inscr: 'I.R.HERBERT | 1844' bottom right; and 'I R HERBERT' on the hem of More's gown
Exh: RA 1844 (364)
Copy: [unknown]
Engr: J. Outrim, *Art Journal*, 1850,
opp. p.136
N00425

This picture illustrates an episode from the life of the Roman Catholic martyr, Sir Thomas More (b.1478). More was imprisoned in the Tower of London and charged with treason for not acknowledging Henry VIII as the supreme head of the Church. He was beheaded on Tower Hill on 6 July 1535. While he was in the Tower, More was visited by his daughter Margaret Roper: looking out of his cell window he saw a group of monks being led away for execution because they had refused to take the oath of supremacy. A label on the back of this picture, written by Herbert, quotes from the relevant portion of the biography of More which his son-in-law William Roper had pub-

lished in 1626. It tells of that moment when More, filled

> with desyre to bear them company, said unto his daughter … looke Megge, dost thou not see that these blessed fathers be now going as cherefully to theyr deaths, as bridegrooms to theyr marriage by which thou mayest see (myne owne good daughtr) what a great difference there is between such as have spent all thyr dayes in a religious hard and penitential life and such as in this world like wretches (*as thy poore Father here hath done*) consumed all theyr tyme in pleasure and ease.

Herbert became a convert to Roman Catholicism in 1836 and thereafter, according to his obituary in the *Magazine of Art*, 'threw all his energy into religion, and looked upon art as a missionary, not as a substantive aim'. He held that the subject of a picture "to the glory of God" was of far greater importance than the execution'. Herbert's Catholic zeal mirrors the intense Anglo-Catholicism of his contemporary, the painter William Dyce (1806–64) who, at just about the time of Herbert's conversion, had also set out to imbue his art with Christian feeling. Herbert, in converting to Catholicism, was almost certainly influenced by the debate (and the conflicts which it aroused within the Anglican church) about belief and liturgy which the High Church Tractarian (Oxford) movement had sparked-off during the 1830s. One of Herbert's close friends was the Gothic revival architect A.W. Pugin (1812–52); he had become a Catholic convert, just before Herbert, in 1835, and this might also have swayed Herbert.

Herbert's religious certainty (like Dyce's and Pugin's) gave his work a sincerity of purpose which was unusual in British art of this period. His rigorous draughtsmanship and the studied severity of his manner of depicting figures looked back to medieval prototypes and anticipates some aspects of Pre-Raphaelitism. Some of the antagonism which his work provoked – as for example in 1845 when he was described as 'aping the shortcomings of a less-instructed century' – also anticipates the treatment meted out to the Pre-Raphaelites in 1849 and 1850. Herbert, who in 1845 wrote (of current British art) 'Thank God the age of splash dash is nearly over', later became quite close to the Pre-Raphaelites, who identified him as an ally and 'pretty safe'.

According to the artist, 'Sir Thomas More and his Daughter' was painted over a nine day period immediately before the sending-in day for the Academy exhibition of 1844; it was finished off during the two days it hung in the exhibition room before the public were admitted. This extraordinary situation, not dissimilar to one in which Landseer found himself in 1845 (see no.42), came about because of a wager between Herbert and S.C. Hall, editor of the *Art Journal*, who had refused to believe that Herbert could produce a picture for exhibition in such a short time. Although he lost the bet, Hall neglected to honour it. (Information from letters of J.R. Herbert in the Ulster Museum, Belfast, kindly supplied by Martyn Anglesea.)

This oil was executed at great speed. However, the fact that it depicts an episode from English history, and a powerfully moralising one at that, suggests that it had its roots in the competition for fresco designs for the new Palace of Westminster which took place in 1843. To ensure that the faces of More and his daughter were accurate likenesses Herbert must have studied contemporaneous portraits – most probably through the medium of engravings. More's features are clearly modelled on a devotional portrait, now known through a painting by an unknown seventeenth or eighteenth-century artist, which shows him bearded and holding a crucifix as he prepared for death. Margaret Roper's likeness is based on a miniature of *c*.1536–40 by Hans Holbein the Younger which is now in the Metropolitan Museum, New York.

Vernon purchased 'Sir Thomas More and his Daughter' at the private view of the Royal Academy. In 1845 Herbert painted a small copy of the picture for the use of an engraver. He spent three weeks completing it and eventually sold it to the Belfast patron Francis McCracken for 100 guineas.

The frame for this painting was designed by Herbert. It is decorated with a diaper pattern which includes a floral device, the centre of which is touched in with a spot of crimson paint. Tudor in inspiration, the design sets out to complement the subject matter of the picture. This union of fine and decorative arts became a feature of Pre-Raphaelite paintings.

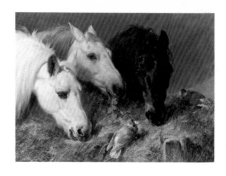

JOHN FREDERICK HERRING
1795–1865

33 The Frugal Meal exh. 1847
Oil on canvas 54.6 × 74.9 (21½ × 29½)
Exh: BI 1847 (259)
Copy: [unknown]
Engr: E. Hacker, *Art Journal*, 1850, p.16
N00452

Herring, a self-taught artist, is best known as a painter of race-horses. Between 1815 and 1849 he painted many of the winners of the St Leger, the Derby and the Oaks, as well as numerous other equestrian portraits. He was also a prolific painter of pictures in which working horses and other farm animals were the principal subjects. 'The Frugal Meal' was one of a number of stable scenes – which have their roots in Edwin Landseer's treatment of the same theme – in which several horses are shown at a manger. The *Art-Union*, reviewing the British Institution exhibition, stated that it was 'painted in a manner superior to anything of the kind we have ever seen … [the result of] the closest observation of Nature'. Vernon, described in the *Athenaeum* at the time as the 'Maecenas of Modern Art', bought the picture from the exhibition for 60 guineas.

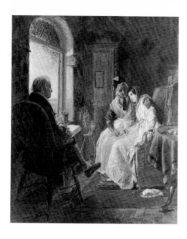

JOHN CALLCOTT HORSLEY
1817–1903

34 The Pride of the Village 1839
Oil on mahogany panel 76.2 × 62.2
(30 × 24½)
Inscr: 'JCH/1839' on sampler on wall
Exh: RA 1839 (58)
Copy: B. Wilkinson
Engr: G.A. Perrian, *Art Journal*, 1851,
opp. p.325
N00446

When this picture was exhibited at the
Royal Academy in 1839 the following
quotation from Washington Irving's short
story 'The Pride of the Village' was print-
ed in the catalogue.

A tear trembled in her soft blue eye. –
Was she thinking of her faithless lover? –
Or were her thoughts wandering to that
distant churchyard into whose bosom
she might soon be gathered?

Irving (1783–1859) was an American
author. 'The Pride of the Village', written
in 1819, was one of a number of short
stories originally produced for his home
market during his first visit to England
between 1815–20. They were collected
and published in London in 1820 under
the title of *The Sketch Book of Geoffrey
Crayon, Gent*. Irving's graceful prose, his
fine sense of pathos and gently moralising
sentiments met with great public approval.
His antiquarian's eye for old English
customs influenced the art of his close
friend C.R. Leslie (see nos.45–6) and thus
played an important part in the direction
which historical genre painting took in
England.

 Irving's story told of an only daughter,
'the pride of the village' who, as the May
Queen, had caught the attention of a
young army officer. When his regiment
was sent abroad, their courtship came to
an abrupt end: the young man proposed
that the girl join him, but not as his wife.

The idea so shocked the innocent villager
that she fled from the man whom she now
saw only as a faithless lover. She gradually
pined away in her parent's cottage. Hors-
ley depicts that moment just before the
repentant soldier, to whom the girl had
written a farewell letter, rushes back and
throws himself at her feet: 'she looked
down upon him with a smile of unutter-
able tenderness, – and closed her eyes
forever!' The artist enlarges the narrative
by including a number of objects – the
symbolism of which is easily read: a caged
bird, an unused spinning wheel, a small
spray of flowers lying on the rug all allude
to the girl's desolate state; through the
window can be seen the maypole on the
green where the tragic story began.

 'The Pride of the Village', Horsley's
first Academy exhibit, was bought by
Vernon for £45 before Horsley sent it to
the Royal Academy. The picture had been
seen earlier by Sir David Wilkie (see
nos.71–4) who had then spoken to Vernon
about it. According to Horsley, Vernon
paid £5 less than the asking price because
he did not want to pay extra for the frame
into which the artist had put the picture.

GEORGE JONES 1786–1869

35 Battle of Borodino exh.1829
Oil on canvas 121.9 × 213.4 (48 × 84)
Exh: RA 1829 (257)
Copy: [unknown]
Engr: J.B. Allen, *Art Journal*, 1850,
opp. p.308
N00391

The Battle of Borodino took place just
outside Moscow on 7 September 1812 and
was the culminating action of the cam-
paign which took Napoleon into the Rus-
sian capital on 14 September. The French
Emperor was to remain in Moscow for
only a month before retreating from Rus-
sia through the winter snows. In 'Battle of
Borodino', Napoleon can be seen in the
right foreground, standing next to his
charger 'Marengo', watching his army
attack the Russians under their leader
Kutuzov. Marshal Murat, commander of
the French cavalry, is on the left.

According to Vernon's 'Accounts of
Pictures' book (Jenkyns 11.3), the picture
was painted for the Hon. Edward Petre
and subsequently purchased by Vernon at
Christie's.

 Jones had been a soldier and was in the
allied Army of Occupation in Paris after
Waterloo. One result of his first-hand
experience of active service was a large
picture 'The Battle of Waterloo' (Royal
Military Hospital, Chelsea) the original
sketch for which was presented to Vernon
by Jones. Jones based that picture on a
visit to the battlefield and on accounts
given to him by eyewitnesses, though he
did not visit Borodino.

GEORGE JONES

36 Utrecht exh.1829
Oil on mahogany panel 91.4 × 71.1
(36 × 28)
Exh: BI 1829 (160)
Copy: E. Challis
Engr: E. Challis, *Art Journal*, 1853,
opp. p.214
N00392

George Jones travelled to Holland and
Germany during the summer of 1825
when he visited Haarlem, Utrecht and
then along the Rhine to Cleve, Düs-
seldorf, Andernach and Mainz, reaching
Wiesbaden by 1 September and returning
home via Aachen (Aix-la-Chapelle). His
friend Turner covered some of the same
ground at exactly the same time – a prolific
record of his trip is found in the *Holland*
and *Holland, Meuse and Cologne* sketch-
books (TB CCXIV, TB CCXV) – but there
is no evidence that the two men actually
met during their travels.

 The chalk drawing on blue paper (Ash-
molean Museum, Oxford) which formed
the basis for this painting is dated 14

August and also inscribed 'Oude Gracht' a reference to one of the two canals which pass through Utrecht and which can be seen in the foreground (information supplied by Ian Warrell). The view shows the tower of the Gothic cathedral of St Martin, with the spire of St Pieterskirk beyond, as seen from the Maartensbrug which crosses the Oude Gracht. Just out of sight, to the left, is the fishmarket.

The first product of Jones's 1825 trip was an oil painting entitled 'Utrecht', the same size as this 1829 picture, which he exhibited at the British Institution in 1827 (127; whereabouts unknown). This was probably a view of the cathedral from the Niewe Gracht taken from a drawing also made on 14 August (Ashmolean Museum).

Turner's Continental tours undoubtedly provided Jones with a model for his own trips abroad. The influence of Turner can also be seen in this painting both in the way Jones exaggerates architectural motifs to achieve grandeur of effect and also in his successful use of delicately scumbled pearly tints to achieve a subtle sense of aerial perspective. According to the *Literary Gazette* for 14 March 1829 'Utrecht' was bought by Vernon at the British Institution, while Vernon's 'Accounts of Pictures' book notes that the picture was painted for him.

GEORGE LANCE 1802–1864

37 **Fruit ('The Autumn Gift')** 1834
Oil on mahogany panel 46 × 52.1 (18⅛ × 20½)
Inscr: 'GL (monogram) | 1834'
Exh: ?BI 1834 (360)
Copy: Miss Sharpe
Engr: J.C. Armitage, *Art Journal*, 1854, opp. p.270
N00441

Lance, like Edwin Landseer (see nos.40–2) and Charles Eastlake (see nos.22–3), started his artistic studies under the history painter Benjamin Robert Haydon (1786–1846), joining his 'school' in about 1816 and working under him for about seven years. For some period, from 1820, he was also a student in the Royal Academy Schools and in 1822 he assisted Haydon with his large painting 'The Raising of Lazarus'.

According to Lance's own account, his first still life was commenced as an exercise in colouring and handling, preparatory to embarking on a subject taken from the *Iliad*. The exercise consisted of painting, in oil, a subject from nature: Lance described it as a group of fruit and vegetables. This work was bought by Haydon's patron Sir George Beaumont and Lance subsequently received commissions for similar works from the Earl of Shaftsbury and the Duke of Bedford. Lance thereafter devoted himself almost exclusively to still-life painting or figure subjects in which fruit and silver and gold table ware featured prominently.

Lance's pictures, such as 'Fruit ("The Autumn Gift")', are clearly modelled on seventeenth and eighteenth century Dutch and Flemish still lifes which he could have seen in the old master loan exhibition at the British Gallery from about the time he joined Haydon. Interestingly, both Lance and Landseer turned to such highly realistic and highly finished still life and 'larder' subjects as models for their own artistic development more or less simultaneously. Certainly, in Landseer's case, it was the depictions of dead animals by Franz Snyders (1579–1657) which inspired him; most probably in Lance's case, it was the fruit and flower paintings of Jan van Huysum (1682–1749) and Jan van Os (1744–1808) among others. This interest in an art which was concerned above all with the truthful representation of natural objects, and Lance's and Landseer's ability to emulate it so successfully, undoubtedly owed something to Haydon's obsessive emphasis on the need for an artist to study the human form through dissection and then record it in écorché drawings. Lance is reported in the *Art Union* for November 1847 as having gone through three courses of dissecting.

Vernon was one of Lance's earliest patrons, buying a fruit piece as early as 1826 from the exhibition of the Society of British Artists; that picture, which was not included in the Vernon Gift, was one of Vernon's first purchases from a living artist.

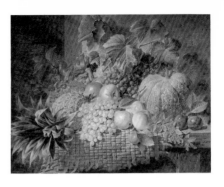

GEORGE LANCE

38 **Fruit ('The Summer Gift')**
exh.1848
Oil on canvas 71.1 × 91.4 (28 × 36)
Inscr: 'G.Lance | 1848'
Exh: BI 1848 (38)
Copy: Miss Sharpe
Engr: C.H. Jeens, *Art Journal*, 1854, opp. p.300
N00443

This work was probably commissioned by Vernon in 1847. When it was exhibited at the British Institution it was untitled but described in the catalogue as 'Painted for Robert Vernon, Esq., to form part of the extensive collection given by him to the nation'. Lance also included in the catalogue a quotation, slightly adapted from a line spoken by Polonius in Act II, scene 2 of *Hamlet*, 'The Fruit to this great Feast'. In the context of Shakespeare, the 'Fruit' was the revelation Polonius would make to the king and queen about Hamlet's madness after the 'Feast' of news brought to them by the Norwegian ambassadors. Lance used the quotation as a witty allusion to the fact that his painting was a late addition to the feast of British art which Vernon had given to the nation in December 1847. In 1840 B.R. Haydon had, with typical hyperpole, praised Lance as 'the first fruit painter in Europe'; Vernon's inclusion of this picture in his gift certainly confirmed Lance's position as the leading British painter of still life and as the artist who had given this particular art form a status which it had not hitherto enjoyed in the national school. The *Art Union* for March 1848 commented of the work that 'the very motes are painted with a degree of truth absolutely wonderful'.

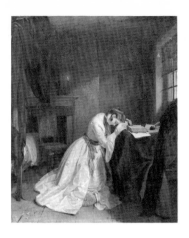

CHARLES LANDSEER 1799–1879

**39 Clarissa Harlowe in the Prison
Room of the Sheriff's Office**
exh.1833
Oil on canvas 61 × 50.8 (24 × 20)
Exh: SBA 1833–4 (136)
Copy: C.H. Woodman
Eng: G.A. Perriam, *Art Journal*, 1850,
opp. p.186
N00408

This is an illustration of a scene described
in Letter LXXXV of Samuel Richardson's
epistolary novel *The History of Clarissa
Harlowe* which was first published in seven
volumes in 1747–8. The novel was de-
scribed by the author as demonstrating
'the Distresses that may attend Miscon-
duct both of Parents and Children in
relation to marriage'.

The heroine of the novel is Clarissa, a
woman of great virtue and integrity. A
conspiracy within her family leads to her
being wooed by the villainous rake Robert
Lovelace. Clarissa, who resists Lovelace's
desire to live with him out of wedlock, is
raped by him. Her continuing denial of
him after this act transforms Clarissa into
a dramatic and tragic heroine who domi-
nates the closing scenes of the book. At
one point she is imprisoned for debt;
Landseer depicts that moment when she is
discovered, at dawn, by John Belford who
describes the scene in a letter to his friend
Lovelace. Landseer was scrupulously
faithful to Richardson's text:

a den … with broken walls … the ceil-
ing smoked with initials … A bed at one
corner, with coarse curtains … a cover-
lid [with] the corners tied up … that the
rents in it might go no farther. The
windows dark and double-barred; the
tops boarded up … On the mantelpiece
was an iron shove-up candlestick, with a
lighted candle in it … Near that, on the
same shelf, was on old looking glass,

cracked through the middle, breaking
out into a thousand points … [Clarissa]
was kneeling in a corner of the room,
near the dismal window, against the
table, on an old bolster … her arms
crossed upon the table, the fore finger
of her right hand in her Bible … Paper,
pens, ink, lay by her book on the table.
Her dress was white damask … her
charming hair, in natural ringlets …
irregularly shading one side of the
loveliest neck in the world … Her face
… was reclined when we entered, upon
her crossed arms …

Just as Richardson's novel immediately
recalls the contemporaneous 'modern
moral subjects' of the painter William
Hogarth, so too Landseer's painting
seems to look back to that artist's work.
This is particularly evident in its detailed
depiction of an eighteenth century interior
and the accessories, such as the broken
mirror and the guttering candle, which
respectively symbolise Clarissa's loss of
virginity and her tenuous hold on life; she
also wears a white dress, symbolising her
virtue. On the whole, nineteenth-century
critics upheld the eighteenth-century view
of *Clarissa Harlowe* as a moral novel and of
the heroine as a sweet and saintly female
in a corrupt world. The critic of the *Liter-
ary Gazette* for 19 October 1833 thought
Landseer's painting was the best in the
exhibition and favourably compared its
'technicalities of execution, colouring, and
chiaroscuro' not with Hogarth but with
the work of the seventeenth-century
Dutch master Gabriel Metsu (1629–67).
Indeed, 'Clarissa' could almost be a pair
with Vermeer's 'Metsu' (fig.4 on p.12).

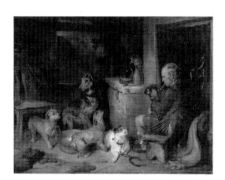

SIR EDWIN LANDSEER 1803–1874

40 Highland Music ?1829
Oil on mahogany panel 46.8 × 61
(18⁷⁄₁₆ × 24)
Exh: BI 1830 (60)
Copy: [unknown]

Engr: H.S. Beckwith, *Art Journal*,
1849, opp. p.6
N00411

In a note for Vernon's 'Accounts of Pic-
tures' book (Jenkyns 11.3) Landseer re-
corded that 'Highland Music' was
'Painted from nature, Glen Feshie 183–'.
However, since Landseer exhibited a
picture of this title at the British Insti-
tution in 1830 and the *Literary Gazette* for
24 April 1830 noted that it was bought by
Vernon, it seems quite clear that the work
must date from an earlier visit to Scotland
– possibly one made in the autumn of
1829.

Landseer was a regular visitor to the
Highland retreat – consisting of a series of
wooden and turf huts – which the Duch-
ess of Bedford had built at Glenfeshie,
near Braemar. 'Highland Music' was one
of the first of a group of Scottish subjects,
all depicting everyday life among the
Highlanders, which Landseer produced
during the late 1820s and early 1830s. His
interest in such 'low-life' scenes, very
different to the deer-stalking subjects
which caught his eye in the years immedi-
ately following his first visit to Scotland in
1824, might have been sparked-off by a
search for suitable material for illus-
trations to the Waverley Edition of Walter
Scott's novels which appeared from 1829
onwards: Landseer was working on these
commissions from about 1828. These
Highland pictures, most of them showing
interiors, are highly finished, with effects
of light, particularly on domestic utensils,
which recall Dutch seventeenth-century
paintings.

'Highland Music' was possibly con-
ceived as a pendant to 'The Stone Break-
er', which Landseer also exhibited at the
British Institution in 1830' (53; Victoria
and Albert Museum): it is a pairing in
which the rigours and humble pleasures of
Scottish peasant life are starkly contrasted.
The reviewer in the *Court Journal* for 6
February 1830, thought the title of 'High-
land Music' was 'facetious' and described
the work as 'half-a-dozen dogs howling to
the sound of their master's bagpipes – as if
they had never heard it before, and as if
the principal performers in such a concert
would be likely to continue it under such
accompaniments'.

Although Vernon at one time owned a
small painting by Landseer which had
been exhibited in 1824 ('Puppy and Frog',
Harris Art Gallery, Preston) it is not
known when he acquired it. Quite pos-
sibly, then, 'Highland Music' was the first
work by Landseer to enter Vernon's col-
lection.

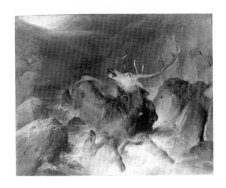

SIR EDWIN LANDSEER

**41 Deer and Deer Hounds in a
Mountain Torrent ('The Hunted
Stag')** ?1832
Oil on mahogany panel 68.6 × 91
(27⅝ × 35⅞)
Exh: RA 1833 (268)
Copy: W. Fisk
Engr: J. Cousen, *Art Journal*, 1851,
opp. p.4
N00412

When a stag is pursued by deer hounds, it
will find the best possible place from
which to mount a defence and it will resist
the hounds to the bitter end. Its instinct
will lead it to water: in deep rivers or
streams, the stag's long legs give it an
advantage over the dogs, who soon lose
their foothold; furthermore, the stag takes
up a position where deeper water or rocks
make it difficult for the hounds to ap-
proach it from the rear. Thus at bay, and
by sweeping its antlers against the dogs,
the stag can injure and exhaust its assail-
ants and leave them to the mercy of the
currents and the cold. The moment is one
of the most dramatic a deer-stalker can
experience: his dogs are in danger and he
awaits the opportunity of finally killing the
stag when they are out of the line of fire.

Landseer depicts such a scene – at the
end of a day's stalking. It was one which,
as a keen deer-stalker, he must have often
witnessed. Already wounded in the chase
and clearly exhausted, the stag has fought
off two hounds. Landseer views the noble
animal through the unflinching eye of the
marksman: only with his bullet can he
claim the prize and save the dogs. True to
his early training as a history painter,
Landseer has the principal light falling on
the upturned head of the stag and he
anticipates, rather than shows, the climax
of the action.

In Vernon's 'Accounts of Pictures' book
(Jenkyns II.3), Landseer described this
picture as 'Hart and deer hounds in
mountain torrent. Painted in the High-
lands 183–', – which might date it to one of

the artist's Scottish trips during the period
1830–2. The picture was possibly bought
by Vernon at the Royal Academy exhibi-
tion of 1833; if this was the case, then
(presumably at Landseer's request) he
allowed it to be re-exhibited at the British
Institution in early 1834. At the time of the
Academy exhibition, the *Athenaeum* for 25
May declared that the picture 'is truth
itself; truth exalted by feeling and skill'.

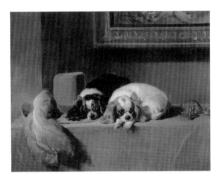

SIR EDWIN LANDSEER

**42 King Charles Spaniels ('The
Cavalier's Pets')** 1845
Oil on canvas 70 × 90.2 (27½ × 35½)
Exh: BI 1845 (134)
Copy: W. Fisk
Engr: John Outrim, *Art Journal*, 1852,
opp. p.5
N00409

This picture is probably the most cele-
brated example of Landseer's brilliant
powers as a painter. The history of the
commission which gave rise to it, with the
artist's struggle to resolve its design before
finally abandoning it to produce this *tour
de force* of brushwork and canine charac-
terisation, and then his reconciliation with
his aggrieved patron conforms in many
ways to the popular view of the romantic
artist at work. The whole episode has
frequently been quoted as an instance of
just how prodigious were Landseer's
talents.

In about 1837–8 Vernon, who was
particularly fond of spaniels (see no.54)
commissioned Landseer to paint a picture
that included portraits of his pets. It was
agreed that it would take the form of a
portrait of Ellen Power, a society beauty
who was the niece of Landseer's friend
the Countess of Blessington, who would
be accompanied by two of Vernon's spa-
niels. Vernon paid Landseer £150 in ad-
vance.

From the outset, the artist experienced

difficulties. However, the 'Lady and the
Spaniels' as it was by now known, must
have been more or less finished by the
summer of 1842 when an engraving of it
was published – apparently without Ver-
non's permission. Vernon's displeasure at
this turn of events appears to have forced
Landseer into taking up his brushes again:
by the end of the year the canvas required
only about two hours work 'to make it
perfect'. Nonetheless, only slight improve-
ments had been put in hand by February
1843, which Landseer excused by saying,
quite truthfully, that he had been much
engaged in work for Queen Victoria and
Prince Albert. Landseer seems to have
made a determined effort to make the
picture ready for the 1844 Academy exhi-
bition; indeed a further engraving after the
work, when the original was described as
'in the collection of Robert Vernon', was
advertised in the *Art-Union* for April, just
before the exhibition opened. This par-
ticular work was, in fact, a new painting on
top of the old one and was seen by Vernon;
and then, just before the exhibition
opened, Landseer scraped out the figure
of Miss Power and made the canvas un-
exhibitable.

Further delays ensued when Landseer
was injured by a fall from his horse during
the summer of 1844; by mid-December,
Vernon's agent had to write to the artist
complaining that Vernon 'considers him-
self both ill-treated and neglected' in the
matter. Landseer was galvanised by this.
Not only did he write to his own man-of-
business, Jacob Bell, telling him to inform
Vernon that his 'motive in keeping the
picture this long is simply to make it more
worthy of his collection', but he also set
out to finish the picture in time for the
British Institution exhibition of February
1845.

On 9 January, Bell was asked by Land-
seer to seek Vernon's permission for him
to send the 'Lady and Spaniels' to the
Institution. Because Vernon was confined
to bed at Ardington, this permission did
not come in time for Landseer to meet the
sending-in deadline of 14 January, though
he had taken the precaution of sending
along an empty frame so that space for the
picture would be reserved on the walls.

Vernon's support for the picture did not
in the end, outweigh Landseer's own
doubts about the 'Lady and the Spaniels'.
While Vernon by 25 January was labouring
under the impression that his picture was
finally in the exhibition room, Landseer
had set out to create an entirely new paint-
ing. This was the 'King Charles Spaniels',
painted sometime between 14 January and
3 February when it was pronounced by

Landseer as 'nearly dry enough to move'.

In a letter to S.C. Hall, editor of the *Art-Union*, Vernon claimed that Landseer painted the 'Spaniels' in two days. To produce it, he undoubtedly copied the dogs, portrayed from life, in the 'Lady and Spaniels' and Vernon's claim is borne out by the thin application of the paint and, more particularly, the assured, impulsive brushstrokes used on the feather.

THEODORE LANE 1800–1828

43 Enthusiast ('The Gouty Angler')
1828
Oil on mahogany panel 42.5 × 56.5
(16¾ × 22½)
Inscr: 'Theodore Lane 1828' on band
of tub
Exh: SBA 1828 (32)
Copy: C.H. Woodman
Engr: M. Beckwith, *Art Journal*, 1850,
opp. p.372
N00440

Nineteenth-century British genre painting of the type which can be loosely grouped under the heading of 'scenes from familiar life' had a distinct and flourishing offshoot which consisted of comic subjects. These works were quite distinct from the subtle illustrations to humorous or picaresque literature such as C.R. Leslie's 'Uncle Toby and Widow Wadman' (no.45) which formed a genuinely original contribution to the growing reputation which British Art enjoyed in Europe at this period.

Usually small in scale, or 'cabinet sized' and in their handling looking back to Hogarth or earlier Dutch and Flemish masters, these comic works tended to depict instances of everyday domestic discomfort, drollery, eccentricity, or 'ruling passions'. Quite conceivably these paintings were based on real-life incidents but they were more likely to be products of the imagination. Many of them were quite simply vulgar or cruel: this sub-genre was at its worst in so-called 'monkeyana'

subjects where monkeys were depicted acting out aspects of human nature. By the middle of the century the continuing taste for such pictures was a catalyst in the Pre-Raphaelite's search for serious subject matter.

A number of artists active during the 1820s specialised in this minor art form; its popularity was partly explained by the fact that its humour, as a manifestation of a national characteristic, made it worthy of the attention of the new breed of collectors of British art. Several of these artists, now all forgotten, were at one time represented in Robert Vernon's collection: Edmund Bristowe (1787–1876); Henry Pidding (1797–1864); Henry Liverseege (1803–32) and M.W. Sharp (d.1840). Lane's 'Enthusiast' is a good example of his taste for comic art. It shows a gout-stricken angler confined to his sitting room but pursuing his hobby against all the odds. His medicines are in the lovingly rendered bottles on the table, while his 'bible', Isaak Walton's classic discourse on fishing, *The Compleat Angler*, which first appeared in 1653, lies open on the floor.

Lane trained as an engraver. His sense of humour and passion for the theatre led him in 1822 to produce six designs inspired by the life of an actor. In 1824 these, along with other designs, appeared as illustrations to *The Life of Actor* written by the fashionable chronicler of London high-and-low-life, Pierce Egan. The work made Lane's name. His graphic work and his eye for the humorous narrative discernable in London's fashionable goings-on, owes a debt to George Cruikshank (1792–1878) a draughtsman and comic illustrator of real genius whom Lane got to know and who, in turn, admired Lane's work.

According to Egan, who appended a *Memoir* of Lane to his poem 'The Show Folks' of 1831, the subject of the 'Enthusiast' was worked up with the help of suggestions from the painter Alexander Fraser and was also partly painted under his supervision. However, since Lane was a keen fisherman and his father, it is recorded, suffered from severe gout (as did Vernon), it seems likely that the initial idea for the picture was his.

Unfortunately, Lane's career came to an abrupt end at the very moment this picture was being exhibited. He fell through a skylight at the New Horse Bazaar in Gray's Inn Road on 21 May 1828 and was killed instantly. A subscription for the benefit of his widow and two children was raised, with an engraving of the 'Enthusiast' by Robert Graves being published for the same purpose. Graves

was paid 125 guineas for his work. A pendant to the 'Enthusiast', 'Mathematical Abstraction' was exhibited posthumously at the British Institution in 1829 (397).

FREDERICK RICHARD LEE
1799–1879

44 Sea Coast, Sunrise 1834
Oil on canvas 85.7 × 109.2 (33¼ × 43)
Inscr: 'Fredk. Richd. Lee | 1834'
bottom right
Exh: BI 1834 (75)
Copy: J.A. Sleape
Engr: E. Ratcliffe, *Art Journal*, 1851,
opp. p.316
N00419

Like George Jones (nos.35–6), Lee served in the army and practised as an amateur before becoming a professional painter. He enrolled as a student in the Royal Academy Schools in 1818 and first exhibited in London at the British Institution in 1822. His amateur origins betrayed themselves in his attitude to his art for, as his friend and occasional collaborator T.S. Cooper noted, 'he was fond of his profession to a certain extent, but more as a pastime than as a business, and he always gave … the impression that he considered the profession beneath him'. John Constable described him as a 'fool'. However he was extremely proficient and enjoyed considerable success as a landscape painter. Vernon purchased six works by him between the late 1820s and the mid-1830s; only one other work by him, 'Cover Side', painted with Sir Edwin Landseer, was in the Vernon Gift (N00418).

One of Lee's most important patrons was William Wells (1768–1847) a ship-builder, at whose house in Redleaf, Kent, Lee often stayed, and 'Sea Coast, Sunrise' represents a view on the Kent coast. The critic of the *Times* for 5 February 1834 described it as 'a well chosen subject, executed with breadth and effect'.

CHARLES ROBERT LESLIE
1794–1859

45 A Scene from Tristram Shandy ('Uncle Toby and Widow Wadman') 1829–30

Oil on canvas 81.3 × 55.9 (32 × 22)
Exh: RA 1831 (238)
Copy: R. Woodman, Sr
Engr: L. Stocks, *Art Journal*, 1853,
opp. p.33
N00403

An illustration from chapter 24 of volume 8 of Lawrence Sterne's humourous, whimsical and discursive novel, *The Life and Opinions of Tristram Shandy, Gentleman*, published 1760–7.

Tristram's uncle, Toby, is an old soldier who was injured in the groin at the Siege of Namur. His hobby is the scientific study and re-enactment in miniature, in his garden, of other historic sieges. During his 'campaigns', masterminded from his sentry box, his neighbour widow Wadman lays siege to his heart. In Sterne's words 'the first moment [she] saw him, she felt something stirring within her in his favour' and she set out upon an 'endeavour to blow my Uncle Toby up in the very sentry box itself'. Preliminary skirmishes between the two took place over Toby's maps as he explained his strategies – but the widow failed to catch his eye. In a final push she hopes to take Toby by storm, but with the 'siege' of Dunkirk over and the map redundant, she has to resort to complaining that she has a speck of dust in her left eye. Toby looks, sees nothing, but this eye 'full of gentle salutations – and soft responses', seduces him; as the ash falls out of his pipe, he falls in love.

Leslie first treated this subject from Sterne in about 1827–8 when he painted a small watercolour for an album created by Mrs George Haldimand (sold Christie's, 18 March 1980). He started reworking the idea, using the same composition but on a larger scale, in autumn 1829. For Leslie, who was a master at handling gesture and expression on a small scale (as in 'Sancho Panza in the Apartment of the Duchess', no.46), the decision to paint larger figures than usual, caused him difficulties. According to the writer Washington Irving, the picture was half finished by December 1829, and Leslie's close friend John Constable, who was on the Hanging Committee for the 1830 Academy exhibition, wanted to see the picture in the show. However, Leslie was still working on it in July 1830, the characterisation of Uncle Toby having been criticised by both Constable and Jack Bannister the actor. Bannister wanted Toby to be 'the rough but quiet soldier, not the polished physician'; his biographer recorded that Bannister sat for the figure of Toby on 7 August 1830. The difficulties Leslie experienced in getting this figure right are evident from the areas of cracked paint.

'Uncle Toby' proved to be one of Leslie's most popular and enduring works, no doubt because in this illustration he is almost entirely innocent of the kind of *double entendre* which peppers Sterne's novel. Vernon appears to have bought the picture in 1830 – the first work by Leslie that he acquired. A print by the American engraver M.J. Danforth was published in 1833 and Leslie painted versions of the subject for two other important patrons, Jacob Bell (1842; now Tate Gallery, N00613) and John Sheepshanks (by 1855; Victoria and Albert Museum).

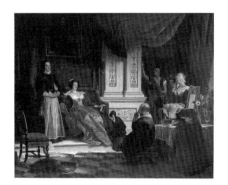

CHARLES ROBERT LESLIE

46 Sancho Panza in the Apartment of the Duchess* 1843–4

Oil on canvas 121.3 × 151.2
(47¾ × 59½)
Exh: RA 1844 (351)
Copy: [unknown]
Engr: R. Staines, *Art Journal*, 1849,
opp. p.59
N00402

A repetition of a subject which Leslie had first painted for the 3rd Earl of Egremont and exhibited at the Royal Academy in 1824 (95). On that occasion the picture was accompanied by Sancho Panza's words to the duchess from chapter 23 of Part Two of Cervante's satirical romance *Don Quixote* (1605–15):

> First and foremost, I must tell you I look on my master Don Quixote, to be no better than a down right madman, though sometimes he will stumble on a parcel of sayings so quaint and so tightly put together, that the devil himself could not mend them; but in the main, I cannot beat it out of my noddle, but that he is as mad as a March-hare.

The 1824 picture (Petworth House), which for one reviewer at the time depicted 'the *Sancho*, and will remain the *stock* squire for a thousand years', soon became a classic among *genre* pictures through its popularity as an engraving. The first study for the work is in the Tate Gallery (N01796).

Leslie was possibly first approached by Vernon in 1842 to produce a reworking of his famous painting for inclusion in the nascent 'National Gallery of British Art'. In August of that year the artist wrote to the poet and collector Samuel Rogers asking for the loan of a small version of the 'Sancho' which he had sold him some years before. Leslie eventually had the painting in his studio by the summer of 1843, having in the meantime worked from the earlier engraving. Leslie, in his note about the picture for Vernon's 'Accounts of Pictures' book (Jenkyns II.3), stated that 'though resembling [the Petworth picture] in the attitudes & relative position of the figures [it] is greatly altered in its details, no part being copied from the first picture'. There are many differences between the two works, for example: the Petworth picture is smaller; the colours of the protagonists' costumes are different in both works and the chair on the left-hand side of the Vernon picture replaces a large oriental vase in the Petworth picture.

Leslie wrote in a letter to his sister Eliza that when Queen Victoria attended the private view of the Academy exhibition 'she told me she admired my picture of "Sancho and the Duchess"'.

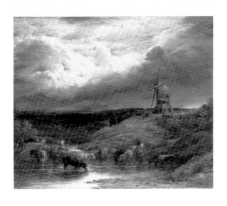

JOHN LINNELL 1792–1882

47 A Landscape ('The Windmill')
1844–5
Oil on canvas 37.8 × 45.1 (14⅞ × 17¾)
Exh: BI 1845 (369)
Copy: J.C. Bentley
Engr: J.C. Bentley, *Art Journal*, 1850,
opp. p.230
N00439

This is an 'ideal' landscape and not of any particular place and stems from, in Linnell's own words, the artist's 'vivid perception of those qualities in nature which most effect the mind with emotions of moral sympathy, sublimity and beauty'.

According to Linnell's Journal, he was working on 'A Landscape' in October 1844. The *Art-Union*, reviewing the British Institution exhibition wrote that 'A Landscape' was 'altogether full of that kind of truth that is not accessible to ordinary minds'. The picture was first recommended to Vernon by George Jones who had been to the British Institution to report on Landseer's 'King Charles Spaniels' (no.42). Jones, in a letter of 15 February, noted that the Linnell was 'shamefully hung tho' the best from his hand, but much too good for the understanding of the Connoisseurs' (Jenkyns II.1). Vernon clearly acted immediately, for when the artist visited the British Institution the same day he discovered Vernon had bought the picture for 50 guineas. Linnell painted another version of it, finishing the sketch for Vernon's work, for the dealer William Wethered in 1848.

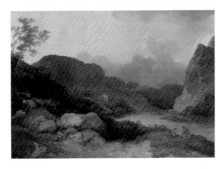

PHILIP JAMES DE
LOUTHERBOURG 1740–1812

48 Lake Scene, Evening 1792
Oil on canvas 43.8 × 61.5 (17½ × 24½)
Inscr: 'P I de Loutherbourg 1792'
bottom centre
Copy: T.A. Prior
Engr: W. Richardson, *Art Journal*,
1851, opp. p.232
N00316

Vernon bought this picture in 1837 as 'A View in Wales, near the head of a Lake … beautiful effect of Evening' but by the time it was first noted as part of his collection in the *Art Journal* for November 1847, it was described as 'a passage of lake scenery in Cumberland or Westmoreland' and then when it was engraved in 1851 it was entitled 'A Scene in Cumberland'. Loutherbourg toured the Lake District in 1783 and Wales in 1786 but this picture has not so far been identified with any specific location (assistance in this has been kindly given by Vicky Slowe). The extent to which it conforms to the notion of Picturesque topography, as laid down by William Gilpin, the apostle of the Picturesque movement, suggests that this work is a *capriccio* – an amalgam of various motifs which the artist recorded on these tours. Two of de Loutherbourg's paintings dated 1791 and 1793 fall into this category.

In his *Observations Relative Chiefly to Picturesque Beauty ... Particularly the Lakes of Cumberland and Westmoreland*, published in 1786, Gilpin noted how cows should be grouped together, standing and recumbent in opposition, and that cattle and sheep mixed 'very agreeably together'. This is precisely the convention de Loutherbourg adopts in his picture, just as he introduces other Gilpinesque devices such as a rough, broken foreground juxtaposed with smooth water, a ruined building in the middle distance and storm clouds gathering over the mountain tops. The figures in the lower right hand side of the picture are a soldier talking to a woman suckling her child; the soldier is, perhaps, saying a last farewell before he rejoins his regiment. In a departure from strict Picturesque formulae – Gilpin thought that soldiers were suitable additions to a wild landscape because they suggested the idea of 'ferocity', but only if they were in antique garb and not modern regimentals – de Loutherbourg reflects the militarised state of Britain at a time when Europe was engulfed in war with revolutionary France.

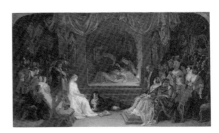

DANIEL MACLISE 1806–1870

49 The Play Scene in 'Hamlet'
exh.1842
Oil on canvas 152.5 × 274.2
(60 × 108)
Exh: RA 1842 (62)
Copy: F.R. Roffe
Engr: C. Rolls, *Art Journal*, 1854,
opp. p.214
N00422

At the beginning of Shakespeare's play *Hamlet*, Hamlet, Prince of Denmark, is told by his father's ghost that he was murdered by his brother Claudius, who then became king. The murder was perpetrated by poison being poured into the king's ear while he was asleep in his garden. Later in the play (Act III, scene 2), at Hamlet's instigation, some strolling actors put on a play in the hall of Elsinore Castle, in which the murder is re-enacted. When Claudius jumps up to stop the play, he exposes his guilt, and thereby confirms Hamlet's suspicions. This play within the play marks a turning point in the drama.

Maclise shows the moment just before Claudius rises. Hamlet lies on the floor at Ophelia's feet, watching for any sign of Claudius's guilt. He has the text of the play, *The Murder of Gonzago*, before him. Claudius looks away at the very moment the poisoning is acted out but his clenched hands betray his fear of discovery. The picture is filled with details which amplify the drama, though many of these are now partly obscured through darkening of the paint. Statues of 'Prayer' and 'Justice' flank the proscenium, while the biblical scenes of the 'Expulsion from the Garden of Eden' (on the left) and 'Cain Murder-

ing Abel' (on the far right) are depicted in wall tapestries. The critic of the *Athenaeum* for 7 May 1842 noted of Maclise's Shakespearean paintings generally that there is 'not a tendril on the tapestry – not a shadow on the floor, that has not its part in enhancing meaning or marking action'. A much admired *coup de théâtre* in *Hamlet* was Maclise's use of the shadow cast by the poisoner's hand to introduce a note of Gothic horror.

The picture was one of the most ambitious compositions attempted by Maclise and it clearly caused him some problems. At one point he decided to enlarge his original canvas by adding further strips of canvas, about 30 cm (12 in.) to the top, and right-hand and left-hand edges. The figure of Ophelia was described by *Blackwood's Magazine* for July 1842 as 'little better than a barmaid ... and we are at first sight reconciled to her drowning' and Maclise returned to correct her deficiencies in 1848. The *Art Journal* for 1 September 1848 reported that she had 'been entirely repainted, and is now exquisitely perfect in character'.

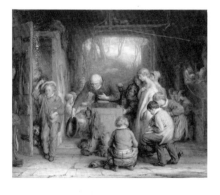

WILLIAM MULREADY 1786–1863

50 The Last In 1834–5
Oil on mahogany panel 62.2 × 76.2 (24½ × 30)
Inscr: 'WM 1835' (monogram) bottom left
Exh: RA 1835 (105)
Copy: J. Archer
Engr: J.T. Smyth, *Art Journal*, 1850, opp. p.76
N00393

Nineteenth-century painters frequently explored the theme of childhood. Within the Vernon collection children can be found as the principal subjects in works by William Collins (no.16), Henry Howard (N00349), Thomas Webster (N00426; N00427), David Wilkie (no.73) and W.F.

Witherington (N00421). For the most part artists of the period dwelt on the sentimental or picturesque possibilities which children and their activities provided, though Wilkie's 'The First Ear-Ring' (no.73), showing a young girl being painfully initiated into adulthood, clearly alludes to the difficulties of puberty and growing up.

Mulready consistently explored the motif of the child throughout his career – almost always with a serious moralising intent, touched by humour and irony, which clearly marked out childhood as a transitional state and a prelude to maturity and its tribulations. Sometimes figures of authority intrude on childish preoccupations, threatening or enforcing discipline over the unruly.

The schoolroom scene of 'The Last In' shows the master bowing with mock deference to the boy who has arrived late and is now fearful of his fate. The boy already in disgrace in the foreground is a reminder of what will happen to him, as is the birch lying at the foot of the desk. The pain and frustrations of learning are seen in the expressions of some of the other children in the room. For this painting, Mulready simplified a narrative scheme which he had originally worked out in detail in a preliminary chalk cartoon (T06501). In this figure, clearly someone with whom the guilty pupil has been playing, is seen among the trees in the distance. Within the schoolroom, a child leans over from the staircase on the right-hand side, signalling to the distant figure that his accomplice has arrived. Besides this cartoon several other preparatory sketches, including two small oil sketches, exist: four, in pen and ink, are in the Victoria and Albert Museum and two, in the same medium, are in the Whitworth Art Gallery, Manchester. Mulready was meticulous in his preparations for paintings, as well as in their execution. In his Account Book in the National Art Library at the Victoria and Albert Museum, he recorded in 1834 'Sep 26 Sk[etch] Cartoon Last in Fin-[ished] Tracing on Panel 31 Dec'; the same book records under 5 November 1835 payment of £420 for the work from Vernon.

When the picture was exhibited, the *Athenaeum* for 23 May 1835 described it as 'a school scene of ludicrous distress [which] represents a boy who has the double misfortune of being dull and dilatory' and went on to comment on how Mulready 'seems fond of subjects unwelcome to our feelings'. It was the first picture by Mulready to be acquired by Vernon.

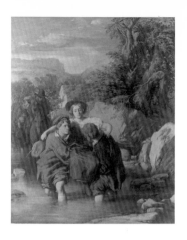

WILLIAM MULREADY

51 The Ford ('Crossing the Ford')
exh.1842
Oil on mahogany panel 60.8 × 50 (24 × 19¾)
Exh: RA 1842 (91)
Copy: J. Archer
Engr: L. Stocks, *Art Journal*, 1852, opp. p.158
N00395

Mulready's image of a group of people who have travelled over a rock-strewn landscape and are passing, or about to pass, through a ford, is a fine example of how the artist could endow a scene from familiar life with a more potent significance. The theme of crossing water is a common one in art and literature and its symbolism is obvious. Mulready has here exploited the idea of a rite of passage to the full: while the young girl, who is the main subject of the picture, is being borne across the stream by two youths, her glance tells us that at the same time she is making a momentous choice, as to which of them is most desirable. The old and the very young, excluded from this intense drama, follow in the distance. On the back of the panel on which this picture is painted is a rapidly drawn preliminary sketch for 'The First Voyage' which Mulready exhibited in 1833 (Bury Art Gallery). This deals with the same theme as 'The Ford' and shows a child in a tub being pushed and towed across a stream.

The *Art-Union* for May 1842 pointed out that 'the reading of this picture is ... simple' and added that 'it is a work of surpassing beauty, grace, and excellence – one of the most valuable paintings ever produced in England'. The critic for *Blackwood's Magazine* of the following July noted of the work that 'Mr Mulready has fallen into a reprehensible style of colouring', though curiously he failed to comment on the unusual extent to which

Mulready allowed the pencil underdrawing on the white ground of the panel to read as part of the finished painting. A pen and ink drawing for 'The Ford' is in the Huntington Art Gallery, San Marino; the chalk cartoon, exhibited at the Royal Academy in 1847 (966) is in a private collection.

Mulready's Account Book records that Vernon paid 600 guineas for the picture, in three instalments, the first on 29 October 1842.

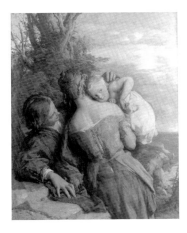

WILLIAM MULREADY

52 The Young Brother 1856–7
Oil on canvas 80.5 × 63.3 (31¾ × 24⅞)
Exh: RA 1857 (138)
Engr: R.C. Bell, *Art Journal*, 1862, opp. p.69
N00396

Although this picture was not completed and exhibited until 1857, the list of Vernon's collection prepared for the use of the Trustees of the National Gallery in 1847 noted that Mulready had been commissioned to produce a work for Vernon. It was a commission that clearly caused him some difficulties: he took an uncharacteristically long time before deciding on a subject and, when he did, it was a repetition, with variations, of an earlier work – the 'Brother and Sister' exhibited in 1837, which had been bought by the collector John Sheepshanks (Victoria and Albert Museum). Curiously, too, at the time Mulready was painting 'The Young Brother', he must have known that Sheepshanks intended giving his collection of paintings to the nation.

Henry Cole, who visited Mulready's studio on 17 February 1856 recorded that the artist was 'at work on Pinching the Ear "large"' and then, over a year later, on 15 March 1857, further noted 'His picture of

brother & sister finished'. Mulready's problems with the picture were no doubt exacerbated by the daunting prospect of the work entering the national collection and becoming one of the yardsticks by which his genius would be judged in the future. It would appear that his worries were widely known, for the *Art Journal* for June 1857, in reviewing the picture stated that it 'has … been long on Mr Mulready's easel, and has cost him much anxiety'.

The ambiguity of the subject matter of 'The Young Brother' has been frequently commented upon. For the critics in 1857, its theme was more or less clearly identifiable, if ultimately rather slight. A small boy perched on the arm of his sister or mother, is about to have his ear playfully pinched by his elder brother. There is, nonetheless, an erotic tension about the relationship between the boy and the girl which becomes more apparent when a comparison is made with 'Brother and Sister'. In the earlier work, the elder brother is clearly just a boy, whereas in 'The Young Brother' he is verging on manhood.

The ambiguity in the relationship which results from this change, and which is implicit in a title which casts the girl in the role of mother or sister, is a motif which occurs elsewhere in Mulready's depictions of males and females together. In this case, one senses that he is moving closer to realising, albeit within the bounds of accepted taste, the full potential of an early pen and ink study of 1835 for 'Brother and Sister' (private collection): in this the male adopts a more sexually aggressive, certainly less brotherly, stance. Possibly, Mulready's difficulties in re-working this aspect of the subject were partly responsible for the long delay in completing the picture.

Mulready's Account Book records that Vernon's executors paid £1050 for the picture on 8 April 1857.

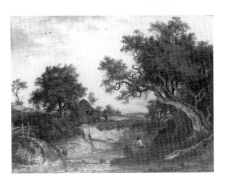

PATRICK NASMYTH 1787–1831

53 A Landscape ('The Angler's Nook') 1825
Oil on mahogany panel 30.2 × 41 (11⅞ × 16⅛)
Inscr: 'Patᵏ Nasmyth 1825' bottom right
Copy: J. Carter
Engr: J. Carter, *Art Journal*, 1853, opp. p.56
N00381

Nasmyth was born in Edinburgh, the eldest son of the portrait and landscape painter Alexander Nasmyth (1758–1840). He first visited London with his father in 1806 when he saw landscapes by the seventeenth century Dutch masters, Meyndert Hobbema, Jacob van Ruisdael and Jan Wijnants – all of whom Alexander admired. Patrick also sought to emulate them. He moved to London in 1808 where he lived until his death.

Patrick's subject matter – landscapes in which twisted trees with methodically touched-in foliage, frame winding paths or distant vistas – recalls Hobbema's and earned him the soubriquet 'The English Hobbema' (subsequently inherited by T.S. Cooper, no.19). Patrick Nasmyth's work was widely collected: Vernon owned a larger painting by him, 'Carisbrooke Castle' possibly bought at the Society of British Artists in 1826.

Nasmyth's landscape in this work is probably invented, partly composed out of his memories and notes of Scottish landscape and incorporating motifs found during the short sketching trips of the kind which it is known he made in Hampshire in 1814 and Surrey in 1819. The title 'The Angler's Nook' was given to the picture when it was engraved for the *Art Journal*.

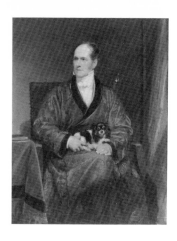

HENRY WILLIAM PICKERSGILL
1782–1875

54 Robert Vernon 1846
Oil on canvas 142.2 × 111.8 (56 × 44)
Exh: RA 1847 (156)
Engr: W.H. Mote, *Art Journal*, 1849,
frontispiece
N00416

During the middle decades of the nine-
teenth century Pickersgill was England's
leading portraitist. His strength lay in
capturing a good likeness and, if he lacked
the brilliance of his younger contemporary
Francis Grant, he nonetheless painted
many of the celebrities of his day. During
the early 1840s, when Vernon became
something of a public figure by opening
his collection to selected visitors, and his
intention of giving it to the nation became
widely known, it was almost inevitable that
he would sit to Pickersgill. This portrait
was on display at the Academy in June
1847, just at the time Vernon made his first
formal approach to the Trustees of the
National Gallery about his proposed gift
of British art.

Pickersgill shows Vernon wearing a rich
silk brocaded chamber robe, a state of
dress which emphasises the extent to
which he was housebound through severe
attacks of gout. Vernon was fond of King
Charles spaniels: Landseer had once,
famously, painted two of them (no.42),
both of which were accidentally killed.
The King Charles in Pickersgill's portrait
was, according to the *Art Union*, 'well
known' to Vernon's friends and could well
be 'Sylph' who was mentioned in his will.
Vernon Heath, Vernon's nephew, noted
that Landseer had offered to paint this
dog into the portrait, 'an offer which, it is
to be deplored, Pickersgill declined'. Even
if he had accepted, the dog might have
died in the time taken before Landseer
picked up his brush.

The critic of the *Athenaeum* described

this portrait as 'faithful' while the *Art
Union* described it as 'a memorial of so
truly great a man … among the mightiest
benefactors of the age and country'. When
engraved for the *Art Journal* it bore the
dedication to 'The British People'.

RICHARD REDGRAVE 1804–1888

55 Country Cousins ?1847–8
Oil on paper on canvas 83.9 × 109.6
(33 × 43⅛)
Inscr: 'Rich^d Redgrave 1848' bottom
right
Exh: RA 1848 (173)
Copy: C.H. Woodman
Engr: H.C. Shenton, *Art Journal*,
1854, opp. p.320
N00428

Richard Redgrave's most distinctive con-
tribution to the genre of 'scenes from
familiar life' was a small group of paintings
which dealt with contemporary social
wrongs. He wrote in his 'Autobiography',
published in the *Art Journal*, 1850, that 'it
is one of my most gratifying feelings that
many of my best efforts in art have aimed
at calling attention to the trials and strug-
gles of the poor and the oppressed'.

When 'Country Cousins' was first
exhibited, the critic of the *Athenaeum*
certainly recognised that Redgrave was
'once more arguing by the means of Art
for the redress of social wrong'. However,
what precisely the moral was seems to
have been lost on most critics: they saw
the meeting of the two sides of the family
merely as unexpected and fraught with
embarrassment – but not much more. It is
only when one notices the picture over the
fireplace – which is an illustration of the
parable of Dives and Lazarus (the rich
man at his table, the poor man at his gate)
that one realises that the country cousins
have come in the hope of getting some
help from their rich relations.

Vernon had owned a painting by Red-
grave, 'Olivia's Return to her Parents', an

illustration to Oliver Goldsmith's *The
Vicar of Wakefield*, since 1839. The *Art
Journal* for 1 November 1847, when de-
scribing Vernon's collection at 50 Pall
Mall, noted that a commission to Red-
grave – presumably for 'Country Cousins'
– was in hand. A study in pencil, chalk and
bodycolour for the two female country
cousins is in the Victoria and Albert Mu-
seum.

SIR JOSHUA REYNOLDS
1723–1792

56 Self-Portrait *c*.1775
Oil on canvas 73.7 × 61 (28¾ × 24)
Copy: B. Wilkinson
Engr: T.W. Hunt, *Art Journal*, 1854,
opp. p.129
N00306

Joshua Reynolds was President of the
Royal Academy from its founding in 1768
until his death. He was knighted in 1769.
His *Discourses*, the lectures which he
delivered to the Academy students every
two years when the Gold Medals were
awarded, were prompted by his desire to
'animate and guide [the students] in their
future attempts'. In them, he consistently
underlined the necessity for students to
study and emulate the works of the great
masters – particularly those of the Italian
Renaissance. His philosophy and the
extent to which artists either followed it or
rejected it continued to influence the
course of British art until well into the
nineteenth century.

Reynolds was a portrait painter. He
produced a great number of self-portraits,
more, in fact, than any other British pain-
ter. They range from a pencil drawing
made when he was about seventeen to an
oil made in the final year of his life. This
portrait shows Reynolds aged about fifty-

two. It is an unfinished preparatory study for the self-portrait which he was invited to present to the Uffizi Gallery following his election to the Florentine Academy in 1775. For such an important picture, he instinctively looked to the work of a great portraitist for inspiration and his pose is borrowed from Van Dyck's portrait of Sir Kenelm Digby. He is dressed in a bonnet and a cloak which signify his academic status. The Tate Gallery possesses another self-portrait by Reynolds showing him aged about thirty (N00889).

DAVID ROBERTS 1796–1864

57 Entrance to the North Transept, Cathedral of Burgos 1835
Oil on mahogany panel 55.4 × 30.4
(21¾ × 12)
Inscr: 'D.Roberts│1835' bottom right
Exh: BI 1836 (238)
Copy: E. Challis
Engr: E. Challis, *Art Journal*, 1849,
opp. p.204
N00400

Roberts visited Spain for eleven months during 1832–3 and he stayed in Burgos for a week during December 1832. He made several drawings of the interior and the exterior of the cathedral and this picture, which shows the Escalera Dorada in the right transept, was based upon one of them. The picture was painted for Robert Vernon, who paid the artist £38 10s od for the work.

Roberts produced a finished watercolour of the same view, signed and dated 1836, for an engraving that was published in the *Landscape Annual* for 1837 (Whitworth Art Gallery, University of Manchester).

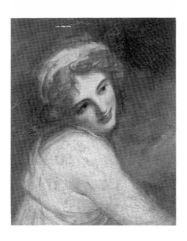

GEORGE ROMNEY 1734–1802

58 Lady Hamilton (?as a Figure in 'Fortune Telling') c.1782–4
Oil on canvas 49.5 × 40 (19½ × 15¾)
Copy: Miss Sharpe
Engr: C. Holl, *Art Journal*, 1854,
opp. p.88
N00312

Amy (later Emma) Lyon (c.1761–1815) married the diplomat and connoisseur Sir William Hamilton in September 1791. She is, however, most famous for her liaison with Admiral Lord Nelson and to a lesser extent today, for her performances of artistic, sometimes risqué, 'attitudes'. These gave her a European-wide reputation which declined over the years in direct proportion to weight she gained.

Emma was often painted by Romney, frequently for fancy portraits such as this work. She first sat to Romney in 1782, remaining a favourite with him until 1786 when she went to Italy, and then again in 1791 when she gave him twenty-eight sittings – the last one as Lady Hamilton. Rather than just being a study, this portrait would appear to be a fragment from a larger composition. It is painted on two pieces of canvas joined vertically about 12.8 cm (5 in) from the right-hand edge. This join was possibly made in the course of work on a much bigger canvas when Romney experienced difficulties with the overall composition and had to cut out a portion of it; or perhaps the portrait of Emma Hamilton was cut out from this composition when it was abandoned and the right-hand strip of canvas added to give the work more balance. It has been suggested that the larger painting with which this portrait should be associated was 'Fortune Telling' which Romney was working on in about 1782–4. Drawings for this painting are in the Fitzwilliam Museum, Cambridge.

Vernon bought the picture for £15 4s 6d

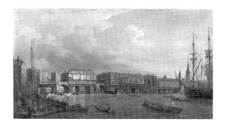

SAMUEL SCOTT c.1702–1772

59 A View of London Bridge before the Late Alterations engr.1758
Oil on canvas 28.5 × 54.5 (11¼ × 21½)
Copy: J.F. Salmon
Engr: J.B. Allen, *Art Journal*, 1853,
opp. p.82
N00313

This is a pendant to another painting by Scott, 'A View of Westminster Bridge with Parts Adjacent' of about 1750–7, which is also part of the Vernon Gift (N00314). It shows Old London Bridge as it looked before 1760 when the houses on it were demolished. The subject was a popular one, for obvious reasons, and eleven versions of the composition are known. The two earliest, both dated 1747, are in private collections. This version was the one used for an engraving by P.C. Canot which was published in February 1758.

Samuel Scott began his career as a marine painter (and is represented as such in the Tate Gallery: 'Admiral Anson's Action off Cape Finisterre', 1747; T00202) and at his death was described by one obituarist as the 'English Vandervelde' – a reference to the Dutchman Willem van de Velde (1633–1707). Vernon owned one marine subject attributed to Scott, a 'Harbour Scene', which he sold in 1842. These two early London views lay rather outside the conventional nineteenth-century perception of what constituted the modern British School and Vernon accordingly left a decision about including them in his gift to the National Gallery Trustees. By selecting them, they undoubtedly had in mind a connection between Scott's London views and those of the far better known view painter Canaletto who was active in England between 1746 and 1755.

at Christie's, 14 April 1837 (82) when it was described as 'Portrait of Lady Hamilton. From Romney's sale'.

CLARKSON FREDERICK
STANFIELD 1793–1867

60 Lake Como 1825
Oil on oak panel 47.8 × 78.3
(18¹³⁄₁₆ × 30⅞)
Inscr: 'C Stanfield│1825' bottom left
Copy: J. Cousen
Engr: J. Cousen, *Art Journal*, 1850,
opp. p.260
N00406

Before he established himself as an easel
painter, Stanfield was first a sailor and
then, from 1816, a theatre scene-painter.
He first exhibited in London at the British
Institution and the Royal Academy in
1820. Between July and September 1824
he travelled through the French, Swiss
and Italian Alps with his friend the artist
William Brockedon (1787–1854) who
wanted to retrace the route of Hannibal
and his army. The following year Stanfield
exhibited one painting at the Society of
British Artists, 'Fishermen of the Isola
d'Piscatori, Lago Maggiore', based on his
Italian sketches. 'Lake Como' was not
exhibited. The tranquil lake scene, with its
spectacular backdrop of mountains, shows
Stanfield searching, in his oil paintings,
for the same sort of dramatic and accurate
effect that he used in his theatre dioramas.
The view is looking west from the prom-
ontory of Lavedo, with Campo on the
right and the island of Comacina, with the
church of S. Giovanni, in the middle
distance. Monte Generoso rises up be-
yond.

CLARKSON FREDERICK
STANFIELD

**61 Oude Scheld – Texel Island,
Looking towards Nieuwe Diep and
the Zuider Zee** exh.1844
Oil on canvas 100.3 × 125.7
(39⅛ × 49½)
Exh: RA 1844 (523)
Copy: J. Smith
Engr: R. Wallis, *Art Journal*, 1849,
opp. p.103
N00404

In the summer of 1843, Stanfield made a
tour of Holland. This picture, and a much
larger canvas, 'The Day after the Wreck',
also exhibited at the Academy in 1844
(187; Sheffield City Art Galleries) were
the two works which directly resulted from
this trip.

After Turner, Stanfield was the most
admired marine painter of his day. The
literalness of his views – rooted in his
experiences as a sailor during the period
1808–16, as well as his use of the accurate
scale models of ships with which his studio
was crammed – also brought him the kind
of consistent critical acclaim which Tur-
ner, with his frequently sensational marine
subjects, was denied. John Ruskin, in the
section 'Of Truth of Water' in *Modern
Painters* (1843), wrote that Stanfield, in
painting water 'fears no difficulty, desires
no assistance, takes his sea in open day
light, under general sunshine, and paints
the element in its pure colour and com-
plete form'; but he went on to wish that the
artist were 'less clever, and more affecting'.

In reviewing this work, the critic of the
Art-Union for 1 June 1842 singled out for
praise the 'astonishing movement and
clearness of the water, which is painted
with a triumphant challenge to the closest
comparison with nature, even to the
slightest beading on the crests of the
waves'. He added that 'before [Stanfield's]
time water has never before been so paint-
ed, and, as approaching as closely to the
reality as painting admits of, can never be
excelled'.

THOMAS STOTHARD 1755–1834

**62 Intemperance: Mark Antony and
Cleopatra** *c*.1802
Oil on canvas 49.5 × 74.9 (19½ × 29½)
Inscr: 'THE SKETCH OF THE SUBJECT
OF INTEMPERANCE PAINTED ON THE
WALLS OF THE GREAT STAIR-│CASE AT
BURLEIGH THE SEAT OF THE MOST
NOBLE THE MARQUIS OF EXETER.
A.D.MDCCCII'
Exh: ?RA 1805 (146)
Copy: R. Woodman Jr
Engr: W. Chevalier, *Art Journal*, 1851,
opp. p.200
N00321

Like Benjamin West's finished sketch for
'The Institution of the Order of the Gar-
ter' (no.70) this work by Stothard relates
to a large-scale decorative scheme – in this
instance, for the staircase at Burghley
House, Northamptonshire. Successful
projects of this kind, dating from about the
middle of the eighteenth century (the
period which interested Vernon as a col-
lector), were relatively rare in British art
and by their very nature impossible to
represent in a private, domestic, collec-
tion. And yet, as products of the Grand
Style advocated by Sir Joshua Reynolds in
his *Fourth Discourse* of 1771, they are an
important aspect of British painting. Ver-
non clearly believed that they should not
be overlooked.

At the time he was given the commis-
sion to decorate the staircase at Burghley,
Stothard's fame rested on his delicate
book illustrations and small-scale oil
paintings. At Burghley, where he worked
between 1799 and about 1803, he had to
take account of an existing ceiling dec-
oration, 'Hell', by Antonio Verrio (1639–
1707; he is represented in the Tate by a
sketch for a ceiling decoration, T00916).
While Stothard borrowed something of
Verrio's baroque energy in the three sub-
jects he painted ('The Horrors of War',
'Orpheus and Eurydice' and 'Intemper-
ance') he was more strongly influenced by
the work of Peter Paul Rubens (1577–
1640). 'Intemperance' shows Mark Anto-
ny embracing Cleopatra as she drops a

pearl into her goblet. Mark Antony, the Roman triumvir, and Cleopatra, Queen of Egypt, were lovers. John Lempriere's *Classical Dictionary*, first published in 1788 and well known to many artists and writers of Stothard's day, notes that 'Cleopatra was a voluptuous and extravagant woman, and in one of the feasts she gave to Antony at Alexandria, she melted pearls in her drink to render her entertainment more sumptuous and expensive'.

This picture was perhaps the work that was exhibited at the Royal Academy in 1805 as 'A design for part of the great staircase, Burghley'.

THOMAS STOTHARD

63 Diana and her Nymphs Bathing
exh.1816
Oil on canvas 50.8 × 61 (20 × 24)
Exh: RA 1816 (324)
Copy: R. Woodman Sr
Engr: C. Cousen, *Art Journal*, 1853, opp. p.116
N00320

This picture is loosely based on the writings of the Roman poet Ovid (43BC–AD18). In his mythological tales, the *Metamorphoses*, he wrote of how Diana, goddess of the chase, when tired of hunting would bathe in a cool, crystal clear stream in a shady grove. Before entering the water, she would give her spear, quiver and unstrung bow to her armour bearer, while other nymphs would undress her. One day, the hunter Actaeon came upon Diana and her nymphs as they were bathing. For this, the goddess, who was celibate, had Actaeon turned into a stag, whereupon he was devoured by his own dogs.

Stothard shows that moment when Diana and her nymphs first become aware of Actaeon's approach. The attendant nearest her has moved to shield her from the gaze of any intruder, having overturned a gold ewer as she leapt up. The

nymphs in the water turn towards the disturbance, as do Diana's hounds. In the middle distance a stag, fearful of the approaching huntsman, makes for the safety of the river; at the same time its presence anticipates Actaeon's fate.

Stothard's choice of subject matter, as well as his treatment of it, was almost certainly inspired by Titian's painting of 'Diana and Actaeon' of 1556–9 (National Gallery of Scotland), which he could have seen in London in 1798 when it was acquired by the Duke of Bridgewater and in subsequent years when it was displayed in the private galleries of the Duke and the Marquis of Stafford who inherited his collection.

Stothard's picture is much darker in tone than the Titian 'Diana', but the debt to the Venetian artist, as far as handling is concerned, is clear. It is perhaps also worth noting that Stothard's palette in this work recalls the experiments of Benjamin West (see no.70) with the so-called 'Venetian Secret' – a false recipe claimed to be based on genuine old master painting methods – in the 1790s. At the time Stothard's work was shown at the Academy in 1816 a critic writing in the *Examiner* for 12 May wrote (though not specifically of this painting) 'Mozart has not more melody and elegant spirit than is often seen in Mr Stothard's colouring'.

It is not known when Vernon acquired the 'Diana'. However, the *Literary Gazette* for 5 April 1828 reported that Mr Hobday's Gallery in Pall Mall had just acquired a 'Titian-like composition of Diana and Nymphs' by Stothard. This might perhaps be the Vernon picture.

JOSEPH MALLORD WILLIAM TURNER 1775–1851

64 Bridge of Sighs, Ducal Palace and Custom-House, Venice: Canaletti Painting* exh.1833
Oil on mahogany panel 51 × 82.5 (20³⁄₁₆ × 32⁷⁄₁₆)
Exh: RA 1833 (109)

Copy: W. Smith
Engr: T.A. Prior, *Art Journal*, 1850, p.92
N00370

Purchased by Vernon from the Royal Academy exhibition for 200 guineas. Vernon acquired his first painting by Turner, the 'Prince of Orange, William III … Landed at Torbay' (N00369), from the 1832 Academy exhibition. In 1834 Turner seems to have introduced Wilkie to Vernon, resulting in the commission for 'The Peep-o'-Day Boys' Cabin, in the West of Ireland' (no.74).

JOSEPH MALLORD WILLIAM TURNER

65 The Dogano, San Giorgio, Citella, from the Steps of the Europa
exh.1842
Oil on canvas 62 × 92.5 (24½ × 36½)
Exh: RA 1842 (52)
Copy: W. Smith
Engr: J.T. Willmore, *Art Journal*, 1849, opp. p.260
N00372

Purchased by Vernon from the Royal Academy exhibition. By the deed of gift of his pictures to the Trustees of the National Gallery, signed by Vernon on 22 December 1847, this painting was transferred from Vernon's house, in Pall Mall to the National Gallery in Trafalgar Square 'in the name of the whole'. It was on display, the first Turner in a public collection, immediately after Christmas, on 27 December 1847.

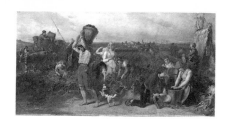

THOMAS UWINS 1782–1857

66 The Vintage in the Claret Vineyards of the South of France, on the Banks of the Gironde

1847–8
Oil on canvas 78.7 × 154.9 (31 × 61)
Exh: RA 1848 (36)
Copy: C.H. Woodman
Engr: J. Outrim and L. Stocks, *Art Journal*, 1854, opp. p.356
N00387

Uwins started his artistic career in 1797 when he was apprenticed to an engraver. The drudgery of the work and his desire for self-improvement led him to become a student in the Royal Academy Schools into which he was admitted in December 1798. Despite the ideas about 'high art' which permeated Academic training at this time, Uwins remained essentially a miniaturist. His strength lay in renderings, in watercolour, of picturesque rural life. After he became a full member of the Society of Painters in Water-Colours in 1810, his search for more novel and interesting material, appropriate to his new position in this distinguished exhibiting body, led him to the hop fields of Surrey.

In 1811, while on a visit to Farnham during the hop-picking season, he wrote of the pictorial possibilities of the harvesting and added, 'that it has never been made more use of by artists is altogether a mystery to me, it is so much superior to any other harvest that we in England have to boast'. It was, of course, very much the kind of 'national' subject which British artists sought out and developed during the war with France. Interestingly and fairly obviously, Uwins also made the point, 'what the gathering the vintage on the continent may be I cannot say': it seems almost certain that his ambition to paint an important vineyard subject, finally realised in this oil painting, dates from this period. Quite conceivably, his belief in the potential of such a theme was underpinned by a recollection of J.M.W. Turner's grand, Claudian 'The Festival upon the Opening of the Vintage of Macon' (Sheffield, Graves Art Gallery), exhibited at the Academy in 1803 and which Uwins must have seen.

Because of the Napoleonic Wars, artists of Uwins's generation were unable to travel to France until after Wellington's glorious defeat of Bonaparte at Waterloo in June 1815. In the summer of 1817, with the specific object of painting the grape harvest, Uwins journeyed to Bordeaux, via Paris and Lyon, with letters of introduction to a vineyard proprietor. For four weeks during September and October from the beginning of the vintage, he lived with the Cabareuss family on their estate at St Julien in the claret country of the upper Medoc. Despite his finding the countryside 'detestable; it is literally a sea of vines extending every way to the horizon', in the end Uwins found the subject sufficiently interesting to work up into a large drawing which was based on the sketches he had made in the vineyards everyday from morning to night. This work was destined for the Watercolour Society exhibition of 1818. It was to be the first in a series showing the different stages of wine-making but though Uwins did exhibit in 1818 two watercolours inspired by his time in Medoc, because of financial difficulties he thereafter had to devote himself to earning money as a portraitist and illustrator.

However, a visit to France during the vintage of 1846 appears to have re-awakened his interest in that subject which he had originally hoped would make his name. Using at least some of the sketches he made in 1817 – the children of M. Cabareuss were subsequently able to identify the people depicted – Uwins produced 'The Vintage'. When it was exhibited in 1848, the painting was accompanied by a quotation, printed in the catalogue, from a book *Autumn in the South of France*, the author of which is unidentified. This described the grape-gathering process, each stage of which is shown in Uwins's picture. By retaining the didacticism of his very first idea, and also by working on a larger canvas than he had ever done before, Uwins elevated his subject above mere 'familiar life'.

The importance of the work was clearly recognised by Vernon. He bought the picture at the Academy, successfully persuading its first purchaser, the well-known collector Elkanah Bicknell, to relinquish his claim on it. In a letter of 1 August 1848, Vernon then asked the Trustees of the National Gallery, who had by then accepted his gift of pictures, if 'The Vintage' could replace Uwins's 'The Neapolitan Wedding'.

EDWARD MATTHEW WARD
1816–1879

67 The Disgrace of Lord Clarendon, after his Last Interview with the King – Scene at Whitehall Palace, in 1667 (replica) 1846

Oil on canvas 54 × 73.8 (21¼ × 29⁹⁄₁₆)
Inscr: 'E.M.Ward │ 1846' bottom left
Copy: C.H. Woodman
Engr: F. Bacon, *Art Journal*, 1849, opp. p.115
N00431

Edward Hyde, 1st Earl of Clarendon (1609–74) was Lord High Chancellor to one of England's most colourful and profligate kings, Charles II. Charles's general neglect of national affairs, combined with the damaging effects of an Anglo-Dutch war and court intrigues against him led to Clarendon's dismissal. This happened on 30 August 1667. In this painting, Clarendon is seen leaving the King's palace at Whitehall. Charles, who has preceded him after they had their last interview, is seen swaggering out of the garden on the left.

This is a small replica of a picture which was painted for Lord Northwick and exhibited at the Royal Academy in 1846 (545; whereabouts unknown). According to the artist W.P. Frith, Northwick bought the picture from Ward on his recommendation. This replica appears to have been painted specifically for Vernon and was hanging near Landseer's 'Low Life – High Life' (A00702–3), in the boudoir of his house at 50 Pall Mall by November 1847.

When Lord Northwick's picture was exhibited an excerpt from the *Continuation of the Life of Edward, Earl of Clarendon*, published in three volumes in 1827, was printed in the catalogue. Apart from Lord Clarendon, other figures who are identified in this passage are Barbara Villiers, Lady Castlemaine, later Duchess of Cleveland (c.1641–1709), a famous court beauty and the King's mistress; Henry Bennet, Earl of Arlington (1618–85) who

led the opposition to Clarendon; and Baptist May (1629–98), Keeper of the Privy Purse to Charles II. All three are seen leaning over the parapet behind Clarendon and rejoicing in his defeat. In order to recreate likenesses of Clarendon, Arlington and May, Ward clearly looked at Sir Peter Lely's portraits of them. Similarly, the portraits of Lely, who was principal painter to Charles II, must have provided Ward with many of the details for the costumes which his figures wear, although his treatment of costume is not strictly authentic. In an affecting touch, deriving presumably from Ward's desire to associate her with Lady Castlemaine's legendary beauty rather than with any of her other less attractive characteristics, the artist's future wife, Henrietta, sat for this figure. Mrs S.C. Hall sat for the figure in the right foreground whose back is turned to the viewer. The face of the courtier beside Clarendon was taken from a likeness of Wilkie Collins.

The crowds were so great within doors, that tables with clerks were set in the streets. In this motley throng were blended all ranks, all professions, and all parties; Churchmen and Dissenters, Whigs and Tories, country gentlemen and brokers. An eager strife of tongues prevailed in this second Babel; new reports, new subscriptions, new transfers flew from mouth to mouth; and the voice of ladies (for even many ladies had turned gamblers) rose, loud and incessant, above the general din.

Mrs E.M. Ward, the artist's wife, wrote in her *Reminiscences* that Ward 'in all his pictures, pointed to some particular moral'. Here, the object of his satire was the foolishness of the 'Railway Mania' of 1844–5, and the accompanying 'froth of a thousand schemes' (as the *Times* described it) which quickly brought about a panic in the Stock Market and the loss of many fortunes.

a reference to slightly earlier paintings of the same subject (i.e. Tabley Tower) by J.M.W. Turner and Henry Thomson, that he had 'had to tell a story that has been told before so beautifully' yet 'with great Poetic liberties as to the Picturesque'. Ward therefore felt he had to produce 'something new by a more rigid attention to truth. The effect is such as I have seen on the spot, It is a close sultry day … when the air is charged or charging with Electric fluid preparitory [sic] to a Thunder storm'. He further explained that so far from 'chance' dictating his composition, all the parts were carefully 'chained' together, with 'one extreme [gliding] into the other without violence'. Thus, the 'beauty and vivacity' of 'the Young White Bull, the Adonis of my picture' add 'by contrast to the Repose around'; the swallows on the water 'independent of the sentiments add as another link to the chain – leading to the swans whose classic form and hue act as a contrast to and yet assimilate with the Tower'; and the 'whole foreground objects are counterballanced [sic] by a play of colour form etc … in the upper part of the sky which otherwise is composed of large and simple characters'.

Despite his protestations, Ward was obviously persuaded by Leicester to alter the picture; by late April 1814 he had been 'over it again and again' and then, by March 1818 finally stated that he had made it 'satisfactory' to Sir John, at which point he received payment of 150 guineas for the work.

EDWARD MATTHEW WARD

68 The South Sea Bubble: A Scene in 'Change Alley in 1720* 1847
Oil on canvas 130 × 190 (51 × 74¾)
Inscr: 'E M Ward│1847' bottom centre
Exh: RA 1847 (291)
Copy: [unknown]
Engr: J. Carter, *Art Journal*, 1853, opp. p.16
N00432

Exhibited at the Royal Academy accompanied by three separate quotations, including 'The earth hath bubbles, as the Water hath;│And these are of them.' from Act I, scene 3 of Shakespeare's *Macbeth* and an extended passage from volume 2 (p.16) of Lord Mahon's *History of England from the Peace of Utrecht, to the Peace of Aix-la-Chapelle*, published in 1837, describing the impact of the speculative boom of 1720 known as the South Sea Bubble:

JAMES WARD 1769–1859

69 View in Tabley Park 1813–18
Oil on canvas 94 × 134.9 (37 × 53⅛)
Inscr: 'J.Ward (in cipher) RA.1814' bottom left
Copy: T.A. Prior
Engr: T.A. Prior, *Art Journal*, 1851, opp. p.52
N00385

Like Callcott's 'Littlehampton Pier' (no.10) this picture was commissioned by Sir John Leicester and it remained in his collection until it was bought by Vernon for 190 guineas in 1827.

From a letter which Ward wrote to Leicester in January 1814, when the picture was completed, it is clear that the artist's treatment of the subject was not entirely to Leicester's liking: he appears to have thought that Ward was guided by the 'effect of chance', rather than sound Picturesque principles, in his handling of the landscape. Ward, in defence, admitted, in

BENJAMIN WEST 1738–1820

70 Sketch for 'The Institution of the Order of the Garter' *c.*1787
Oil on canvas 41.2 × 55.7 (16½ × 22)
Exh: ?RA 1787 (19)
Copy: C.H. Woodman
Engr: W. Taylor, *Art Journal*, 1852, p.360
N00315

Probably the 'finished sketch' for the large picture (287 × 448.3 cm; 113 × 176½ in) which West painted for the Audience Chamber at Windsor Castle in 1787. It was one of eight paintings inspired by events from the reign of King Edward III, who founded the Order of the Knights of the Garter in 1348, which West produced between 1786 and 1789. The 'Institution' picture is now in the Palace of Westminster. West depicts the scene in St George's Chapel, Windsor: King Edward III and the Prince of Wales are kneeling on either side of the altar, while Queen Philippa kneels at the left.

This sketch was bought by Vernon for 125 guineas at the sale of West's pictures held by the artist's sons in May 1829. It was one of five works that he acquired at this sale (and it was the work for which he paid most), though the only one that was included in his gift to the National Gallery.

West was a major figure in English history painting although his reputation rapidly waned after his death. In an attempt to rival the old masters, he was eclectic in his borrowings. The composition of this picture is based on Rubens's 'Coronation of Marie de' Medici' in the Louvre. The relatively high price Vernon paid for the work suggests that it might well be the richly finished (though overcleaned in the late 1800s) sketch which West is thought to have reworked in 1807 in an attempt to emulate Rembrandt's technique in 'The Woman Taken in Adultery' (National Gallery).

The picture was possibly exhibited at the Royal Academy in 1787 as 'The original institution of the most noble order of the Garter by Edward IIId, a finished sketch'.

SIR DAVID WILKIE 1785–1841

71 Newsmongers 1821
Oil on mahogany panel 43.2 × 36.3 (17 × 14¼)
Inscr: 'D. Wilkie 1821' bottom centre
Exh: RA 1831 (137)
Copy: B. Wilkinson
Engr: W. Taylor, *Art Journal,* 1850, opp. p.152
N00331
Illustrated on cover

In a letter of 16 February 1821 to his patron, Sir George Beaumont, Wilkie wrote of the pictures which he intended sending to the forthcoming Royal Academy exhibition, 'one of which (The Newsmongers) is for General Phipps, a subject of his own suggestion'.

Wilkie had met Phipps (1760–1837) of the 60th Foot, younger brother of another patron, the 1st Earl of Mulgrave, soon after he arrived in London from Scotland in 1805. Like Beaumont and Mulgrave, he was one of a number of collectors and connoisseurs who would visit Wilkie's studio to watch work in progress or, occasionally, offer advice and suggest titles for pictures – as Beaumont certainly did. Beaumont and Phipps (described by the painter Benjamin Robert Haydon as the 'pupil and apprentice' of Beaumont) were amateur artists and Wilkie would have respected their views on practical and aesthetic matters. An immediate precedent for a patron suggesting a subject to Wilkie can be seen in the way the Duke of Wellington had the first idea for the painting which subsequently became 'Chelsea Pensioners Reading the Waterloo Despatch' (RA 1822; Apsley House). This Wellington commission was, according to Wilkie's biographer, 'like a spell' on the artist in 1821. It seems very likely that the scheme for 'Newsmongers' was sparked off by Phipps seeing the 'Chelsea Pensioners' – in which the entire action centres on a pensioner reading out aloud from a newspaper – on Wilkie's easel.

The picture was the first commission given to Wilkie by Phipps and he paid £120 for it. Wilkie's biographer described it as 'one of these hasty, and certainly happy things, which supplied the artist with the necessaries of life'. When it was exhibited, the critic of the *Literary Gazette* for 26 May 1821, thought that the roast meat on the baker's tray was a 'curious incident' with its 'smoking effluvia seen against the clear sky … a novel experiment'. 'Newsmongers' was engraved as an illustration to a short story in the annual *Friendship's Offering* for 1830. Vernon acquired the picture in May 1841.

SIR DAVID WILKIE

72 A Woody Landscape 1822
Oil on mahogany panel 24.1 × 24.1 (9½ × 9½)
Inscr: 'D.Wilkie f.1822' on back
Copy: J.C. Bentley
Engr: J. Cousen, *Art Journal,* 1853, opp. p.152
N00330

On the back of this picture is a faint inscription 'Painted at the Grove Little Bealings | Mr Nurseys late Residence | presented to Perry Nursey Esq | [by] his affectionate friend Mr Wilkie | [?and left] with him [as] a token [?of his] friendship'.

Wilkie, together with his mother, visited his friend Peregrine Pickle Nursey (1772–1840) at his home, The Grove, Little Bealings, Woodbridge in July 1822. This view appears to show some of the Nursey children and their ponies. At the time, Wilkie was en route to Scotland to view the entrance of George IV into Edinburgh – a subject which he was planning to paint.

Wilkie rarely painted pure landscape and exhibited only one, the 'Sheepwashing', in 1817; but on a previous visit to The Grove in 1816 he had produced at least three small oil studies of Mr and Mrs Nursey with their children in their garden. These were preparatory sketches for a family portrait that was never executed. One of these studies is in the Tate Gallery (N02131) and it would appear that the glade by the stream depicted in the Vernon picture was the setting in which Wilkie had placed the family for the 1816 sketches.

which protected the Protestant peasantry and took their name from the dawn raids that were made on Catholic villages. Wilkie shows one of these rebels asleep beside his watchful wife; a girl enters the cabin and whispers the alarm, 'most probably', as the reviewer in the *Athenaeum* of 7 May 1836 wrote, 'of the approach of a party of military'.

SIR DAVID WILKIE

73 The First Ear-Ring 1834–5
Oil on mahogany panel 74.3 × 60.3
(29¼ × 24¾)
Exh: RA 1835 (88)
Copy: R. Woodman Sr
Engr: W. Greatbach, *Art Journal*,
1849, opp. p.352
N00328

Wilkie first conceived and painted this subject in 1821 but returned to it in the 1830s in response to a commission from the 6th Duke of Bedford. The Duke's picture had a long gestation period with Wilkie characteristically working out the whole composition and details of the figures from models in a series of sketches. In this case it seems to have occupied him over about two years. A pen and ink study of the whole composition, which differs in many details from the final work, is in the British Museum and is dated 1832. A highly finished drawing dated 1833, now in the Princeton Art Museum, shows the girl (upon whom the action is centred) posed on her own with a cloth over her left shoulder acting as a substitute for her mother's wrist. A study for the seated woman, dated June 1834, is in the Victoria and Albert Museum and the Tate possesses a fine chalk and wash study, dated 3 July 1834, of the two standing figures (N04830). The critic of the *Athenaeum* for 16 May 1835 described the finished work as a 'hasty and happy' little picture.

The painting was still with the Duke of Bedford's widow in 1840 but it is not known when Vernon acquired it.

SIR DAVID WILKIE

74 The Peep-o'-Day Boys' Cabin, in the West of Ireland 1835–6
Oil on canvas 125.7 × 175.2
(49½ × 69)
Exh: RA 1836 (60)
Copy: Miss Sharpe
Engr: C.W. Sharpe, *Art Journal*, 1850,
opp. p.360
N00332

In November 1834, Vernon asked Wilkie, through their mutual friend, the artist George Jones, if he could buy the picture which was then on his easel. As it happened, the painting, 'Columbus in the Convent of La Rábida', was a commission from another collector, 'otherwise', Wilkie responded, 'it would have given me the greatest pleasure to have seen it in the possession of Mr Vernon'. Jones went on to suggest that Wilkie paint another work for Vernon and Wilkie promised to think about possible subjects. When he and Vernon met in December that year, Vernon again expressed an interest in ordering a picture of the 'size and character' of 'Columbus' though, as Wilkie reported, he said he 'would prefer a female to be in it'. The artist considered painting an episode from the life of Mary, Queen of Scots for Vernon, but it was not until he had returned from a trip to Ireland, made during August and September 1835, closely followed by a visit from Vernon at the very beginning of October, that Wilkie felt he had a subject which met Vernon's requirements. In mid-October Wilkie wrote to Vernon that he was ready to show him a 'slight drawing' of what was to become 'The Peep-o'-Day Boy's Cabin'. Vernon presumably saw and approved Wilkie's scheme and the painting was finished by February 1836. Vernon paid 350 guineas for the work.

At the time Wilkie first proposed the subject to Vernon, he described it as 'The Sleeping Whiteboy' – Whiteboys being a secret society devoted to championing the rights of oppressed tenants. The Peep-of-Day Boys were another Irish secret society

RICHARD WILSON 1713–1782

75 Lake Avernus and the Island of Capri* *c.*1760
Oil on canvas 47 × 72.4 (18½ × 28½)
Copy: [unknown]
Engr: J.C. Bentley, *Art Journal*, 1851,
opp. p.212
N00304

Richard Wilson travelled to Italy in 1750 where he remained until 1756. He was the son of a Welsh clergyman and had a thorough grounding in classical literature. Once in Rome, Wilson rapidly assimilated the principles of historical landscape painting exemplified by the work of the two great seventeenth century masters of the classical tradition – Claude Lorraine and Gaspard Dughet: his view of the Italian landscape was coloured by his feeling for the ideal beauty which, through its associations with the ancient Hellenic and Roman civilisations, permeated it.

Wilson visited Lake Avernus, just north-west of Naples, in about 1754–6 when he made a chalk drawing, on grey paper, of the view which subsequently formed the basis of this oil (now in the British Museum, Department of Prints and Drawings). The region had potent classical associations. Avernus is located in the Phlegraean (or Burning) Fields, a volcanic area between Naples and Cumae. Characterised in ancient times by earth tremors and the flare of volcanoes, it was identified with the Infernal Regions by the Ancient Greeks and the entrance to the underworld, or Hades, was said to lie there. Virgil, in the *Aeneid*, relates how Aeneas, having led his people to Italy and

landed near Avernus, asked the Cumaean Sibyl to prophecy his future and was led by her into Hades to meet the ghost of his father who foretold his destiny.

In Wilson's day, the subterranean passage down which Aeneas is reputed to have travelled to the underworld survived in the so-called Grotto of the Sibyl. In 'Lake Avernus and the Island of Capri', the artist's viewpoint is taken from near the Grotto towards what was known as the Temple of Apollo (in fact a Roman bath). Wilson appears to reinforce the historical association with Apollo, the Sun God to whom, on first landing in Italy, Aeneas vowed to build a temple, by showing the sun setting behind this 'temple'. In the distance, beyond the Lucrine Lake, the presence of vessels pulled up on the shore almost seems a conscious evocation of the moment when Aeneas's fleet reached landfall.

Vernon probably acquired this picture through the dealer Norton who purchased it for £78 15s od at the sale of Sir John Pringle's pictures held at Christie's on 20 April 1843.

76

77

76 Hadrian's Villa *c.*1765
Oil on canvas 35.6 × 25.4 (14 × 10)
Copy: [unknown]
Engr: J. Carter, *Art Journal*, 1850, opp. p.356
N00302

77 Maecenas' Villa, Tivoli, *c.*1765
Oil on canvas 36.1 × 25.4 (14³⁄₁₆ × 10)
Copy: [unknown]
Engr: T.A. Prior, *Art Journal* 1852, opp. p.381
N00303

Probably bought by Vernon in 1835, these two small landscapes by Wilson were among the very first British 'old masters' he acquired. Up until the early 1830s, Vernon's collecting had been devoted almost exclusively to subject paintings by living artists but then, in 1832, he bought the large 'Sunset: Carthorses Drinking at a Stream' by Thomas Gainsborough (no.27).

The reputations of both Gainsborough and Wilson as two of the founding fathers of the English school of landscape painting had grown in the years following their deaths: Wilson had been represented in the National Gallery since 1826 and Gainsborough since 1828. With the new direction which his collecting took in 1832 it was inevitable that Vernon would want to include Wilson's work in his gallery. The two paintings by him in the National, 'Tivoli: Villa of Maecenas' (N00108) and 'The Destruction of the Children of Niobe' (destroyed), were both large, formally constructed, neo-classical landscapes – with the 'Niobe' a dramatic historical subject which had always suffered from Sir Joshua Reynolds's criticism that the figures were quite inappropriate to the sublimity of the landscape. By contrast – and maybe even purchased by Vernon with this in mind – these two Tivoli scenes are unpretentious, though they still convey the essence of Wilson's art: his painterliness, the truth and beauty of his colouring and handling of light, and his skill in endowing even these informal compositions with a contemplativeness worthy of far grander canvases. The theme that unites the view of the ruined arches of the Emperor Hadrian's villa, now with a simple dwelling built on top of them, and the view of the shell of the so-called 'Maecenas' Villa', with shattered antique remains prominent in the foreground, is that of change and decay. The presence of the two figures in the latter picture reinforces the sense of melancholy. Our attention is drawn to them by the diagonal shaft of sunlight that pierces the darkness beyond them. Their solitariness and the gesture of one who seems to be pointing at a broken statue or an inscription, recalls the image of the idle shepherds who, in the Golden Age, came across a tomb inscribed with the words 'Ego Fui in Arcadia' ('I, too, once lived in Arcadia') and are so reminded of their own mortality.

Both works are based on chalk drawings on coloured paper made during Wilson's stay in Italy between 1750–6 or 7: that for 'Hadrian's Villa' is in the Glynn Vivian Art Gallery, Swansea, and that for 'Maecenas' Villa, Tivoli' is in the British Museum. The subjects were 'good breeders', with Wilson painting several versions of each on his return to England. Because the subjects were also engraved and published in 1776, they were frequently copied by other artists and amateurs. Wilson's pupil, Joseph Farington, owned versions of 'Hadrian's Villa' and its pendant and lent them to John Constable in 1803 for copying. When, in 1836, Constable gave his lectures on the history of English landscape painting, his praise of Wilson was infused with a sense of the debt he owed to Wilson and his art: 'To Wilson … may justly be given the praise of opening the way to genuine principles of landscape in England … He looked at nature entirely for himself'.

The approximate dating of these works and other versions is based, firstly, on the fact that two pictures, 'A Small Landskip, with a Ruin' and 'its companion', which Wilson exhibited at the Society of Artists in April 1764 may have shown these subjects (though which versions is unknown); and secondly, that a label in Farington's hand, on the back of the 'Maecenas' Villa' formerly owned by him (and now in the Art Gallery of Western Australia, Perth) describes it as having been painted in Wilson's 'fifty second year' (i.e.1765).

It would be agreeable to think that Vernon, as a latter-day Maecenas himself (Maecenas was a great Roman patron of the arts), was attracted to at least one of these works because of its particular subject. However, at the time he bought them both pictures had more mundane titles than those they now have: namely 'An Italian Hut Built on the Ruins of a Roman Acquaduct' and 'Ruins of a Roman Bath'.

A Checklist of the Vernon Gift

Works included in the catalogue are asterisked

ALLAN, Sir William 1782–1850
*Tartar Robbers Dividing Spoil
1817 exh.1817
Oil on mahogany panel
64.2 × 52.4 (25⁵⁄₁₆ × 20⅝)
N00373

BACON, John, the Younger
1777–1859
*The Marquis Wellesley
?exh.1808
Marble 62.2 × 42.3 × 29.5
(24½ × 16⅝ × 11⅝)
Transferred from the Tate Gallery
to the National Portrait Gallery
1957

BAILY, Edward Hodges
1788–1867
*Samuel Johnson (after Joseph
Nollekens) 1828
Marble 68.5 × 58 × 29
(27 × 22¹³⁄₁₆ × 11⅜)
Transferred from the Tate Gallery
to the National Portrait Gallery
1957

*Sir Isaac Newton (after Louis
François Roubiliac) 1828
Marble 68.5 × 51 × 29
(27 × 20¹⁄₁₆ × 11⅜)
Transferred from the Tate Gallery
to the National Portrait Gallery
1957

*George Canning (after Joseph
Nollekens) 1829
Marble 72.4 × 50.8 × 27.9
(28½ × 20 × 11)
N02247

*The First Duke of Wellington
(after Joseph Nollekens)
c.1828–30
Marble 79.3 × 59 × 32.5
(31¾ × 23¼ × 12¹³⁄₁₆)
N02236

BEHNES, William 1795–1864
*Robert Vernon 1849
Marble 77.5 × 58 × 28
(30½ × 22¹³⁄₁₆ × 11)
N02237

BIRD, Edward 1762–1819
The Raffle for the Watch
Oil on oak panel 44.5 × 61
(17½ × 25)
N00323

BONINGTON, Richard Parkes
1802–1828
*View of the Piazzetta near the
Square of St Mark, Venice 1827
exh.1828
Oil on canvas 44.2 × 36.7
(17½ × 14½)
N00374

BRIGGS, Henry Perronet
1793–1844
*The First Interview between
the Spaniards and the
Peruvians exh.1827
Oil on canvas 147.5 × 197.6
(58 × 77¾)
N00375

Romeo and Juliet – Act II
Scene 5 ('Juliet and her Nurse')
exh.1827
Oil on canvas 88.9 × 69.8
(35 × 27½)
N00376

CALLCOTT, Sir Augustus Wall
1779–1844
*Littlehampton Pier 1811–12
exh.1812
Oil on canvas 140.3 × 106.1
(55¼ × 41¾)
N00345

*The Shore at Scheveningen
(after Willem van de Velde)
c.1820–30
Oil on oak panel 16.4 × 24
(6½ × 9½)
N00348

*Dutch Landscape with Cattle
c.1830–40
Oil on oak panel 16.2 × 33.5
(6⅜ × 13³⁄₁₆)
N00342

Dutch Coast Scene exh.1832
Oil on canvas 68.6 × 91.4
(27 × 36)
N00341

Sketch for 'The Benighted
Traveller' c.1832
Oil on paper on millboard
15.9 × 13.3 (6¼ × 5¼)
N00344

*Entrance to Pisa from Leghorn
exh.1833
Oil on canvas 109.2 × 164.5
(43 × 64¾)
N00346

Dutch Peasants Waiting the
Return of the Passage Boat
exh.1834
Oil on canvas 64.8 × 95.9
(25½ × 37¾)
N00347

Returning from Market
exh.1834
Oil on canvas 109.2 × 144.8
(43 × 57)
N00340

Wooden Bridge c.1835
Oil on canvas 22.9 × 29.8
(9 × 11¾)
N00343

CHANTREY, Sir Francis
1781–1841
*Sir Walter Scott 1841
Marble 76.2 × 53.3 × 31.8
(30 × 21 × 12½)
Transferred from the Tate Gallery
to the National Portrait Gallery
1957

CLINT, George 1770–1854
*Falstaff's Assignation with
Mrs Ford ?1830–1 exh.1831
Oil on canvas 76.6 × 64.3
(30 × 25¼)
N00377

COLLINS, William 1788–1847
Happy as a King (replica)
c.1836
Oil on canvas 71.1 × 91.4
(28 × 36)
N00351

*Prawn Fishing 1828 exh.1829
Oil on mahogany panel
43.8 × 58.4 (17¼ × 23)
N00352

COOKE, Edward William
1811–1880
Undercliff Cave, Isle of Wight
exh.1836
Oil on canvas 41.9 × 52.1
(16½ × 20½)
N00448

*Dutch Boats in a Calm 1843
exh.1844
Oil on mahogany panel 42.5 × 49
(16¾ × 27¹⁄₁₆)
N00447

COOPER, Thomas Sidney
1803–1902
*Milking Time – Study of a
Farm-Yard near
Canterbury 1833–4 exh.1844
Oil on canvas 96.8 × 132.7
(38⅛ × 52¼)
N00435

Among the Cumberland
Mountains – Mist Clearing Off
1847 exh.1847
Oil on canvas 59.7 × 88.9
(23½ × 35)
N00436

CRESWICK, Thomas 1811–1869
*The Stile 1839 exh.1847
Oil on mahogany panel 61 × 50.1
(24 × 19¾)
N00429

DANBY, Francis 1793–1861
Sunrise – the Fisherman's
Home exh.1846
Oil on canvas 76.2 × 106.7
(30 × 42)
[destroyed during the Second
World War]

DUBUFE, Claude-Marie
1790–1864
The Suprise exh.1828
Oil on canvas 65 × 54
(25⅝ × 21⅜)
Transferred from the Tate Gallery
to the National Gallery 1956

DUPONT, Gainsborough
1754–1797
*Cottage Children
Oil on canvas 46 × 36.2
(18⅛ × 14¼)
N00311

EASTLAKE, Sir Charles Lock
1793–1865
Haidée, a Greek Girl 1827
exh.1831
Oil on canvas 63.5 × 50.8
(25 × 20)
N00398

*Christ Lamenting over
Jerusalem ?1846
Oil on canvas 104.8 × 156.2
(41¼ × 61½)
N00397

*The Escape of Francesco Novello di Carrara, with his Wife, from the Duke of Milan 1849 exh.1850
Oil on canvas 127 × 101.6 (50 × 40)
N00399

EGG, Augustus Leopold 1816–1863
*Scene from 'The Devil upon Two Sticks' 1844 exh.1844
Oil on canvas 87 × 111.3 (34¼ × 44½)
N00444

ETTY, William 1787–1849
*Candaules, King of Lydia, Shews his Wife by Stealth to Gyges, One of his Ministers, as she Goes to Bed exh.1830
Oil on canvas 49.7 × 60.7 (19⁹∕₁₆ × 23⅞)
N00358

Window in Venice, during a Festa exh.1831
Oil on canvas 61 × 50.2 (24 × 19¾)
N00364

*Youth on the Prow, and Pleasure at the Helm 1830–2 exh.1832
Oil on canvas 158.7 × 117.5 (62½ × 46¼)
N00356

The Dangerous Playmate exh.1833
Oil on mahogany panel 26.7 × 27.9 (10½ × 11)
N00360

Christ Appearing to Mary Magdalene after the Resurrection exh.1834
Oil on canvas 40 × 66 (15¾ × 26)
N00362

The Persian exh.1834
Oil on canvas 40.6 × 30.5 (16 × 12)
N00357

The Lute Player exh.1835
Oil on mahogany panel 62.9 × 53.3 (24¾ × 21)
N00359

Il Duetto ('The Duet') exh.1838
Oil on mahogany panel 38.1 × 49.2 (15 × 19⅜)
N00363

Female Bathers Surprised by a Swan exh.1841
Oil on mahogany panel 98.7 × 97.8 (38⅞ × 38½)
N00366

The Magdalen ?exh.1842
Oil on millboard 49.2 × 39.1 (19⅜ × 15⅜)
N00365

The Saviour or the Disciple
Oil on millboard 48.3 × 37.8 (19 × 14⅞)
N00361

FRASER, Alexander 1786–1865
Interior of a Cottage in the Hebrides ?c.1835
Oil on canvas 70.5 × 90.5 (29½ × 37⅜)
N00453

GAINSBOROUGH, Thomas 1727–1788
*Sunset: Carthorses Drinking at a Stream c.1760
Oil on canvas 144.9 × 155.1 (57⅛ × 61⅛)
N00310

Musidora c.1780–8
Oil on canvas 188 × 153 (74 × 60½)
N00308

*Boy Driving Cows near a Pool c.1786
Oil on canvas 62.7 × 76 (24⅝ × 29⅞)
N00309

GEDDES, Andrew 1783–1844
Dull Reading ?c.1826
Oil on mahogany panel 25.4 × 33 (10 × 13)
N00355

GIBSON, John 1790–1866
*Hylas Surprised by the Naiades 1827–?36 exh.1837
Marble 160 × 119.4 × 71.8 (63 × 47 × 28¼)
N01746

GOOD, Thomas Sword 1789–1872
*A Man Reading exh.1827
Oil on mahogany panel 24.1 × 19 (9½ × 7½)
N00378

GOODALL, Frederick 1822–1904
The Village Holiday 1847 exh.1847
Oil on canvas 106.7 × 171.4 (42 × 67½)
N00450

*The Tired Soldier Resting at a Roadside Well 1842 exh.1842
Oil on canvas 71 × 91.4 (27¹⁵∕₁₆ × 36¹∕₁₆)
N00451

HAGHE, Louis 1806–1885
Council of War at Courtray 1839 exh.1839
Watercolour on paper 76.2 × 71.1 (30 × 28)
N00456

HART, Solomon Alexander 1806–1881
Interior of a Polish Synagogue, at the Moment when the Manuscript of the Law is Elevated 1829–30 exh.1830
Oil on canvas 81.3 × 67.3 (32 × 26½)
N00424

HERBERT, John Rogers 1810–1890
*Sir Thomas More and his Daughter 1844 exh.1844
Oil on canvas 86.2 × 112 (34 × 44¹∕₁₆)
N00425

HERRING, John Frederick 1795–1865
*The Frugal Meal exh.1847
Oil on canvas 54.6 × 74.9 (21½ × 29½)
N00452

HILTON, William, the Younger 1786–1839
Cupid and Nymph exh.1828
Oil on canvas 72.4 × 88.9 (28½ × 35)
N00337

Rebecca and Abraham's Servant at the Well exh.1833
Oil on canvas 86.4 × 110.5 (34 × 43½)
N00338

Editha and the Monks Searching for the Body of Harold exh.1834
Oil on canvas 335.3 × 243.8 (132 × 96)
N00333

Study of Editha's Head for 'Editha and the Monks' c.1834
Oil on canvas 50.2 × 64.8 (19¾ × 25½)
N00334

Study of a Monk's Head for 'Editha and the Monks' c.1834
Oil on canvas 49.5 × 35.6 (19½ × 14)
N00335

Study of a Monk's Head for 'Editha and the Monks' c.1834
Oil on canvas 49.5 × 35.6 (19½ × 14)
[destroyed in the Thames flood 1928]

HORSLEY, John Callcott 1817–1903
*The Pride of the Village 1839 exh.1839
Oil on mahogany panel 76.2 × 62.2 (30 × 24½)
N00446

HOWARD, Henry 1769–1847
The Florentine Girl (The Artist's Daughter) exh.1827
Oil on canvas 96.5 × 61 (38 × 24)
N00349

JACKSON, John 1778–1831
Catherine Stephens, later Countess of Essex c.1822
Oil on canvas 76.4 × 64.1 (30¼ × 25¼)
Transferred from the Tate Gallery to the National Portrait Gallery 1957

JOHNSTON, Alexander 1815–1891
Dr Tillotson Administering the Sacrament to William, Lord Russell, at the Tower exh.1846
Oil on canvas 110.5 × 157.5 (43½ × 62)
[destroyed in the Thames flood 1928]

JONES, George 1786–1869
*Battle of Borodino exh.1829
Oil on canvas 121.9 × 213.4 (48 × 84)
N00391

*Utrecht exh.1829
Oil on mahogany panel 91.4 × 71.1 (36 × 28)
N00392

The Burning Fiery Furnace exh.1832
Oil on mahogany panel 90.2 × 60.8 (35½ × 27½)
N00389

Godiva Preparing to Ride through Coventry exh.1833
Oil on mahogany panel 74.9 × 61 (29½ × 24)
N00390

LANCE, George 1802–1864
*Fruit ('The Autumn Gift') 1834 ?exh.1834
Oil on mahogany panel 46 × 52.1 (18⅛ × 20½)
N00441

The Red Cap 1847
Oil on mahogany panel 44.8 × 50.8 (17⅝ × 20)
N00442

*Fruit ('The Summer Gift') 1848 exh.1848
Oil on canvas 71.1 × 91.4 (28 × 36)
N00443

LANDSEER, Charles 1799–1879
*Clarissa Harlowe in the Prison Room of the Sheriff's Office exh.1833
Oil on canvas 61 × 50.8 (24 × 20)
N00408

LANDSEER, Sir Edwin Henry
1803–1874
*Highland Music ?1829 exh.1830
Oil on mahogany panel 46.8 × 61
(18⅞ × 29)
N00411

Low Life 1829 exh.1831
Oil on mahogany panel
45.7 × 35.2 (18 × 13⅞)
A00702

High Life 1829 exh.1831
Oil on mahogany panel
45.7 × 34.9 (18 × 13¾)
A00703

*Deer and Deer Hounds in a
Mountain Torrent ('The
Hunted Stag') ?1832 exh.1833
Oil on mahogany panel 68.6 × 91
(27⅝ × 35⅞)
N00412

*King Charles Spaniels ('The
Cavalier's Pets') exh.1845
Oil on canvas 70 × 90.2
(27½ × 35½)
N00409

Time of Peace exh.1846
Oil on canvas 86.3 × 132
(34 × 52)
[destroyed in the Thames flood
1928]

Time of War exh.1846
Oil on canvas 86.3 × 132
(34 × 52)
[destroyed in the Thames flood
1928]

A Dialogue at Waterloo
exh.1850
Oil on canvas 193.7 × 388
(76¼ × 152¾)
N00415

LANE, Theodore 1800–1828
*Enthusiast ('The Gouty
Angler') 1828 exh.1828
Oil on mahogany panel
42.5 × 56.5 (16¾ × 22¼)
N00440

LAWRENCE, Sir Thomas
1769–1830
The Countess of Darnley
c.1825–30
Oil on canvas 63.5 × 50.5
(25 × 19⅞)
N00324

John Fawcett 1828–?30;
exh.1833
Oil on mahogany panel
76.2 × 62.2 (30 × 24½)
Transferred from the National
Gallery to the National Portrait
Gallery 1883

LEE, Frederick Richard
1799–1879
*Sea Coast, Sunrise 1834
exh.1834
Oil on canvas 85.7 × 109.2
(33¼ × 43)
N00419

LEE, Frederick Richard
1799–1879, and LANDSEER,
Sir Edwin Henry 1803–1873
Cover Side (Figures and
Animals by Sir E. Landseer)
1839; ?exh.1840
Oil on canvas 48.9 × 40.6
(19¼ × 16)
N00418

LESLIE, Charles Robert
1794–1859
*A Scene from Tristram Shandy
('Uncle Toby and the Widow
Wadman') 1829–30 exh.1831
Oil on canvas 81.3 × 55.9
(32 × 22)
N00403

*Sancho Panza in the
Apartment of the
Duchess 1843–4 exh.1844
Oil on canvas 121.3 × 151.2
(47¾ × 59½)
N00402

LINNELL, John 1792–1882
Windsor Forest ('Wood-
Cutting in Windsor Forest')
1834–5 exh.1835
Oil on mahogany panel
23.5 × 38.1 (9¼ × 15)
N00438

*A Landscape ('The Windmill')
1844–5 exh.1845
Oil on canvas 37.8 × 45.1
(14⅞ × 17¾)
N00439

DE LOUTHERBOURG, Philip
James 1740–1812
*Lake Scene, Evening 1792
Oil on canvas 43.8 × 61.5
(17¼ × 24¼)
N00316

MACLISE, Daniel 1806–1870
*The Play Scene in 'Hamlet'
exh.1842
Oil on canvas 152.5 × 274.2
(60 × 108)
N00422

Scene from 'Twelfth Night'
('Malvolio and the Countess')
exh.1840
Oil on canvas 73.7 × 124.5
(29 × 49)
N00423

MÜLLER, William James
1812–1845
Eastern Landscape 1843
Oil on mahogany panel
35.6 × 52.1 (14 × 20½)
N00379

MULREADY, William
1786–1863
Fair Time ('Returning from the
Ale-House') 1809–1839
exh.1809, 1840
Oil on canvas 78.7 × 66 (31 × 26)
N00394

*The Last In 1834–5 exh.1835
Oil on mahogany panel
62.2 × 76.2 (24½ × 30)
N00393

*The Ford ('Crossing the Ford')
exh.1842
Oil on mahogany panel 60.8 × 50
(24 × 19¾)
N00395

*The Young Brother 1856–7
exh.1857
Oil on canvas 80.5 × 63.3
(31¼ × 24⅞)
N00396

NASMYTH, Patrick 1787–1831
Landscape c.1807
Oil on oak panel 29.8 × 39.1
(11¾ × 15⅜)
N00380

*A Landscape ('The Angler's
Nook') 1825
Oil on mahogany panel 30.2 × 41
(11⅞ × 16⅛)
N00381

NEWTON, Gilbert Stuart
1794–1835
A Dutch Girl ('The Window')
exh.1829
Oil on mahogany panel 37.1 × 27
(14⅝ × 10⅝)
N00354

Yorick and the Grisette
exh.1830
Oil on canvas 75.9 × 57.1
(29⅞ × 22½)
N00353

PHILLIPS, Thomas 1770–1845
Nymph Reposing exh.1837
Oil on canvas 68.6 × 88.9
(27 × 35)
[destroyed in the Thames flood
1928]

PICKERSGILL, Frederick
Richard 1820–1900
Amoret, Aemylia, and Prince
Arthur, in the Cottage of
Sclaunder exh.1845
Oil on canvas 59.1 × 88.9
(23¼ × 35)
N00445

PICKERSGILL, Henry William
1782–1875
A Syrian Maid exh.1837
Oil on canvas 91.4 × 71.4
(36 × 28⅛)
N00417

*Robert Vernon 1846 exh.1847
Oil on canvas 142.2 × 111.8
(56 × 44)
N00416

REDGRAVE, Richard
1804–1888
*Country Cousins ?1847–8
exh. 1848
Oil on paper on canvas
83.9 × 109.6 (33 × 43⅛)
N00428

REYNOLDS, Sir Joshua
1723–1792
*Self-Portrait c.1775
Oil on canvas 73.7 × 61
(28¾ × 24)
N00306

Sir Abraham Hume c.1783
Oil on canvas 69.8 × 55.2
(27½ × 21¾)
N00305

The Age of Innocence ?1788
Oil on canvas 76.2 × 36.5
(30 × 25)
N00307

RIPPINGILLE, Edward Villiers
1798–1859
Capuchin Friar c.1833
Oil on canvas 68.6 × 58.4
(27 × 23)
N00455

Female Head
Oil on canvas 72.4 × 52
(28½ × 21½)
[destroyed]

ROBERTS, David 1796–1864
*Entrance to the North
Transept, Cathedral of Burgos
1835 exh.1836
Oil on mahogany panel
55.4 × 30.4 (21¾ × 12)
N00400

Chancel of the Collegiate
Church of St Paul, at Antwerp
1848 exh.1848
Oil on canvas 141.9 × 111.8
(56 × 44)
N00401

ROMNEY, George 1734–1802
*Lady Hamilton (?as a Figure in
'Fortune Telling') c.1782–4
Oil on canvas 49.5 × 40
(19½ × 15¾)
N00312

SCOTT, Samuel c.1702–1772
*A View of London Bridge
before the Late Alterations
engr.1758
Oil on canvas 28.5 × 54.5
(11¼ × 21½)
N00313

A View of Westminster Bridge
and Parts Adjacent engr.1758
Oil on canvas 29.8 × 54
(11¾ × 21¼)
N00314

SHEE, Sir Martin Archer
1769–1850
A Young Bacchus exh.1824
Oil on canvas 70.5 × 90.5
(27¾ × 35⅝)
N00367

Thomas Morton Esq. exh.1835
Oil on canvas 76.2 × 63.5
(30 × 25)
N00368

SIMPSON, John 1782–1847
Head of a Negro ?c.1827
Oil on canvas 55.9 × 55.9
(22 × 22)
N00382

STANFIELD, Clarkson Frederick
1793–1867
*Lake Como 1825
Oil on oak panel 47.8 × 78.3
(18¹³⁄₁₆ × 30⅞)
N00406

Sketch for 'The Battle of
Trafalgar, and the Victory of
Lord Nelson over the
Combined French and Spanish
Fleets, October 21, 1805' 1833
Oil on oak panel 38.9 × 80.3
(15¼ × 31⅝)
N00405

The Canal of the Guidecca, and
the Church of the Gesuati,
Venice 1836 exh.1837
Oil on canvas 61 × 90.2
(24 × 35½)
N00407

*Oude Scheld – Texel Island,
Looking towards Nieuwe Diep
and the Zuider Zee exh.1844
Oil on canvas 100.3 × 125.7
(39⅛ × 49½)
N00404

STOTHARD, Thomas
1755–1834
*Intemperance: Mark Antony
and Cleopatra c.1802 ?exh.1805
Oil on canvas 49.5 × 74.9
(19½ × 29½)
N00321

Calypso with her Nymphs
Caressing Cupid exh.1814
Oil on mahogany panel
39.4 × 30.5 (15½ × 12)
N00319

*Diana and her Nymphs
Bathing exh.1816
Oil on canvas 50.8 × 61 (20 × 24)
N00320

The Vintage exh.1821
Oil on canvas 104.8 × 132.1
(41½ × 52)
N00317

A Battle
Oil on canvas 61 × 68.6 (24 × 27)
N00322

A Woodland Dance
Oil on canvas 63.8 × 47
(25⅛ × 18½)
N00318

THOMSON, Henry 1773–1843
The Dead Robin
Oil on canvas 89.5 × 52.8
(35¼ × 20¾)
[perished 1917]

TURNER, Joseph Mallord
William 1775–1851
The Prince of Orange, William
III, Embarked from Holland,
and Landed at Torbay,
November 4th 1688, after a
Stormy Passage exh.1832
Oil on canvas 90.2 × 120;
N00369

*Bridge of Sighs, Ducal Palace
and Custom-House, Venice:
Canaletti Painting exh.1833
Oil on mahogany panel 51 × 82.5
(20³⁄₁₆ × 32⁷⁄₁₆)
N00370

The Golden Bough exh.1834
Oil on canvas 104.1 × 163.8
(41 × 64½)
N00371

*The Dogano, San Giorgio,
Citella, from the Steps of the
Europa exh.1842
Oil on canvas 62 × 92.5
(24¼ × 36½)
N00372

UWINS, Thomas 1782–1857
Le Chapeau de Brigand 1839
exh.1839
Oil on canvas 79.2 × 57.8
(31³⁄₁₆ × 22¾)
N00388

*The Vintage in the Claret
Vineyards of the South of
France on the Banks of the
Gironde 1847–8 exh.1848
Oil on canvas 78.7 × 154.9
(31 × 61)
N00387

WARD, Edward Matthew
1816–1879
Doctor Johnson in the Ante-
Room of the Lord Chesterfield
Waiting for an Audience,
1748 1845 exh.1845
Oil on canvas 106 × 139.4
(41¾ × 54⅞)
N00430

*The Disgrace of Lord
Clarendon, after his Last
Interview with the King –
Scene at Whitehall Palace, in
1667 (replica) 1846
Oil on canvas 54 × 73.8
(21¼ × 29⁹⁄₁₆)
N00431

*The South Sea Bubble: A Scene
in 'Change Alley in 1720 1847
exh.1847
Oil on canvas 130 × 190
(51 × 74¾)
N00432

WARD, James 1769–1859
*View in Tabley Park 1813–18
Oil on canvas 94 × 134.9
(37 × 53⅛)
N00385

The Council of Horses vide
Gay's Fables exh.1848
Oil on canvas 169 × 121.2
(66½ × 47¾)
[destroyed in the Thames flood
1928]

WEBSTER, Thomas 1800–1886
Late at School 1834 exh.1835
Oil on mahogany panel
43.2 × 36.8 (17 × 14½)
N00426

A Dame's School 1845 exh.1845
Oil on mahogany panel
62.2 × 121.9 (24½ × 48)
N00427

WEST, Benjamin 1738–1820
*Sketch for 'The Installation of
the Order of the Garter' c.1787
Oil on canvas 41.2 × 55.7
(16½ × 22)
N00315

WILKIE, Sir David 1785–1841
The Bag-Piper 1813 exh.1813
Oil on silk on mahogany panel
25.4 × 20.2 (10 × 8)
N00329

*Newsmongers 1821 exh.1821
Oil on mahogany panel
43.2 × 36.3 (17 × 14¼)
N00331

*A Woody Landscape 1822
Oil on mahogany panel
24.1 × 24.1 (9½ × 9½)
N00330

*The First Ear-Ring 1834–5
exh.1835
Oil on mahogany panel
76.2 × 61.9 (30 × 24⅜)
N00328

*The Peep-o'-Day Boys' Cabin,
in the West of Ireland 1835–6
exh.1836
Oil on canvas 125.7 × 175.2
(49½ × 69)
N00332

WILLIAMS, Penry 1798–1885
Pilgrims Reposing at a Cross
?exh.1835
Oil on canvas 50.8 × 40.6
(20 × 16)
N00434

Italian Girl with Tambourine
1837
Oil on canvas 50.8 × 40.6
(20 × 16)
N00433

WILSON, Richard 1713–1782
*Lake Avernus and the Island of
Capri c.1760
Oil on canvas 47 × 72.4
(18½ × 28½)
N00304

*Hadrian's Villa c.1765
Oil on canvas 35.6 × 25.4
(14 × 10)
N00302

*Maecenas' Villa, Tivoli c.1765
Oil on canvas 36.1 × 25.4
(14³⁄₁₆ × 10)
N00303

Strada Nomentana c.1765–70
Oil on canvas 57.1 × 76.2
(22½ × 30)
N00301

WITHERINGTON, William
Frederick 1785–1865
Stepping Stones on the
Machno, North Wales – Study
from Nature exh.1844
Oil on canvas 63.5 × 76.2
(25 × 30)
N00420

The Hop Garland exh.1843
Oil on mahogany panel
44.5 × 35.6 (17½ × 14)
N00421

WYATT, Henry 1794–1840
Vigilance 1835 exh.1835
Oil on canvas 34.9 × 29.8
(13¾ × 11¾)
N00383

Archimedes ?exh.1832
Oil on canvas 75.9 × 62.5
(29¾ × 24⅝)
N00384

Select Bibliography

With the exception of nos.2–7, 14 and 25, all the works in the Vernon Gift were engraved and published by the *Art Journal* with Robert Vernon's full approval. They appeared in fifty-seven parts between January 1849 and December 1854. Each part contained two (and, from February 1851 – Part Twenty-two – onwards, three) prints with accompanying letter press. Parts One to Twenty-one also contained two engravings of sculptures (mostly British), reduced to one in subsequent numbers. Each part had pale blue paper covers and cost five shillings. The editor for the first two parts was Mrs Anna Maria Hall and thereafter her husband S.C. Hall.

The same Vernon prints were published simultaneously in the monthly *Art Journal* along with a briefer commentary, and a reference to these appears in each of the entries in this catalogue. The part-work was subsequently reissued in three volumes, or 'series', as *The Vernon Gallery, 1850–4*, edited by S.C. Hall.

In addition to the literature cited below, details of the works catalogued in this volume, and other works in the Vernon Gift, can be found in the British Collection Catalogue Files which are part of the Tate Gallery Records.

All books published in London unless otherwise stated.

SIR WILLIAM ALLAN
[anon.], 'Living Artists – No.XVI. William Allan, A.R.A.', *Athenaeum*, 8 Sept. 1832, pp.586–7
David and Francina Irwin, *Scottish Painters at Home and Abroad*, 1975, pp.204–13

JOHN BACON THE YOUNGER
Rupert Gunnis, *Dictionary of British Sculptors 1660–1851*, 2nd ed., 1968, pp.28–31

EDWARD HODGES BAILY
[anon.], 'Portraits of British Artists, No.6. E.H. Baily', *Art-Union*, 1 July 1847, p.260
Gunnis 1968, pp.32–6

WILLIAM BEHNES
[anon.], 'William Behnes', *Art Journal*, vol.3 (n.s.), 1 March 1864, pp.83–4 (obituary)
Gunnis 1968, pp.45–8

RICHARD PARKES BONINGTON
Patrick Noon, *Richard Parkes Bonington: 'On the Pleasure of Painting'*, exh. cat., Yale Center for British Art, New Haven 1991–2

HENRY PERRONET BRIGGS
[anon.], 'Henry Perronet Briggs, R.A.', *Athenaeum*, 27 Jan. 1844, pp.90–1 (obituary)

SIR AUGUSTUS WALL CALLCOTT
Douglas Hall, 'The Tabley House Papers', *Walpole Society*, vol.38, 1960–2, pp.58–122 (p.66)
David Brown, *Augustus Wall Callcott*, exh. cat., Tate Gallery 1991

SIR FRANCIS CHANTREY
George Jones, *Sir Francis Chantrey, R.A.*, 1849
Francis Russell, *Portraits of Sir Walter Scott: A Study in Romantic Portraiture*, 1987

GEORGE CLINT
R.W. Buss, 'George Clint, A.R.A.', *Art Journal*, vol.6 (n.s.), 1 July 1854, pp.212–13 (obituary)

WILLIAM COLLINS
[James Dafforne], 'British Artists: Their Style and Character, no.V. William Collins, R.A.', *Art Journal*, vol.1 (n.s.), 1 May 1855, pp.141–4
Wilkie Collins, *Memoirs of the Life of William Collins*, 2 vols., 1848

JOHN CONSTABLE
Leslie Parris, *The Tate Gallery Constable Collection*, 1981
Leslie Parris and Ian Fleming-Williams, *Constable*, exh. cat., Tate Gallery 1991

EDWARD WILLIAM COOKE
[James Dafforne], 'British Artists: Their Style and Character, no.LXXXV. Edward Cooke, R.A.', *Art Journal*, vol.8 (n.s.), 1 Aug. 1869, pp.253–5
J.L. Howgego with John Munday, *Edward William Cooke, R.A.*, exh. cat., Guildhall Art Gallery 1970

THOMAS SIDNEY COOPER
T. Sidney Cooper, *My Life*, 2 vols., 1890
Stephen Sartin, *Thomas Sidney Cooper, C.V.O., R.A., 1803–1902*, Leigh-on-Sea 1976

THOMAS CRESWICK
[James Dafforne], 'British Artists: Their Style and Character, no.XIV. Thomas Creswick, R.A.', *Art Journal*, vol.2 (n.s.), 1 May 1856, pp.141–4

GAINSBOROUGH DUPONT
John Hayes, *The Landscape Paintings of Thomas Gainsborough: A Critical Text and Catalogue Raisonné*, 2 vols., 1982

SIR CHARLES LOCK EASTLAKE
David Robertson, *Sir Charles Eastlake and the Victorian Art World*, Princeton 1978

AUGUSTUS LEOPOLD EGG
[anon.], 'Augustus Leopold Egg, R.A.', *Art Journal*, vol.2 (n.s.), 1 May 1863, p.87 (obituary)

WILLIAM ETTY
Dennis Farr, *William Etty*, 1958

THOMAS GAINSBOROUGH
John Hayes, *The Landscape Paintings of Thomas Gainsborough: A Critical Text and Catalogue Raisonné*, 2 vols., 1982

JOHN GIBSON
'A.J.', 'Portrait of British Artists: John Gibson', *Art Journal*, vol.1 (n.s.), 1 May 1849, pp.139–41
Lady Eastlake (ed.), *Life of John Gibson, R.A.*, 1870

THOMAS SWORD GOOD
P.E. Bowes, *'In a Strong Light': The Art of Thomas Sword Good*, exh. cat., Berwick-upon-Tweed Borough Museum and Art Gallery 1989

FREDERICK GOODALL
[anon.], 'Portraits of British Artists: Frederick Goodall', *Art Journal*, vol.2 (n.s.), 1 July 1850, p.213
[J. Dafforne], 'British Artists: Their Style and Character, no.IV. Frederick Goodall', *Art Journal*, vol.1 (n.s.), 1 April 1855, pp.109–12
F. Goodall, *The Reminiscences of Frederick Goodall, R.A.*, 1902

JOHN ROGERS HERBERT
[anon.], 'J.R. Herbert, R.A.', *Times*, 20 March 1890, p.10 (obituary)
J.B. Trapp and H.S. Herbrüggen, *'The King's Good Servant': Sir Thomas More 1477/8–1535*, exh. cat., National Portrait Gallery 1977
Alexandra Wedgwood and Christopher Wilson, *Catalogue of the Drawings Collection of the Royal Institute of British Architects: The Pugin Family*, 1977

JOHN FREDERICK HERRING
Oliver Beckett, *J.F. Herring & Sons*, 1981

JOHN CALLCOTT HORSLEY
J.C. Horsley, *Recollections of a Royal Academician*, ed. Mrs E. Helps, 1903

GEORGE JONES
[anon.], 'Living Artists – no.XV. George Jones, R.A.', *Athenaeum*, 4 Aug. 1832, pp.506–7
Joany Hichberger, 'Captain Jones at the Royal Academy', *Turner Studies*, vol.3, no.1, 1983, pp.14–20

GEORGE LANCE
[anon.], 'Portraits of British Artists, no.2. George Lance', *Art-Union*, 1 March 1847, p.96

CHARLES LANDSEER
[anon.], 'Charles Landseer, R.A.', *Athenaeum*, 2 Aug. 1879, pp.153–4 (obituary)

SIR EDWIN LANDSEER
Richard Ormond, J. Rishel and R. Hamlyn, *Sir Edwin Landseer*, exh. cat., Philadelphia Museum of Art and Tate Gallery 1981–2

THEODORE LANE
Pierce Egan, *The Show Folks! … To which Is Added a Biographical Sketch of the Life of Mr Theodore Lane*, 1831

FREDERICK RICHARD LEE
[anon.], 'Frederick Richard Lee, R.A.', *Athenaeum*, 12 July 1879, p.58 (obituary)
R.B. Beckett (ed.), *John Constable's Correspondence: III: The Correspondence with C.R. Leslie*, Ipswich 1965, pp.81, 91–2, 97–9, 118, 134

CHARLES ROBERT LESLIE
Charles Robert Leslie, *Autobiographical Recollections*, 2 vols., 1860
Beckett 1965, pp.27–8, 108

JOHN LINNELL
A.T. Story, *The Life of John Linnell*, 2 vols., 1893
Katherine Crouan, *John Linnell*, exh. cat., Fitzwilliam Museum, Cambridge 1982

PHILIP JAMES DE LOUTHERBOURG
R. Joppien, *Philippe Jacques de Loutherbourg, 1740–1812*, exh. cat., Iveagh Bequest 1973

DANIEL MACLISE
Richard Ormond and John Turpin, *Daniel Maclise 1806–1870*, exh. cat., National Portrait Gallery 1972

WILLIAM MULREADY
Katherine Heleniak, *William Mulready*, New Haven and London 1980
Marcia Pointon, *Mulready*, 1986

PATRICK NASMYTH
J.C.B. Cooksey, *Alexander Nasmyth, 1758–1840*, Whittingehame 1991

HENRY WILLIAM PICKERSGILL
[anon.], 'Henry Pickersgill, R.A.', *Art Journal*, vol.14 (n.s.), 1 Aug. 1875, pp.231–2 (obituary)

RICHARD REDGRAVE
Susan P. Casteras, Ronald Parkinson et al., *Richard Redgrave 1804–1888*, exh. cat., Victoria and Albert Museum 1988

SIR JOSHUA REYNOLDS
David Mannings, *Sir Joshua Reynolds PRA (1723–1792): The Self Portraits*, exh. cat., Plymouth City Museums and Art Gallery 1992

DAVID ROBERTS
Helen Guiterman, Briony Llewellyn et al., *David Roberts*, exh. cat., Barbican Art Gallery 1986–7

GEORGE ROMNEY
Humphrey Ward and William Roberts, *Romney*, 2 vols., 1904
Patricia Jaffé, *Lady Hamilton in Relation to the Art of her Time*, exh. cat., Iveagh Bequest 1972

SAMUEL SCOTT
Richard Kingzett, 'A Catalogue of the Works of Samuel Scott', *Walpole Society*, vol.48, 1980–2, pp.1–134
Elizabeth Einberg and Judy Egerton, *The Age of Hogarth: British Painters Born 1675–1709*, Tate Gallery Collections, II, 1988

CLARKSON FREDERICK STANFIELD
Pieter van der Merwe, *The Spectacular Career of Clarkson Stanfield 1793–1867*, exh. cat., Tyne and Wear County Council Museums 1987

THOMAS STOTHARD
Mrs Bray, *Life of Thomas Stothard*, 1851
Edward Croft Murray, *Decorative Painting in England 1537–1837*, vol.2, 1970
Shelley M. Bennett, 'Thomas Stothard, R.A.', University of California Dissertation 1977, University Microfilms International, Ann Arbor 1982

J.M.W. TURNER
Martin Butlin and Evelyn Joll, *The Paintings of J.M.W. Turner*, rev. ed., New Haven and London 1984

THOMAS UWINS
Sarah Uwins, *A Memoir of Thomas Uwins, R.A.*, 2 vols., 1858

EDWARD MATTHEW WARD
Elliot O'Donnell, *Mrs E.M. Ward's Reminiscences*, 1911
James Dafforne, *The Life and Works of Edward Matthew Ward, R.A.*, 1879

JAMES WARD
Douglas Hall, 'The Tabley House Papers', *Walpole Society*, vol.38, 1960–2, pp.95–6
Edward Nygren, 'The Art of James Ward, R.A.', Yale University Dissertation 1976, University Microfilms International, Ann Arbor 1984

BENJAMIN WEST
Helmut von Erffa and Allen Staley, *The Paintings of Benjamin West*, New Haven 1986

SIR DAVID WILKIE
Allan Cunningham, *The Life of Sir David Wilkie*, 3 vols., 1843
H.A.D. Miles et al., *Sir David Wilkie of Scotland (1785–1841)*, exh. cat., North Carolina Museum of Art 1987

RICHARD WILSON
W.G. Constable, *Richard Wilson*, 1953
David Solkin, *Richard Wilson*, exh. cat., Tate Gallery 1982